Sarah Whitfield

FAUVISM

171 illustrations, 24 in colour

THAMES AND HUDSON

ACKNOWLEDGMENTS

*I should like to express my thanks to the private owners who
generously allowed me to see works in their collections and am
grateful for the co-operation of Tanya and David Josefowitz of
the Fridart Foundation. My thanks go also to the curatorial staff
of the Musée de l'Annonciade, Saint-Tropez; the Musée
Matisse, Cimiez, Nice; the Musée National d'Art Moderne,
Paris; the Israel Museum, Jerusalem, and the National Gallery
of Washington for their kindness in arranging access to works in
storage; and to the Galerie Louise Leiris, Paris, for making the
Kahnweiler archives available for consultation.*

ISBN 0-500-20227-3

Printed and bound in Singapore by C. S. Graphics

Contents

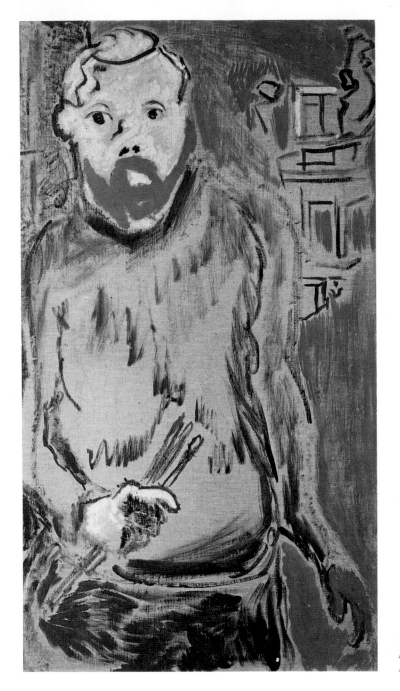

1 André Derain
*Portrait of Henri
Matisse* 1905

Introduction

Les Fauves, the Wild Beasts, was the name an art critic spontaneously gave to a group of young painters after seeing their works hanging together at the Paris Salon d'Automne of 1905. The image that leapt to mind of untamed animals shows how aggressive these paintings appeared at first sight to an audience which was only just coming to terms with Impressionism. Shortly before that historic exhibition, critics had already begun to take notice of Henri Matisse and his fellow students from Gustave Moreau's class at the Ecole des Beaux-Arts: Henri Manguin, Albert Marquet and Charles Camoin, one of the three closely knit groups of painters who constituted the Fauves. Moreau died in 1898 and the following year Matisse began attending classes at the Académie Carrière where he met Jean Puy and a student more than ten years his junior, André Derain. Whereas Puy was easily assimilated into the group from the Ecole des Beaux-Arts, Derain formed a strong, independent partnership with a painter nearer his own age, Maurice Vlaminck, whom he met in the summer of 1900. Derain introduced Vlaminck to Matisse in 1901 but it was not until the spring of 1905 that these two young men from Chatou, a small town in the Seine valley, began exhibiting alongside Matisse and his friends. In 1906 this band of artists was completed by three painters from Le Havre, Emile-Othon Friesz, Raoul Dufy and Georges Braque. Two further painters loosely associated with the Fauves were Georges Rouault, also a student of Gustave Moreau's, and Kees Van Dongen, who had moved to Paris from Holland in 1899.

Matisse, born in 1869, was the oldest of these painters, Braque, born in 1882, the youngest. From the beginning, Matisse's seniority, his authority as an artist and his passionate conviction that new art could and should find a public, singled him out as the driving force among his fellow artists. Once the group had been successful in gaining critical recognition he gradually withdrew from its centre, thus to

some extent weakening its identity; by 1908 the name 'Fauve' was starting to be used as a label broadly synonymous with 'avant-garde'.

The Fauves were bound together more through friendship than through any artistic creed. They did not share the clear-sighted pictorial aims of a group such as the Neo-Impressionists, nor did they act collectively to issue ringing moral directives as did the Futurists and the Surrealists. The friendships they enjoyed were profound and, in some cases, lifelong. Although by 1905 Matisse was finding that his own work had less and less in common with that of his former art school friends, his loyalty to them never wavered. Eventually Derain and Vlaminck were to quarrel as irrevocably as only best friends can, but only after they had weathered the ending of the Fauve years; they remained close until the outbreak of war in 1914. As Braque slowly advanced into Cubism he had the support of Friesz and Dufy, but as the unique fellowship between himself and Picasso developed, so these old ties dissolved and fell away.

Broadly speaking, Fauvism followed where Matisse and Derain led. The paintings they did while staying together in the South of France in the summer of 1905, and which gave Fauvism its name, came out of what Matisse called 'the courage to return to the purity of the means', establishing that its point of departure had been, as he put it, 'beautiful blues, reds, yellows, stuff to stir the sensual depths of man', and the rush of activity released by these works carried the group triumphantly through into 1907. By then it was apparent that Fauvism was not a school of painting (as Cubism was to be), but a restless search for style. This explains its strapping pace which is measurable more in spurts of energy than in the steady rhythm of sustained progress. It also explains why Fauvism in the strict sense had the briefest life of any twentieth-century movement.

Two members of the group, Marquet and Friesz, with hindsight dated the beginning of Fauvism to around 1900 which, in the sense that Fauvism was the result of assimilating the richness and variety of first Impressionism and then Post-Impressionism, is understandable. 'Given our time, what we had behind us, we did what we were obliged to do' is how Matisse defined their position. This sense of responsibility to their immediate past is already apparent in the painting that Matisse and Marquet were doing before 1900. But if that was all there had been to it, there would have been no such

'movement' as Fauvism. Matisse's early associates, Marquet, Camoin and Puy, could not go beyond that point of assimilation; their painting, like that of many other artists of the period, is a pleasing reflection of their admiration for the Impressionists as well as for the next generation of painters, Cézanne, Gauguin, Van Gogh and Seurat. These minor Fauves showed with Matisse, Derain and Vlaminck more out of the solidarity of friendship than out of a common sense of direction, but their comparatively restrained canvases proved extremely useful in attracting dealers and collectors to the idea of buying Fauve pictures. By contrast, the kind of painting done by Matisse, Derain, Vlaminck and Braque was rigorously opposed to the lyrical charm of Impressionism. Fauvism was, according to Matisse 'the result of a necessity within one, not a voluntary attitude arrived at by deduction or reasoning, it was something that only painting can do'. The act of painting itself was at the heart of the matter. Fauvism was the first 'movement' to insist in explicit terms that a painting is the canvas and the pigments. The idea that a picture is the sum of the marks made on the canvas rather than a mirror held up to life, or to nature, or to literature accounts for the chief characteristics of the first true Fauve paintings being composed of briskly applied strokes, patches and dabs of brilliant colour.

One problem in dealing with the Fauve painters is the emphasis which inevitably falls on Matisse. Not only is he the leading Fauve, he is one of the most celebrated painters of this century, which meant that he, much more than the others grouped with him, was the one most sought by critics and journalists for comment and the one who has received and still receives the greatest attention. This, coupled with the fact that Matisse believed that discoveries about painting belonged not to one artist but to all, led him to speak about Fauvism on behalf of the other Fauves: he usually referred to 'we' (in marked contrast to Vlaminck's insistent 'I'). Matisse's definitions of Fauvism, however, while accurately recording his own position, do not necessarily reflect the nuances of opinion and the variety of views that must have existed among a disparate group of artists. His dominant position can also lead to an unintentional devaluation of the achievements of the other painters. Vlaminck is the one Fauve who is the most frequent victim of this partiality, a situation distorted still further by his own attitude to history: buying back and redating some of his early Fauve canvases, as

well as using his several volumes of autobiography to settle old scores, has not helped his case.

It is necessary too to understand the give and take between the two main protagonists, Matisse and Derain, without being unduly influenced by Matisse's greater stature as an artist. All these problems are exacerbated by the disparity between the vast amount of literature to be found on Matisse and the comparatively little amount to be found on the others, and by the fact that extensive archival material on these artists has yet to be published. Nor have such problems been clarified by the attitude of the artists themselves. While Matisse continued to speak up for Fauvism as a whole, the others seldom referred to this period in their careers unless prompted by a direct question: mostly they were content to consign it quietly to the past. Even Derain, who had played such a leading part in the formation of Fauvism, looked back at this period and dismissed it as 'youthful brashness'. Matisse was the only one of the group who never ceased to acknowledge Fauvism as an essential part of his painting, and this is why it was only he who could state with conviction, 'Fauvism is not everything but it is the foundation of everything.'

The Path to Colour

In the summer of 1904 *Les Arts de la vie*, a Paris literary magazine, conducted a questionnaire on teaching methods practised at the Ecole des Beaux-Arts. The purpose of the questionnaire, the results of which were to be published to coincide with the presentation of the government's new budget for the fine arts, was to challenge the official system of rewarding the pursuit of academic art with prestigious prizes such as the Prix de Rome. One of the questions that readers were asked to consider was the abolition of the Ecole itself. The debate was taken up by a leading critic, Gustave Kahn, who, in spite of his strong opposition to the teaching system at the Ecole, came down firmly against the idea of abolishing it, giving as his main reason the example set by 'the pupils of Gustave Moreau'.

Moreau had been appointed Professor at the Ecole on 1 January 1892 at the age of sixty-six. After a long career, he was known only to a small audience of critics and collectors; he had not shown at the Salon since 1880; the Musée du Luxembourg, which housed contemporary art, owned only one early painting; very few of his works had been reproduced. Within a year of his appointment, the jury who judged the studio shows held at the end of each year expressed not only their unanimous satisfaction with the work of Moreau's students, but their regret that they had been unable to award them more prizes. By 1895, when Henri Matisse, Albert Marquet and Henri Manguin, the students who were to form the nucleus of the Fauve group, arrived in his class (Camoin was a latecomer), Moreau had the reputation of being not just the most liberal member of the teaching staff but the most dedicated. Twice a week he followed the same exacting routine: from seven to eight in the morning he corrected students' drawings in the Antique Galleries in the Louvre: from eight to ten he corrected their paintings in the studio and after lunch he returned to the Louvre. As a timetable this was quite exceptional: a fellow student and close

friend of Matisse's, the Belgian painter Henri Evenepoël (who has left a vivid account of Moreau and his studio in the detailed letters he wrote home to Brussels) compared Moreau to Léon Bonnat, another teacher at the Ecole and one of the most successful Salon painters of his day, who, as Evenepoël observed, put in an average appearance of only twenty or thirty minutes a week. Moreau, as Rouault, another of his students, remembered, was the first to arrive and the last to leave.

The experience of an art class at the Ecole des Beaux-Arts in the 1890s came as a shock to Evenepoël, a quiet, serious student who had arrived in Paris in 1892. As a new student he was addressed as 'nouveau', given most of the studio chores as well as a bad place to sit from where he could barely see the model. He described a typical morning as one continual round of shouts, exclamations, quarrels, with easels and stools falling over or being thrown about, all to a continuous background of singing: whether choruses from *Tannhauser* and *Lohengrin*, symphonies by Beethoven and Schumann or popular songs. Moreau's class consisted of about fifty students who, according to Evenepoël, ranged from the rich 'chic' set who talked mainly about horses to the ones he described as 'hooligans'. Serious students, such as Matisse and Rouault were able to get on with their work only by commandeering a corner of the studio for themselves (Matisse later drew a plan of the class which illustrated Evenepoël's point).

Moreau's originality as a teacher lay in his belief that all students of painting had a duty to discover their own artistic personality rather than to follow blindly rules and precepts laid down by tradition. Rouault found that he showed 'constant respect for our little personalities', and in a tribute to his teacher, Matisse wrote: 'The great quality of Gustave Moreau was that he considered that the minds of young students would develop continuously throughout their lives and so he did not push them to satisfy the different scholastic tests which, even when artists have succeeded in the greatest competitions, leave them, around thirty, with warped minds, and an extremely limited sensibility and means.' Moreau's far-sighted concern for his students was every bit as valuable as his corrections of their work. The visits to the Louvre, which Matisse described as 'being almost revolutionary at that time', encouraged them to discover other artists for themselves and to look at their work with their own eyes.

2 Albert Marquet
Woman and Stretcher-Bearer c. 1900

Matisse officially entered the Ecole des Beaux-Arts in March 1895, having passed the entrance examination in February: his marks, which had been only average, won him forty-second place out of the eighty-six offered. Until then Matisse's experience of art schools had been discouraging. In October 1891 he had enrolled at the well-known Académie Julian run by Adolphe-William Bouguereau and Gabriel Ferrier, both eminent Salon painters who pursued a rigorously academic approach to teaching. 'Lost in these chaotic surroundings, discouraged from the moment of my arrival at Julian's by the "perfection" of the painted figures fabricated there from Monday to Friday, and so meaningless that their "perfection" made me dizzy, I dragged myself off to the Ecole des Beaux-Arts where Gustave Moreau and two other professors, Bonnat and Gérôme, corrected candidates for entry to the studios. There, from Gustave Moreau, I got intelligent encouragement.' In fact, he may well have attended Moreau's class for about two years before gaining a place. When Matisse arrived at the Ecole des Beaux-Arts, Rouault was the acknowledged star pupil there and was being groomed for the prestigious Prix de Rome. Neither Matisse nor Albert Marquet, who had met Matisse in 1892 at evening classes run by the Ecole des Arts Décoratifs and had entred Moreau's class at the same time, saw themselves as potential Rome scholars. They identified more easily with the sorts of subjects chosen by painters of modern life, painters 2

such as Manet and the Impressionists, rather than with the style of history painting demanded of candidates for official prizes. During the next decade Marquet remained Matisse's most constant painting companion both in the studio and in the streets of Paris or on excursions to nearby towns. His shy, introverted character prompted Matisse to play a protective role; he later revealed that at this time Marquet had few other friends: 'really he only had me. I'd do what he wanted to do. We could live close together without having to talk: it was because of that I could travel with him and with him alone.' Shy as he was in daily life, Marquet started his career as a highly gifted and even daring artist, who in these early years proved himself to be the most stimulating of all Matisse's art-school friends.

Within a year of his entry, Matisse was encouraged by Moreau to submit work to the recently founded Société Nationale des Beaux-Arts, which held its annual show in the Palais des Beaux-Arts in the Champs-de-Mars, the immense, oblong space between the Ecole Militaire and the Seine. 'Yesterday at half past one', Evenepoël wrote to his father, 'I was strolling along the quay, when I met Gustave Moreau, who like me was going to see one of my good friends, Henri Matisse, a delicate painter well versed in the arts of *greys* . . . At last there we were in the little studio filled with carpet fragments, trinkets, everything grey with dust. Moreau said to me, "We are the jury." He sat down in an armchair, I beside him, and then we spent an exquisite hour. He told us the whys and the wherefores of his loves and his hates: Matisse showed his entries to the Champs-de-Mars, a dozen canvases, with a delicious tone, some still lifes, more or less everything . . .' Moreau's confidence was rewarded: Matisse had seven works accepted by this Salon, five of which were hung. Two were bought by the state: an interior scene of a woman reading (chosen by the President's wife, Mme Félix Faure, for the bedroom she occupied at Rambouillet), and a still life which found a private buyer. This conspicuous success was matched by another. Puvis de Chavannes, the President of the Société Nationale, nominated Matisse for election as an associate member, a position which entitled him to exhibit several works each year without submitting them to the jury. That the nomination went uncontested reflects the promise of Matisse's debut. Such immediate recognition encouraged him to push ahead, and over the next twelve months he set about a rigorous study of what was still

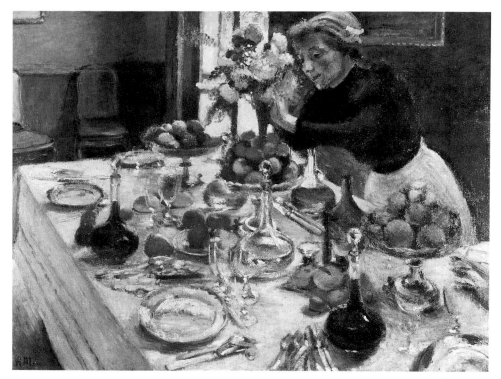

3 Henri Matisse *The Dinner-Table* 1897

the most hotly debated style of painting: 'My friend Matisse is now
doing Impressionism', Evenepoël informed his father on 2 February
1897, 'and thinks about everything in terms of Claude Monet.'

A few weeks later Matisse delivered *The Dinner-Table* to the Salon 3
of the Société Nationale, where its bad placing reflected the
displeasure with which it had been received by the hanging
committee. For even though Matisse had made only modest and
restrained use of the Impressionist palette and technique, the fact that
he had gone over to a school of painting which was still considered
renegade cost him the approval he had won the year before. If it seems
surprising that an exhibiting body, which had itself broken away
from the official Salon, thus distancing itself from the Establishment,
should have reacted with dismay at this incursion of Impressionism – a
school of painting which had been in the public eye for a good twenty
years – it has to be remembered how unacceptable artists like Monet,

Pissarro and Renoir still were to many people. Two months before Matisse's painting was shown, the Musée du Luxembourg had put on view part of the collection of Impressionist works left to the nation by Gustave Caillebotte, a painter and close friend of the Impressionists. The bequest had finally been accepted after several years of prevarication, and then only in part. More than twenty of the works offered were refused, including eight Monets and eleven Pissarros.

The Dinner-Table may be a deliberate essay in Impressionism but there is no Impressionist work like it. The domestic intimacy of the subject is closer to the interiors painted by the Nabis painters, Bonnard and Vuillard for example, or even by some of the Neo-Impressionists. But it is far from being a pastiche of either of these schools and its originality and strength derive from Matisse's concern to create his first consciously 'modern' work. It is modern in the sense not only of choosing an informal domestic scene as its subject but also in adopting the range of separately applied brush-strokes with which the Impressionists invigorated the picture surface; the vibration of colour in their paintings was in total opposition to the smooth, 'licked' surfaces advocated by teachers such as Bouguereau. In this picture, Matisse seems to be following Moreau's principle that new art needs as its foundation a solid knowledge of the old masters; the surface of the table, which dominates the canvas, is spread with an array of china and glass and reveals the hard schooling Matisse received from hours of copying paintings in the Louvre, such as Chardin's *Still Life with Skate* or Fragonard's *The Music Lesson*. Undaunted by the harsh criticism meted out to his pupil, Moreau defended the painting. He observed that the carafes were so convincingly painted that 'you can hang your hat on the glass stoppers', a comment which shows that whatever reservations he may have had over the unorthodox brushwork and palette, he was well pleased with Matisse's mastery of pictorial reality.

In January 1898 Matisse married and, following the advice of Camille Pissarro that he should study Turner, he spent the first week of his honeymoon in London. This was followed by six months in Corsica and a further six months in Toulouse. Absence from Paris, marriage, travelling, all these, may have released in Matisse an energy and passion which bear little relation to the personality of the painter who only the year before had been noted for the delicacy of his grey tones. Inspired in part by the directness of Turner's response to nature,

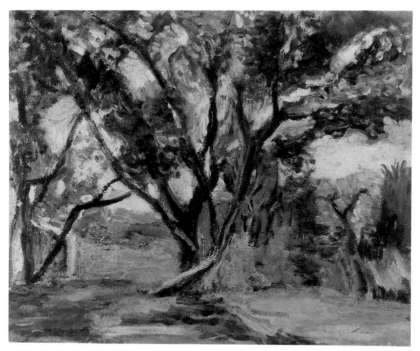

4 Henri Matisse *The Olive Tree* 1898

which Matisse particularly noticed in the watercolours, he turned his back on the deliberation of technique demanded by his work until then, and gave way to paint as though he were tasting it for the first time. Although Matisse's response to Turner was important, it was the first experience of a southern climate which made the more profound impression: 'I went to Corsica one year', Matisse told André Marchand, 'and it was by going to that marvellous country that I learned to know the Mediterranean. I was quite dazed by it all; everything shines, everything is colour and light.' Paintings like *The Olive Tree* also carry out to the letter a lesson Moreau used to drum into his students: 'You must think colour, have imagination with it. If you have no imagination you'll never paint beautiful colour. You must copy nature with imagination – that is what makes an artist. Colour must be thought, dreamt, imagined.' The sheer richness and boldness of the broad streaks of colour, which may owe something to Moreau's own embroidered use of paint, are witnesses to an almost violent repudiation of the Impressionists' desire to catch a moment of

4

nature. Later, Matisse called Impressionism 'a completely objective art, an art of unfeeling'; his new consciousness of nature, which he described later as that of 'mystics awaiting a revelation', is revealed in the rumbling surfaces of these small, highly charged canvases, and shows itself to be just the opposite of that 'unfeeling'.

Evenepoël was almost certainly not the only one among Matisse's fellow students to react unfavourably when shown these new works. In February 1899, still keeping his father informed about Matisse's activities, he wrote: 'He's brought back some extraordinary studies painted as though by an epileptic and crazy Impressionist – it's mad, he who had such fine qualities as a painter!' It is understandable that Evenepoël should have been taken aback by paintings such as *Still Life with Pewter Jug* where the material of the objects is almost obliterated by the material of the paint itself, and where the vigorous marks made by the palette knife and by the end of the brush match the freedom of the scrawling movement of the brush. He may have been particularly disturbed by the absence of the conventional brush–stroke, for Matisse

5 Henri Matisse *Still Life with Pewter Jug* 1898

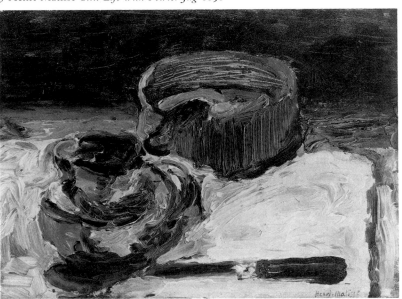

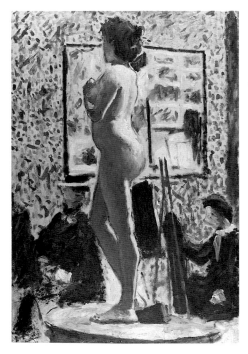

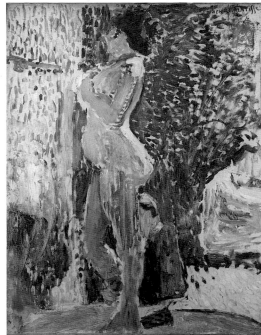

6 Albert Marquet *Nude* 1899 7 Henri Matisse *Nude* 1899

has not so much painted this still life as constructed it out of pigments. While Evenepoël was unable to sanction the freedom with which Matisse was now using paint, Marquet, Matisse's closest friend from the Ecole des Beaux-Arts, solidly supported this new kind of expression, and he and Matisse continued their partnership which had begun in Moreau's class. Two large oil studies they made side by side 6,7 from a model some time in 1899 make a point of exaggerating the broken brushwork of Impressionism by multiplying the uneven flecks of paint which Monet in particular frequently used to agitate a surface in order to increase the overall vibration of colour. Matisse and Marquet also resumed their practice of working together outside the studio.

Two small landscapes done in Arceuil, a short train journey from the Luxembourg gardens, show to what extent they were both now drawing with the brush; thick black lines do more than simply outline

19

a roof or a wall, they make the whole surface jump towards the spectator, in such a way as to contradict the distance between Matisse's subject and himself. Take away the stroke of black paint which defines the sloping roof of the house nearest to us in Matisse's *Landscape at Arceuil* and the whole scene recedes into the middle distance. That one line of paint defining the sloping roof anchors the eye to the surface of the canvas. The same insistence on the surface is made in the roughly brushed strokes of pink colour in the sky; this painting makes us see it as being primarily an arrangement of colour on a canvas. Such disregard for the usual points of emphasis in a landscape – the topographical features – is very close to what was to be the spirit of Fauvism. It is hardly surprising that Marquet should have claimed later that around 1899 he and Matisse were already working in the Fauve style: 'I only painted in that manner in Arceuil and in the Luxembourg gardens', he wrote. 'Sometimes I would begin a canvas in a dazzling tonality and working it further, end on a grey note.' Quite how literally this is supposed to be taken is hard to judge, especially since Marquet's reticence and modesty were so pronounced that some regarded these qualities as faults. A work of his such as *Street in Arceuil*, does not have the recklessness of invention apparent in the similar subject painted by Matisse but nor does it end 'on a grey note'; it is a composed and balanced work, full of light, and painted tonally, a little in the manner of Corot.

8 Henri Matisse *Landscape at Arceuil* 1900

9 Albert Marquet *Street in Arceuil* 1900

The landscapes that Matisse was doing in 1898 are powerful evidence of his independence. If he was not exactly disenchanted with Impressionism he was certainly not committed to it. *Interior with Harmonium*, painted in Matisse's cramped apartment on the Quai St Michel overlooking the Seine, shows how the comfortable domesticity of Impressionism which was so well depicted in *The Dinner-Table* has been disturbed by a lunging, awkward view of the furniture of Matisse's surroundings: a harmonium, a plain kitchen chair and a sofa, one corner of which aggressively intrudes into the picture. The change is a telling one, even allowing for the difference of scale between the two works. The earlier painting, a large set-piece, does not record a scene from his own daily experience. It is to some degree an invention. The props, such as the glass, the china and the chairs, were borrowed and the maid was a model whom Matisse could barely afford and indeed had to replace with a dummy after a few days. The

10

3

21

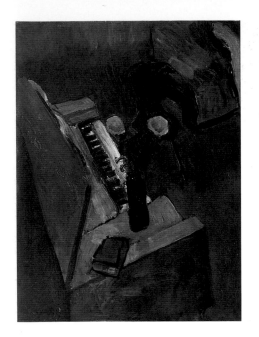
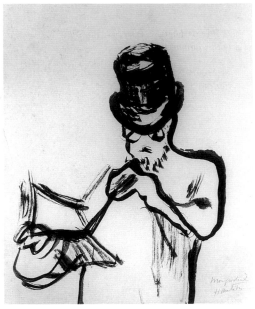

later painting, a much smaller canvas and one which Matisse never parted with, is a record of his own daily life exactly as it was around 1900: stark, uncomfortable, pinched. The reality of an everyday existence is registered with total conviction and without a trace of sentiment. One reason for his hanging on to it, almost like a talisman, was surely because of the radical break it made with Impressionism through the complete rejection of the way in which that school of painting sought to communicate pleasure. The artist who steered Matisse into this uncompromisingly tough way of seeing was Cézanne, who only now, around 1900, was starting to emerge from obscurity. Matisse had been able to see Cézanne's work on the regular visits he paid to Ambroise Vollard's gallery in the rue Lafitte, and he would have also seen it at the Salon des Indépendants in 1898 and 1899. A fellow student, Charles Camoin, who had met Cézanne while stationed at Aix during his military service and subsequently corresponded with him, has testified to the enthusiasm with which Moreau's students discussed his work. But for most young painters at that time, the grand, hovering presence of the great Post-Impressionist was a remote one, as Vlaminck's recollection of how they saw him indicates: 'For us Cézanne was a great fellow, but aside from that, the

10 Henri Matisse *Interior with Harmonium* 1900

11 Henri Matisse *Self-Portrait* 1900

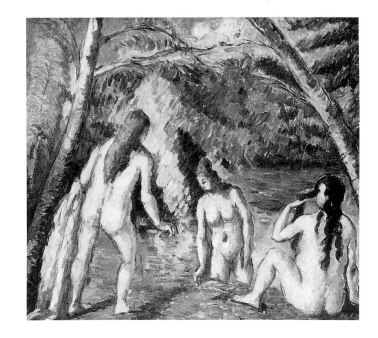

12 Paul Cézanne *Three Bathers* c. 1879–82

meaning of his experiments remained mysterious.' It was a different story with Matisse; he borrowed money from Marquet and managed to scrape together enough to buy a small Cézanne painting of bathers 12 from Vollard. Matisse understood the manner in which Cézanne had unshackled painting from its representational role by making the paint itself the subject of the picture: the way in which every form in a Cézanne canvas is invested with equal weight regardless of its size came as a revelation to him. None the less, in contrast to Camoin, he avoided a meeting with the man himself: 'I have often been in the neighbourhood of Aix without it ever occurring to me to visit Cézanne', he told an early historian of the Fauves, Georges Duthuit, reasoning that as an artist gives his best in his pictures, 'an artist's words do not matter essentially'. This same reason did not prevent Matisse, however, from meeting distinguished painters such as Pissarro, Redon, Rodin and later Renoir, and his statement about Cézanne must be seen as a unique tribute to the emotional truth as well as the pictorial power contained in that artist's work: 'I have nothing to hide in art', Cézanne told Charles Camoin in a letter of February 1903. And it was surely the conviction that the whole man was to be found in his work that discouraged Matisse from seeking him out.

23

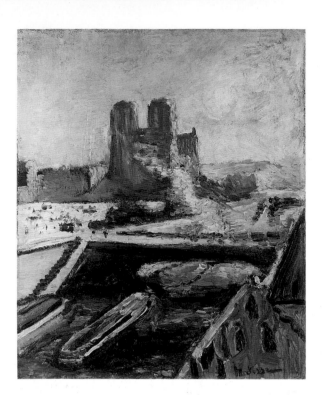

13 Henri Matisse *Notre Dame*
1900

Moreau died in 1898 but Matisse continued to attend the Ecole des Beaux-Arts until the following year when he was asked to leave, officially because of his age (he was coming up to thirty). He recalled, however, that the sight of one of his views of the Quai St Michel (similar to the view of *Notre Dame*) so disconcerted his new teacher, Fernand Cormon, that some excuse had to be found to exclude him from the class. Casting round for somewhere else to go, Matisse joined a class in the rue de Rennes run by Eugène Carrière (who must have remembered Matisse's success at the Société Nationale two years before). There Matisse became the driving force, impressing two students in particular, André Derain and Jean Puy. Puy remembered Matisse's 'bold, almost reckless confidence' and his use of 'extreme, wholly artificial means'. He described how Matisse, when painting from the model, would lay in the side planes of the nose and shadow area under the eyebrows with almost pure vermilion, which exaggerated the projection of the nose and the brow. The full-length oil study of a model, a work painted in Carrière's studio, illustrates this

13

14

24

intensifying of expression through 'wholly artificial' means, the most immediate lesson that Matisse had learnt from Cézanne. Now he and Marquet became obsessed by the solidity of planes, even of planes of shadow, 'for in Cézanne who had taken complete possession of us, the shadows are as firm in their planes as the light planes on either side'. According to Puy, Derain was just as eager as Matisse to impose his own imagination on what he saw: 'It was a dull day. The studio was made gloomy, moreover, by a dark grey paper . . . but Matisse and Derain behind him represented that grey as a great massive blue and the form of the model, orange', and, he went on, 'it was striking but wholly outside reality.' While Derain was to say later that one had only to see the nudes that Matisse was doing in 1900 to realize that Fauvism had already begun, the fact is that however isolated Matisse and Derain may have felt themselves to be in Carrière's small classroom, they were part of a groundswell of young painters waking up to the possibilities laid out before them by the Post-Impressionists.

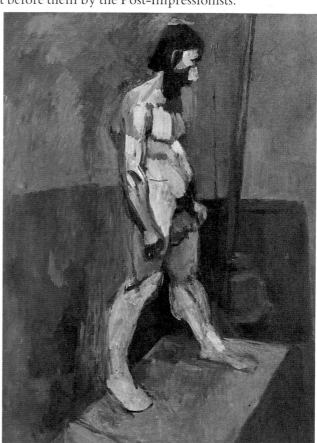

14 Henri Matisse *Male Model c.*1900

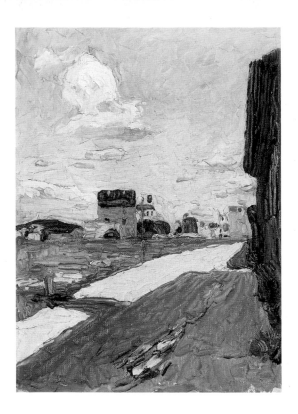

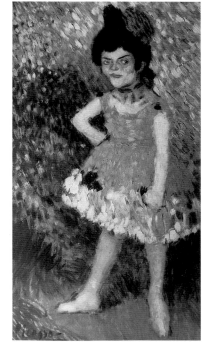

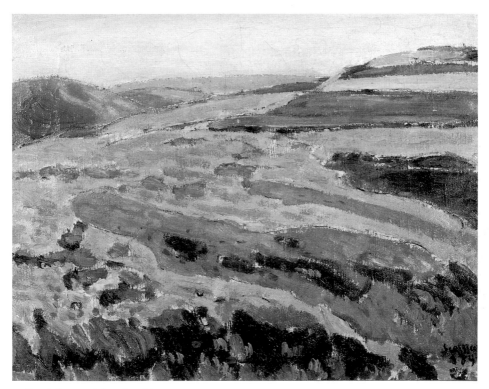

17 René Seyssaud *Les Sainfoins* 1890

Picasso, whose work done in Paris in 1901 brought a new 16
dynamism to Post-Impressionist colour and image, charged into the
twentieth century more self-assured than any painter of his genera-
tion. The intense, textured landscapes that Kandinsky and Mondrian 15
were showing at the Indépendants in the early 1900s were very close to
the attempts made by Matisse and Marquet to discover ways in which
to release painting from its descriptive or documentary role: the
canvases of these artists revel in the texture, the colour and the very
substance of paint. There are other painters too who, although not as
celebrated as those mentioned above, had moments of artistic
perception well ahead of their time. René Seyssaud is one such
example, a Provençal painter who showed regularly in Paris and who,
by the mid-1890s, was making colour the main subject of his
paintings. His landscapes, such as *Sainfoins,* are areas of paint first and 17
landscapes second – to such an extent that several historians have

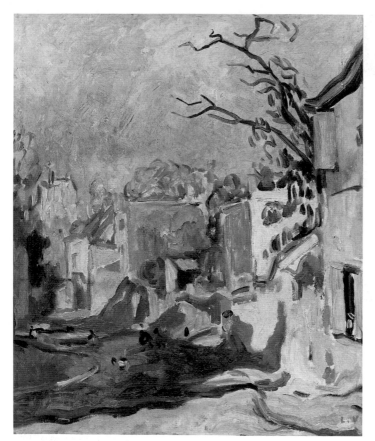

18 classed him as a Fauve in the vanguard of Fauvism. Louis Valtat, whose colour appears to float on the surface of the canvas, is another painter sometimes loosely bracketed with the Fauves. Both Valtat, who like Matisse was born in 1869, and Seyssaud, who was two years older, belonged to the generation of painters who understood the picture surface to be primarily a flat piece of canvas covered with areas of paint. To them flatness was essential and their aim was decoration in the most elevated sense of the word. The famous painting lesson
19 Gauguin had given Sérusier in 1888, which resulted in *Le Bois d'amour*, took on an almost religious significance for Sérusier's generation. 'How do you see these trees?', Gauguin had asked him. 'They are yellow.' 'Well then, put down yellow. And that shadow is rather blue. So render it with pure ultramarine. Those red leaves? Use vermilion.'

28

19 Paul Sérusier *Le Bois d'amour (Le Talisman)* 1888

Near that time, Monet gave a curiously similar lesson to an American admirer: 'When you go out to paint, try to forget what object you have before you, a tree, a house, a field or whatever. Merely think, here is a little square of blue, here an oblong of pink, here a streak of yellow, and paint it just as it looks to you, the exact colour and shape, until it gives your own naïve impression of the scene before you.' Monet may have expected rather different results from those envisaged by Gauguin, but the lessons given by both were about choosing and arranging elements of nature in accordance with an aesthetic temperament. By the mid-1890s, this idea had become widely disseminated: the flat, richly patterned surfaces of Vuillard, built up with blocks of colour used pictorially rather than descriptively, are another of its fruits. Minor painters such as Valtat and Seyssaud, however, looked back rather than forward. For all the tempting similarities to Fauvism that their work suggests, it is actually something very different, indeed it may have been a recognition of the 'school' aspect of the paintings of such artists, that explains the Fauves' apparent indifference to their work. Matisse's use of pure vermilion, as witnessed by Puy, was used to model the face, and as Puy well understood, its purpose was to make the nose and the forehead project outwards. The use that Vuillard, Valtat or Seyssaud made of patches of pure colour was to eradicate modelling in order to flatten the surface absolutely.

Matisse and Derain seem to have recognized immediately something of their own artistic personalities in each other. They saw themselves as part of a tradition and this led to their consuming interest in the work of other artists, whether those in the Louvre or those to be seen in the galleries of dealers like Durand-Ruel and Vollard. They were both highly articulate and enjoyed discussions about art (unlike Marquet and Vlaminck, for instance, who gave those who witnessed such discussions the impression of being ill at ease). One of the first works by Derain that Matisse saw was a copy he had made of Ghirlandaio's *Christ Carrying the Cross*, a painting in which, according to Matisse, Derain had 'not only put back the colour but reinforced the expression', to such a degree that the guards in the Louvre nearly had him thrown out for 'assassinating beauty'. (The surveillance of students copying in the Louvre was strict: for instance, Evenepoël, who liked to sketch the visitors as well as the paintings, was forbidden

20 Maurice Denis *The Little Girl in the Red Dress* 1899

to do so.) Despite such affinities, however, the contrasts in their age and circumstances prevented a more intimate bond between Matisse and Derain and it is unlikely that Matisse saw much that Derain was doing outside Carrière's classroom. Matisse, ten years older and married with small children, maintained a rigorous daily routine, while Derain's existence was less tightly organized. He lived with his parents who ran a prosperous confectioner's shop in Chatou, a small town in the Seine valley, about ten miles outside Paris. Their disappointment at their son's decision to give up his engineering studies to be a painter was expressed in the meagre allowance they gave him in return for his services in the shop as a part-time errand boy.

In the summer of 1900 Derain met Maurice Vlaminck (from nearby Vésinet), an intelligent, tough, rumbustious, politically active character, who gave him the companion and sense of direction he seemed to have been looking for. Vlaminck, who at the time of their meeting was on a fortnight's leave from the army (he was nearing the end of his three-year military service), found himself one day sitting opposite

Derain, whom he knew by sight, on the train that ran from the Paris suburb of St Germain-en-Laye to the Gare St Lazare. That evening they met again for the return journey, which ended prematurely when the train was halted by a derailment of freight trains further up the line (an event Vlaminck later embellished with dead and injured passengers). It was, in fact, only a minor accident and Vlaminck and Derain, deciding not to wait for the relief train, finished the journey on foot.

The next day they met to go painting together. It was probably the first time that Vlaminck had shown his work to another painter. As he recalled, 'André Derain was the first not to laugh at my artistic efforts, to take some interest in them.' He added that it was only at this moment that he began to see himself as a serious painter. It is a poignant story, for although Vlaminck's work was almost certainly not as daring as he would have us believe ('a violent daub made up of vermilion, chrome yellow, prussian blue, viennese green', was how he remembered it), his innocence about his copious talent is convincing. He had, as he recounted later, no conception of painting as a profession – it was an activity he equated more with being an anarchist, a lover, a sprinter, a dreamer or a boxer; painters were born, not made, he thought, and this belief in the instinctive nature of painting never left him. Art took the place of sport in Vlaminck's life and one might say that, at least to begin with, he regarded painting as its equivalent: he had been a serious competitor in the bicycle races that were popular in France during the 1890s, until an attack of typhoid fever in 1896 prevented him from competing in the biggest race of all, the Grand Prix de Paris, and put an end to his career as a racing cyclist. The following year, he began his military service. As he was not eligible for the one-year period reserved for those in certain privileged professions, or with good academic prospects, he – like Derain – had to do the full three-year stint (Braque's apprenticeship to a house-painter and decorator was to make him eligible for the one-year service).

Vlaminck adapted to army life more easily than Derain was to do – he even profited from the experience. Through the access he was given to the officers' mess library, he discovered novelists such as Zola and the Goncourt brothers, as well as political writers like Marx and Kropotkin, while his friendship with Fernand Sernada, an anarchist corporal with a flair for writing, cemented his new interest in

literature and politics. His period of military service, and Derain's too, coincided with an escalation of industrial unrest in France, in rural parts as well as in the cities, and the duties of new recruits involved taking part in the often savage interventions by the army to break up demonstrations and strikes. The determination of the workers is shown by the increasing length of the strikes. Whereas in 1895 the average stoppage had been seven days, by 1902 it was twenty-one days and by 1906 (when there were well over a thousand strikes) some workers stayed out for as long as twelve months. This unrest was further exacerbated by the activities of anarchists, who commanded the respect and support of many intellectuals, including a number of painters associated with Neo-Impressionism, notably Paul Signac and Maximilien Luce. Vlaminck's period in the army largely shaped his political position and on his release, shortly after his meeting with Derain, he too became an active sympathizer and joined *La Libertaire*, an anarchist newspaper, both as a contributor and a fund raiser.

It is in this context that we can best understand Vlaminck's celebrated remark: 'What I could have done in real life only by throwing a bomb – which would have led to the scaffold – I tried to achieve in painting by using colour of maximum purity. In this way I satisfied my urge to destroy old conventions, to "disobey" in order to re-create a tangible, living, and liberated world.' At the same time, with Sernada, the anarchist corporal, he hit on a scheme to make money by writing novels which today would be considered soft-porn. They were published by the Offenstadt brothers whose books *Perverse Desires* and *The Incestuous Woman* found a ready audience. Between 1900 and 1907, Vlaminck and Sernada turned out three such novels, *From One Bed to Another, All for That*, for which Derain provided illustrations, and *The Spirit of the Mannequins* (reputed to have been used as the model for the murder of a young girl).

During the winter of 1900–01, Vlaminck and Derain shared a studio in a disused restaurant on the Ile de Chatou, opposite the small town of Bougival, a place which had seen better days in the 1870s and 1880s when it had prospered as a place for boating parties (one of the several gentle pastimes painted by the Impressionists). Here Derain found a new liberty. In Carrière's studio, he was working beside Matisse and Puy in an atmosphere of stern concentration and intense self-absorption. As Matisse recalled: 'How many sessions, tests of

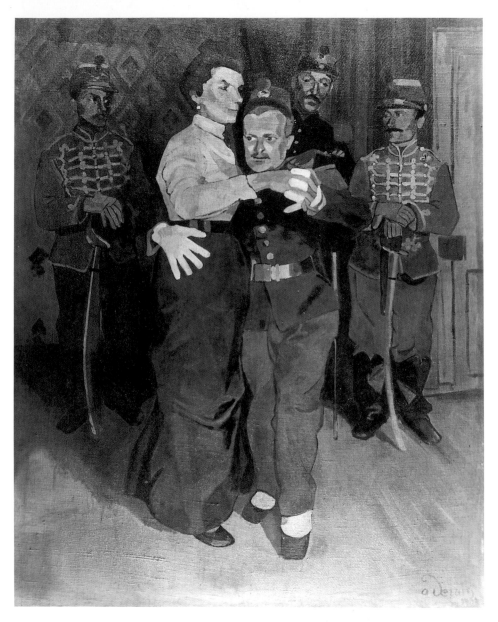

21 André Derain *The Ball at Suresnes* 1903

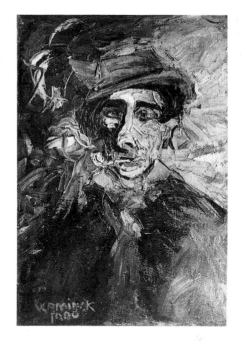

22 Maurice Vlaminck *Man with Pipe* 1900

patience have we sat through? Side by side each dragging his own particular burden along with him together with a respect for the thoughts of those beside him which seems almost inhuman.' He also remembered the lack of communication between the painters: 'Meal times and the end of the day brought no one any closer. Each would close his box and put his canvas away without a word to anyone'. In Vlaminck, Derain was with a painter who was not only nearer his own age than Matisse but who was as yet unburdened by the artistic personalities of other painters. Little survives from this period, almost certainly because both painters destroyed their work by scraping it off the canvases, either in order to save buying new ones (which Vlaminck was forced to do), or at a later date in order to obliterate the past (which Derain is known to have done). *Man with Pipe* gives a 22
strong idea of the physical intensity Vlaminck brought to his painting, both in the way the paint is applied, and in the vigour of the drawing. That Vlaminck's response to art was a profoundly emotional one is illustrated by his famous reaction to the large Van Gogh show put on by the Bernheim-Jeune Gallery in 1901, when he declared that he loved Van Gogh, not better than any other painter, but better than his own father.

35

At their first meeting, Vlaminck had needled Derain by reminding him of his impending military service, but it was mainly his friendship which helped sustain Derain through those three harsh and often joyless years. They corresponded regularly, and from the surviving letters from Derain to Vlaminck (the other side of the correspondence is missing) we find that he too found refuge from the grinding routine of army life in reading a great deal and especially in writing. His various attempts at novels, stories and plays that are revealed in these letters throw some light on the make-up of his artistic personality, particularly on his ambivalence between being an artist of his time and an artist who can transcend those limits. This dichotomy is one that nags away throughout these early years and leaves a very definite mark on his Fauve work. His aspirations were towards Zola's realism but with greater emphasis on dramatic expressionism. Significantly, he made several attempts at writing for the theatre. In a remark to Vlaminck he said: 'The good thing about the theatre is that it allows a much greater logic in building up a person psychologically and physically.' The compelling incongruity of the couple made by the tall, angular woman and her short, stocky partner in *The Ball at Suresnes* (1903) shows this 'building up' of characters through psychological and physical means in order to extract the full drama from reality. For real it certainly was, being copied faithfully from a photograph taken at an army dance. Effects of light, accentuated by the camera, such as the vibrant glare of the white gloves against the dark cloth of the skirt, are exaggerated in order to heighten the human comedy.

21

At this stage Derain – and Vlaminck – was possessed by a vivid, romantic ideal of the artist as hero, a vision fired by the mystique growing round the generation of the 1870s: 'The whole gang of the Manets, the Cézannes, the Degas, the Monets etc. what a great time that was!' Their enthusiasm was fuelled still further by recollecting the trials endured by that generation during the Franco-Prussian war (1870–71) and the period of the 1871 Commune: 'the blood of our dead in the outskirts and in the streets of Paris'. Their attitude closely followed that of anarchist sympathizers in the early 1900s, among whom were a number of the Neo-Impressionists. A painting such as *Une Rue de Paris en mai 1871 ou La Commune*, shown by Maximilien Luce at the 1905 Salon des Indépendants, corresponds with Derain's

36

23 André Derain *Still Life*
1904

24 Maurice Vlaminck
Kitchen Interior 1904

image of the fallen heroes. But although they shared many of the same ideals, Vlaminck and Derain, whose Fauve works are often bracketed together, developed very different personalities as artists. Vlaminck, the more instinctive by nature, did an average of one canvas a day, while Derain, like Matisse, invested his works with an anxious deliberation. (In 1903 Matisse told Henri Manguin that each of his paintings required ten 'sittings'.) Although Derain did not need to come back again and again to the same painting quite in the same way as Matisse did, the landscapes and still lifes he was doing after his release from the army (the few that remain) are just as painstaking in their investigations into the work of other painters. *Still Life* (1904) explores the way in which density of volume and colour in a Cézanne still life impose a monumentality on every form. It is a conscious exercise in style which Vlaminck would never have undertaken. Attack rather than reflection is the tenor of Vlaminck's approach. His is a genuinely expressionist assault on the subject. If 'expressionist' is a word which one falls back on, it is not the Expressionism associated with the German group, Die Brücke, which made its appearance shortly after the Fauves and whose subject-matter as well as manner of painting were meant to register feelings which are at once universal and precise; those German pictures have the quality of contemporary myths. In dramatizing even a dressing-gown, Kirchner conforms to what has come to be seen as the stereotype of the painful process of self-examination so peculiar to the twentieth century. By contrast, Vlaminck had little interest in the dark side of modern life. When confronted by its sleazy reality, as he often was in the early years through his succession of jobs as a violinist in cafés and theatres, the experience more often than not, as he later admitted, made him recoil in disgust. His several books of autobiography affirm time and again that his true place was in the country where he could lead a simple, rustic life. It was Derain who had more of the instinct of an Expressionist. In the first recorded letter that he sent Vlaminck from his army camp, writing about motifs that he would like to paint, he remarks: 'Those telegraph lines, they should be made to look enormous, so much is going on inside', but it was an instinct kept in check by the powerful antidote of realism.

Vlaminck was very conscious of his Flemish origins – one of the reasons, perhaps, why he was always a loner in the predominantly

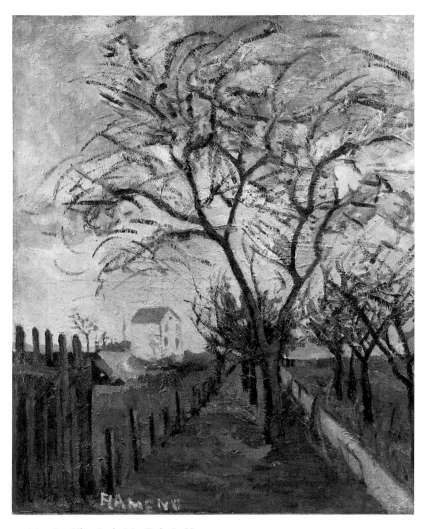

25 Maurice Vlaminck *My Father's House* 1902

French group of painters. The signature 'FLAMENC' on an early 25
landscape reinforces his status as an outsider. Intimations of both the
colour and technique of Vlaminck's Fauve paintings are seen in the
areas of brilliant green and red which, although small, dominate the
surface. His ability to communicate movement in nature is as evident
here, in the swaying branches of the tree, as it is in the more

tempestuous works of 1905 and 1906. The almost religious feeling that he had for nature made him take up painting in the first place, and it stayed with him to the end. The curious fact about Vlaminck's painting is that there is not a great deal of difference between his earliest surviving work and his last. The dark, agitated paint, whipped up by thick flicks of lighter colour, which he used in 1900, returned once the fevered colour of the Fauve period had subsided.

In 1903 Matisse had to face the fact that the sort of experiments that he had been doing over the past few years, investigations into the way sensations could be transmitted through paint in the way that he understood Cézanne to have worked, had put a virtual stop to any hopes he had nursed of making a living from his art. His father, who had not forgiven the controversial reception of *The Dinner-Table* at the Salon de la Nationale, stopped his allowance. Ill health dogged both him and his wife who now had to close the small millinery shop she had opened after their marriage. There were also three children to support, 'these delightful children are so often the cause of many, many worries in families of modest means', Matisse confided to Manguin in the summer of 1903, just when he was on the point of abandoning painting altogether. 'If I could,' he told Manguin, 'I'd chuck painting to the dogs. It is unsatisfying and too unremunerative.' A plan he devised for a group of twelve collectors to give him a small yearly income in return for paintings never got off the ground. 'I'm not fooling myself into believing that I'm indispensable to the progress of painting', he told a friend in a letter of 31 July 1903. 'My only ideal is to earn a living.' To do that, certain concessions had to be made: 'I note a steady and considerable progress, more flexibility of execution than in previous studies and a return towards stricter harmonies and values that will certainly be more acceptable to the collectors who liked them in the past.' In the same letter Matisse writes about being able to present 'a calm and smiling face to the crowd of art-lovers who do not care for anxious and tormented artists'. (Matisse, who was often both, had a horror of displaying this side of his nature.) The paintings that came out of this period of difficulties indicate that he was floundering: the question was not so much about how to paint as about what to paint. His interiors are suddenly peopled with costumed characters, a monk, a woman spinning, a
26 Spanish guitar-player, and even *Carmelina*, an imposing study of a

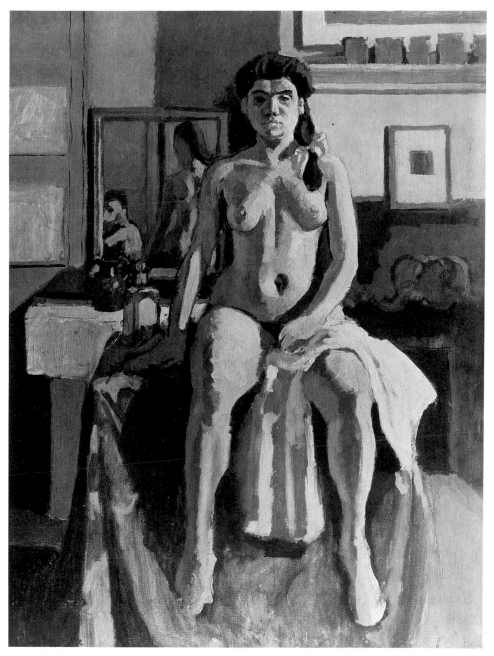

26 Henri Matisse *Carmelina* c.1903–04

nude, lacks the buoyancy of earlier work. In describing his dilemma to Manguin, he wrote: 'I suffer mainly from not being able to work more with my mind. Things go right for a while but I have to face up to the fact that it is very limited, and instinct gets the upper hand and unfortunately abandons me before I finish my painting, which means that what I have is no good. All my labour only leads me to cry out my impotence more and more loudly.'

As part of his abortive plan to interest a group of art-lovers to contribute money towards a yearly salary to be paid to him in exchange for works, Matisse had been thinking of persuading Ambroise Vollard to give him a show, the proceeds of which were to be divided among the collectors as a further means of reimbursement. Vollard, one of the leading dealers in contemporary painting, had already begun to buy work from Matisse but he was in no hurry to commit himself any further and it was only through the influence of the critic Roger Marx that he eventually agreed. The exhibition opened in June 1904 with forty-five canvases, mostly still lifes and landscapes, which presented a review of Matisse's progress from *The Dinner-Table* onwards. Although it failed to attract much attention (the one press notice was written by Roger Marx who was also the author of the catalogue preface), the fact that a show had taken place at all seems to have given Matisse the impetus he so badly needed.

His confidence may have been further restored by what he now saw Derain and Vlaminck doing, for it was probably only in 1904 that he really got to know the paintings of the two young men from Chatou. As he said later, 'To tell the truth, the painting of Derain and Vlaminck did not surprise me for it was close to the researches I myself was pursuing. But I was moved to see that these very young men had certain convictions similar to my own.' These convictions were rooted in their discovery of the work of the artists of the Post-Impressionist generation – Cézanne, Gauguin, Van Gogh and Seurat – painters who had revealed that power of expression can be carried by the paint itself, both through colour and through the marks made on the canvas. Close as these painters must have seemed through the increasing accessibility of their work, their actual presence was unusually remote: few young painters have been so dramatically cut off from direct contact with their immediate predecessors as the Fauves. Van Gogh had died in 1890, Seurat in 1891; Gauguin, who in

any case had been mostly absent from France since 1891, died in 1903; and Cézanne was fast becoming a living legend protected from the curious by the seclusion of his house in Aix. Of these painters, Seurat had been the one most closely committed to finding, and adhering to, a practical theory of art and so it was that his meticulous experiments with colour and his uncompromisingly modern subject-matter had given rise to Neo-Impressionism, the only school of Post-Impressionism. Thanks to the devoted efforts and commanding presence of Seurat's disciple Paul Signac, by the late 1890s Neo-Impressionism had grown into a powerful, widespread movement dominating contemporary art. Quick to spot a serious and talented newcomer (and a potential recruit to the movement), Signac responded to Matisse's wish to join him for the summer of 1904 at St Tropez, a small fishing port on the south coast, mid-way between Toulon and Nice, by offering him the use of La Ramode, the house in which he had lived until 1898 when he had built his villa, La Hune. This act of hospitality made it possible for Matisse and his family to spend the summer months in the south.

Although Matisse had made a habit of working next to his peers, such as Evenepoël, Marquet and Manguin, he had not yet worked with a painter of Signac's distinction and experience. Nor, in his systematic study of recent painting, had he yet fully investigated the resources of Neo-Impressionism. As the successor to Seurat and the chief intepreter and theorist of Neo-Impressionism, Signac was a vital link with the fading generation of Post-Impressionists. At forty-one years old, he was also a powerful figure in contemporary art, having played a major role in the planning and organization of the Société des Indépendants. By all accounts a man of generous impulse, unaffected self-confidence and dominating stature, Signac took pleasure in playing the role of teacher and leader. He could also put people's backs up. Vlaminck, for example, likened Signac's manner of presiding over the submissions to the 1905 Salon des Indépendants to that of a sergeant-major in a barrack room enrolling conscripts: 'His bombastic, bureaucratic manner got on my nerves', he later wrote. It was precisely the domineering side of Signac's temperament against which Matisse wanted to pit himself, for as he told Apollinaire in 1907, 'I believe that the personality of the artist develops and asserts itself through the struggles it has to go through when pitted against other

27 Kees Van Dongen *Le Moulin de la Galette* 1904

personalities. If the fight is fatal and the personality succumbs, it means that this was bound to be its fate.' Matisse was familiar with Signac's influential treatise, *D'Eugène Delacroix au néo-impressionnisme*, which had first appeared in *La Revue blanche* in 1898, and he would have recognized that many of Seurat's preoccupations with light and colour, harmony and line were also his. Apollinaire was to remark on the paradox of a school which appeared to be so hermetic yet did the

27 most to liberate the artistic awareness of the younger generation. The opportunity to work beside the leading practitioner of this school had to be seized.

Seurat and his followers attempted to invest pigments with the same radiance as light itself by creating an equivalent of light through juxtaposing touches of colours, not just the six principal colours (yellow, red, blue, green, orange, violet) but a whole range of

44

pigments. Theoretically, these particles of colour would be observed as coming together to form an optical mixture. In fact, they continue to be seen separately but they break up the surface of the canvas in such a way that the spectator experiences an optical vibration. The Neo-Impressionists wanted, as one contemporary writer put it, 'to reproduce the pure phenomenon, the subjective appearance of things'. The creation of light as a physical entity on the canvas rather than a reproduction of its effects was of paramount importance to Matisse, as it was to be for other Fauve painters. Matisse would have further identified with the belief that art should have an idealistic purpose, for the aim of the Neo-Impressionists went beyond a mere desire to obtain the elusive optical mixture: Signac insisted that Divisionism, as the technique became known, was 'a philosophy, not a system'. It was essentially an art founded on the sort of utopian vision which is spelled out in the title of Signac's large canvas *Au Temps d'Harmonie* (*In the Age of Harmony, the Golden Age is not in the Past, it is in the Future*) painted a decade earlier. Just as 'harmony' was a key concept in the Neo-Impressionist vocabulary ('justice in society and harmony in art – the same thing', wrote Signac), so it became a key word for Matisse. The Neo-Impressionists had also placed a great emphasis on craftsmanship, for the Divisionist technique demanded a thorough knowledge of materials as well as a fluent technical facility, which Matisse, with his own respect for materials and craft, would have appreciated. Such factors help to explain why it was Matisse, rather than any of the other Fauves, who was willing to undergo the experience of Neo-Impressionism at first hand. 28

Matisse's visit to Signac came at a time when the Neo-Impressionists were becoming more relaxed in their practice of Seurat's rigorous colour theory and more ready to experiment with colour as something independent of the dictates of nature or of science. In fact, the practice of Divisionism had always been less strict than its theory: the notion, for example, that painters limited themselves to primary and secondary colours, or even to a small selection of pure colours, has long since been contested. At the height of Seurat's activity, he had as many as eighteen mixtures on the palette, each one of which might be further mixed with white. Already, Signac and Henri-Edmond Cross, a close friend and neighbour of Signac's and one of the most gifted painters in the Neo-Impressionist group, were beginning to break

away from the Divisionist touch and were using large, brick-shaped strokes of brilliant colour. Cross, who during this summer of 1904 was to be of great help and support to Matisse, was acutely aware of the limitations of his own kind of Divisionism. When he referred to 'the numerous attachments' that hamper the artist's vision, meaning the habits of perception instilled by 'false upbringing', as he put it, Cross was painfully conscious of the inhibitions which prevented him from giving himself over entirely to colour. His way of painting, which Matisse was now able to study at first hand, relied on achieving a synthesis between working from the imagination and working from the motif. As he explained, 'I compose in the studio, coming as close as possible to my interior vision; then, the harmony being established, partly on paper and canvas, and partly in my head, I set about making my sensations objective – sensations corresponding to the initial vision – in front of nature.' During the execution of the final painting, he kept those notes made from nature close at hand. The key to his method is the importance he gives to the conception of the painting. A period of composition in the studio, dictated by the imagination, was followed by a session out of doors to 'give life to' and to 'correct' the vagaries of the inner vision, and finally the whole was transmitted to

29 canvas back in the studio. The emphasis that Cross places on what he calls his 'interior vision' is in line with the Neo-Impressionist belief that a landscape painting should extol the eternal rather than the transient aspect of nature.

When Matisse arrived in St Tropez, he may still have been affected by the anxiety about his painting that had pursued him over the last twelve months. In contrast with his usual exacting routine, he seems to have slowed down, although he must also have been recovering from the effort of preparing for the Vollard show. There are a few sketches and some small canvases which he worked on out of doors, to all appearances immune to the Divisionism being practised around him. Then, quite suddenly, an argument with Signac over a painting he

30 was working on at La Hune, *The Terrace*, propelled him into action: apparently, Signac had criticized his treatment of this picture as 'slack'. Amélie Matisse, so the story goes, seeing her husband wrought up by the heated discussion, took him for a calming walk along the nearby shore and there, in the late afternoon, he settled down to paint a small

32 landscape, *The Gulf of St Tropez*. Whether he really painted it

46

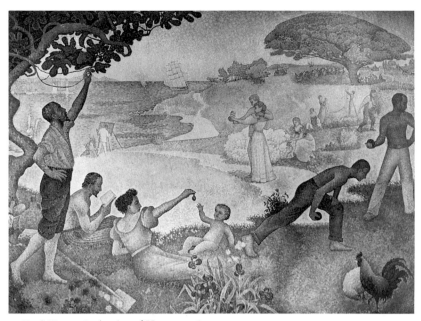

28 Paul Signac *In the Age of Harmony* 1895
29 Henri-Edmond Cross *The Evening Air* 1893–4

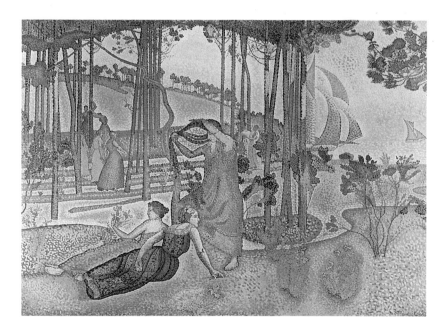

that same day or not is hardly important but it certainly shows an excitement and agitation that is not only absent from other works done at St Tropez, but which had not been present in his work since his trip to Corsica some six years before.

The Gulf of St Tropez, which has many of the features of what was to be identified as a Fauve work, is dominated by strokes of red paint in the foreground, which occasionally slide and slip in the excitement of execution. The way in which certain elements of the landscape, such as the tree, the solitary cloud and the distant hills, are outlined appears to emphasize the use of the brush as a pencil or a crayon. There are parts of this painting where the paint invades the composition, such as the irregular dab of red which pushes up against the small seated figure of the artist's son Pierre. The immediacy of the work and the circumstances in which it is thought to have been made recall the

48

remedy Matisse confided to the poet and critic Guillaume Apollinaire a few years later: 'Whenever I was blocked by difficulties, I would say to myself: "I have colours and a canvas, and I must express myself with purity, even if it means doing so sketchily – by putting down four or five spots of colour, for example, or by tracing four or five lines that have a plastic expression." ' The major significance that this landscape held for Matisse is shown by the use he made of it in the large, figure composition, *Luxe, calme et volupté*, painted after his return to Paris in September. 31

While *The Dinner-Table* has been an exercise in Impressionism, *Luxe, calme et volupté* can be seen as a discreet challenge to Neo-Impressionism. Not only is it painted in a free Divisionist technique but the subject draws on the utopian ideal of that school. Moreover, it enabled Matisse to practise the method of working which he had recently observed at first hand: the bringing together of what Cross called the 'inner vision' and the physical reality of the motif in order to create a single harmonious whole. The discovery Matisse was slowly making at this time, so he said later, was that the 'secret' of his art consisted of 'a meditation on nature, on the expression of a dream which is always inspired by reality'. *Luxe, calme et volupté*, Matisse's first imaginary composition, is a decisive step in that direction. Its title, taken from the refrain in Baudelaire's poem *L'Invitation au voyage*:

Là-bas, tout n'est qu'ordre et beauté
Luxe, calme et volupté

distances the scene from everyday reality. The poetic force of the painting lies in the tension between the naturalness of the small group of figures as they act out the familiar domestic scene of a family afternoon on the beach (a naturalness which is missing from the subjects of bathers and nymphs painted by Signac or Cross) and the knowledge that the group also exists outside measured time, outside everyday reality. *Luxe, calme et volupté* is very close to the accommodation which Apollinaire had written about in *La Chanson du mal-aimé*, published the previous year, between 'a form of lyricism anchored in reality' and 'the symbolist notion inherited from Mallarmé of the poem as an enigma'.

When the painting was shown at the Salon des Indépendants the following spring, Signac snapped it up and took it back to St Tropez.

31 Henri Matisse *Luxe, calme et volupté* 1904

His purchase was a typical act of generosity but he must none the less have been gratified that one of the most talented of the younger artists had publicly paid homage to the principles of Neo-Impressionism. The canvas became a talking point among members of Signac's circle. Some months after it had been installed in the dining-room at La Hune, Cross wrote about it to a fellow Neo-Impressionist, Charles Angrand, saying how much he had liked it when he had first seen it and even more so now that he had been able to see it again: 'Naïvely displayed there is a preoccupation with harmonies of line and tints, obtained (more or less happily) by optical mixture; and this musical canvas can be studied at length.' The word 'musical' would certainly have pleased Matisse. He would also have readily agreed that the application of Divisionist technique was only more or less successful,

32 Henri Matisse *The Gulf of St Tropez* 1904

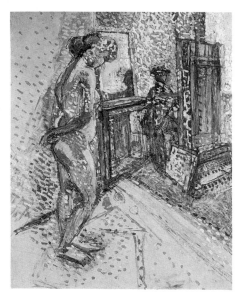

33 Henri Matisse *Marquet Painting from the Model* 1904–05
34 Henri Matisse or Henri Manguin *Artist Painting from the Model* 1904–05

for compared with a finished work by Signac or Cross, Matisse's canvas is distinctly rough and sketchy. Hands and feet trail off, the most extreme example being in the nude on the left with her back turned, her outstretched arms the merest suggestion, or the tenuous presence of the child wrapped in a towel who is anchored to the ground by two red lines. The features are left undefined, so creating a distance between the figures and the spectator. Matisse had surely learnt from Cézanne's bathers that the equilibrium between landscape and figures depended on the figures themselves assuming the anonymity of a tree or a rock. The dabs of colour, predominantly the three primaries yellow, red and blue, are widely and irregularly spaced, making for a crude technique which allows an unusual amount of the prepared white ground of the canvas to show through. This is what gives the painting its illusion of dazzling sunlight. What appears to interest Matisse more than the colour theories of Neo-Impressionism is the problem of finding a way to inject energy into the Divisionist technique in order to avoid the inert quality of a uniform surface. When Cross spoke about the musicality of the painting, he had obviously been moved by the harmony of the lines,

52

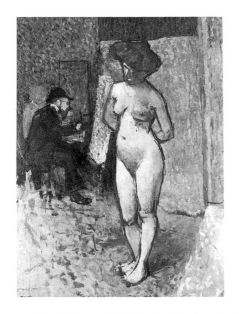

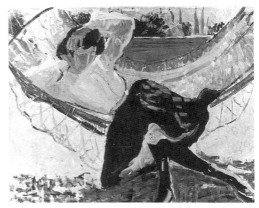

35 Albert Marquet *Matisse Painting from the Model* 1904–05
36 Jean Puy *Woman in a Hammock* 1904–05

the gentle arabesques, such as the rolled sail of the boat, which bind the surface together. But the work also prompted him to tell Matisse that he would not stay with that style for long, for Cross recognized, much sooner than Signac, that the Divisionist technique which made such demands on the artist's patience was ill-suited to Matisse's urgent curiosity.

In fact, Matisse did stay with the technique, on and off, well into 1905. His pursuit of the broken touch was followed through with Marquet and Manguin immediately on his return to Paris. A working session, possibly carried out over several days, which took place in Manguin's studio at 61 rue Boursault, is documented through three paintings: one, an oil study on paper, is Matisse's study of Marquet painting from the model; another, an oil on canvas, is variously ascribed to Manguin or to Matisse, and the third is a finished painting by Marquet, also on canvas, which shows the same pose from the opposite corner of the studio. These are colour notations rather than paintings or drawings in the conventional sense, a method of working that Matisse had certainly seen in action at St Tropez, with Cross and Signac's colour sketches made on the spot. Matisse and his friends had

33
34
35

53

37 Henri Matisse *The Port of Abaill, Collioure* 1905–06

36 worked in oil straight from the model before: then, as now, it had been
chiefly an exercise in composing rapidly from life. While Manguin
39 could carry the exercise through into a painting bought by Leo Stein,
Matisse saw the technique as more appropriate to large-scale
37 decorative pieces; which is why his last major exercise in this style,
The Port of Abaill, Collioure (1905–06), has the format of a frieze. But
he found the technique wearing (it made correcting extremely time-
consuming) and he did not, as he had intended, send that large canvas
to the 1905 Salon d'Automne.

The detachment obtained through the repetitious, almost mechani-
cal method of laying on the paint could hardly be more at odds with
the fierce individualism of the paintings soon to be produced by
Matisse and other Fauves. In *D'Eugène Delacroix au néo-impressionnisme*
Signac had noted approvingly Delacroix's maxim 'the main point is
to avoid that diabolical facility given us by the brush', and accordingly
the Neo-Impressionists had gone to great lengths to counteract that
facility by using the brush-stroke as anonymously as possible. From
the way that Matisse worked on the oil sketch in Manguin's studio,
giving each stroke of the brush its own character, it can be seen that he
was temperamentally unsuited to the anonymity of the disciplined
Divisionist touch, however much he may have been in sympathy with
the thinking that lay behind it. Nevertheless, the practice itself was a
big step towards the modern consciousness of the inherently pictorial
nature of painting because it emphasized that the painting was an

54

image before it was a representation. The mechanics of Divisionism were a necessary lesson to Matisse, as well as Marquet, Manguin and, briefly, Derain – who, in one of his rare Divisionist works, *Trees*, probably done early in 1905, shows himself as the one who was drawn to the strongly poetic side of Neo-Impressionist landscape painting. In *Trees* the touches of primary colours cover the surface like confetti, suggesting the fragility of filtered light, and this tenderness is carried through in the slender trunks of the trees which are made to fall like ribbons from the top of the canvas. The surface has the order and harmony of a Neo-Impressionist painting but avoids the characteristic white light ('bean-coloured' was how Matisse described it) by

38 André Derain *Trees* 1905

introducing clusters of strongly coloured touches which splinter the even surface. Derain evidently shared the awareness of the danger of monotony that Matisse pointed out when he criticized the Neo-Impressionist technique: 'objects are differentiated only by the luminosity given them. Everything is treated in the same way. Ultimately there is only a tactile vitality comparable to the "vibrato" of the violin or the voice.'

La Nouvelle Revue, a magazine well disposed to young artists, noted in its review of the 1905 Salon des Indépendants 'a small bay containing a group of very interesting works by artists who have followed the liberal teachings of Gustave Moreau and among whom a kind of link has grown up, no matter what their differences in temperament and technique'. Matisse and his friends were beginning to take on a strong identity, recognizable enough for them to be labelled *Gustave-moristes*. They were all not only regular exhibitors at the Salon des Indépendants, but members of the organizing Société. Puy was elected in 1900, Marquet in 1901, Camoin and Manguin in 1902. In 1904, Matisse was promoted to *sécrétaire adjoint*, an important gesture of recognition from the Vice-President, Signac, who now appointed Matisse chairman of the hanging committee which included Camoin, Manguin, Marquet and Puy. With such a list it was no wonder that the 1905 Indépendants (which received 4269 entries as opposed to the 2395 of the previous year) established the band of Moreau students as a recognizable group.

In his front-page review in the Paris daily *Gil Blas*, Vauxcelles nominated Matisse as head of the 'school' of former Moreau pupils and told his readers that 'today we find ourselves with a flourishing generation of young painters'. Apollinaire, caustic and pointed as ever, penned lightning descriptions of three of the artists, pinning down their characteristics as rapidly and as surely as Marquet and Matisse had done when sketching passers-by in the street. Vlaminck (who was not a Moreau student) was summed up thus: 'the wealth of his talent is evident, and he spends it extravagantly. For him, painting is a festivity. In his eyes everything is joyous.' About Marquet Apollinaire wrote, 'His modesty . . . forces him in a sense to repeat himself, for fear of going astray'; and about Rouault, 'bright or dark, M. Rouault's paintings always seem intended as decorations for the study of Father Tourmentin.' It was this same vein of criticism which

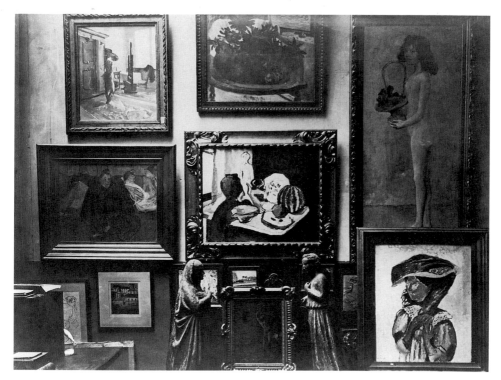

39 Leo and Gertrude Stein's apartment in the rue de Fleurus showing Henri
Manguin's *The Studio*, 1906, top left

led him to demolish Van Dongen's painting a few years later as 'the
expression of what middle-class gentlemen suffering from enteritis
like to call audacity'.

Members of the group managed to find buyers for their work: the
French government bought a work each from Matisse and Marquet,
selecting recognizable 'views' of St Tropez and the cathedral of Notre
Dame; Félix Fénéon, the critic who had been the first to champion
Seurat, bought Van Dongen's *Boniment*, and Leo Stein, the American
collector whose own purchases and those of his brother Michael were
to have a significant effect on Matisse's sales, bought Manguin's *The*
Studio. Camoin scored the biggest success, selling a total of eight
works, including one to Signac. The oddest purchases, however, were
made by Ernst Siegfried, a buyer whose outright contempt for the
new art was a foretaste of the reaction the group was to experience the
next time they showed together. In a bid to mock his son-in-law,

39

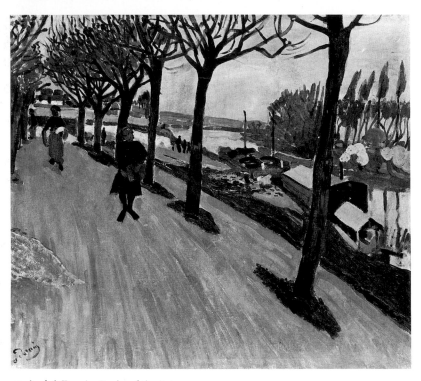

40 André Derain *Banks of the Seine* 1904

Olivier Senn, who happened to be the proud owner of several works by the Impressionists, Siegfried offered one Louis apiece for twenty of the most 'outrageous' paintings on view. His contemptuous proposal was laughed off or ignored by most of the artists, but he did end up with five works – significantly, these included three Derains and one Vlaminck.

The group was also beginning to attract followers. When the young Raoul Dufy visited the 1905 Salon des Indépendants he was struck by one painting in particular, Matisse's *Luxe, calme et volupté*: 'At the sight of this picture I understood all the new reasons for painting, and Impressionist realism lost its charm for me as I contemplated the miracle of the imagination introduced into design and colour. I immediately understood the new pictorial mechanics.' What is interesting about Dufy's reaction is that it should have been this painting that opened his eyes to 'the new pictorial mechanics'

31

58

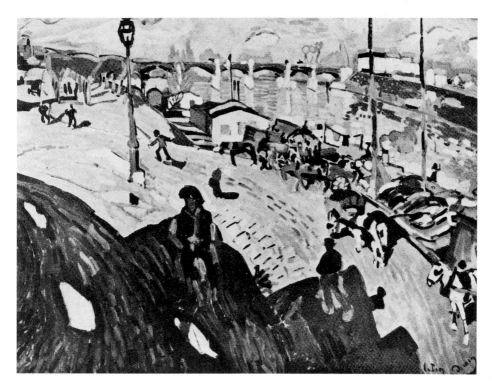

41 André Derain *The Bridge at Le Pecq* 1904–05

rather than one of the acknowledged masterpieces of the Neo-Impressionists, such as Seurat's *Bathers, Asnières* or *A Sunday Afternoon on the Ile de la Grande Jatte*, both of which were included in the large retrospective of his work staged by the Indépendants that year. Possibly, the fact that these works were so evidently 'masterpieces' led Dufy to consign them to the past, however recent that past might have been. The attention of Matisse's work was its energy: the fierce colour and the vigour of the execution generate a force that counterbalances the serenity of the scene and so avoids the passivity of a Neo-Impressionist work.

Matisse opened the path to colour, but it can be fairly said that without Derain that path would not have led to Fauvism. Of all the works shown at the 1905 Salon by the artists associated with Matisse, Derain's *The Bridge at Le Pecq* (1904–05) is the most aggressively disruptive of contemporary pictorial convention. It suggests that it

40

41

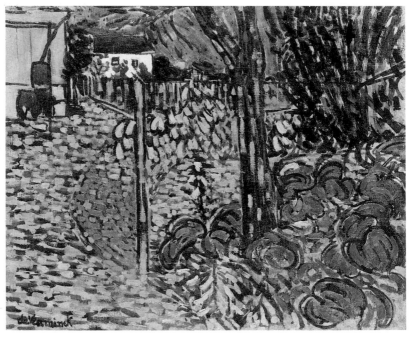

42 Maurice Vlaminck *My Father's House* 1905

was Derain, rather than Vlaminck, who commanded the visual means with which to express their common urge to 'disobey'. (Vlaminck's bravura style, though, seen in a work such as *My Father's House*, also shown at the 1905 Salon des Indépendants, shares Derain's deliberate suppression of Impressionist charm.) While Matisse had been striving for a surface united in a harmonic order, Derain, through devices such as the jolt in the foreground from deep shadow to glaring light, the angle of the lurching bend in the road, the welter of marks deposited along the bustling quayside, deliberately invented disharmonies. *The Bridge at Le Pecq* is a vision of painting far removed from that of *Luxe, calme et volupté*, for Derain's masterly ordering of confusion is impatient with the idea that pictures should give pleasure through harmony. In defying not only the untroubled, pleasurable canvases of painters such as Monet and Renoir but also those of the Nabis and the Neo-Impressionists, he was virtually condemning a whole epoch.

42

In the Face of Nature

Shortage of money had prevented Marquet from accompanying Matisse to St Tropez in the summer of 1904. Now, one year later, he was able to afford a trip to the south and decided to spend it near Signac and Cross at St Tropez, with Camoin and Manguin as painting companions. Matisse, meanwhile, chose to spend the summer at Collioure, a remote fishing port near the Spanish border, which it is likely Signac had recommended, having painted there himself some years before. Whereas Marquet, Manguin and Camoin were still looking to Neo-Impressionism for support, if not actual guidance, Matisse's decision to strike out on his own indicates the new confidence that *Luxe, calme et volupté* had given him. In fact, he had not planned to go alone. Six weeks after Matisse had settled himself and his family into a cheap boarding-house and rented a room on the quayside as a studio, he was joined by Derain, whose family, reassured about his seriousness as a painter by an earlier visit from Matisse and his wife, had consented to finance their son's chosen career. Derain had been further helped by the intervention of Vollard, on Matisse's recommendation, who bought up the entire contents of his studio in February 1905.

Certain remarks in the letters Derain wrote to Vlaminck from Collioure suggest that when he first arrived there he may not have known Matisse very well, even though they had worked together in Carrière's studio and he had felt able to ask Matisse to intervene on his behalf with his parents. Matisse in 1905, with the Vollard show behind him and a few sales to his credit (including the prestigious sale of *Luxe, calme et volupté* to Signac), must have appeared a more relaxed and friendly figure than the one hounded by doubts and debts five years before. Remarking that 'he's a much more extraordinary fellow than I would have thought, from the standpoint of logic and psychological speculations', Derain implied that it was only now that he was able to

discover Matisse's qualities at first hand. It was only now too that he had his first taste of the South, of 'the blond, golden light that suppresses shadows', as he described it to Vlaminck.

The explosive force of the painting that Matisse and Derain did at Collioure testifies to the suddenness of the excited rapport which developed between them. Matisse remembered: 'We were at that time like children in the face of nature and we let our temperaments speak, even to the point of painting from the imagination when nature herself could not be used.' The aim of the painting they now set about was quite specific: 'to free the picture from any imitative or conventional contact'; their chief means of doing so was colour, but the way in which colour was to be used was much less specific. Matisse always insisted that Fauvism was not only about the use of pure colour, 'that is only the surface', he said; 'what characterized Fauvism was that we rejected imitative colours and that with pure colours we obtained stronger reactions – more striking simultaneous reactions; and there was also the *luminosity* of our colours.' One crucial discovery was how light could be thrown off by the colours themselves without recourse to tonal contrasts or optical mixtures. The main question, indeed the main anxiety, was how far colour could be allowed to dominate, to take control of the painting.

Matisse, the more deliberate and patient of the two, told Signac in a letter of 14 July that he was using this time in the south to build up a stock of material for the autumn and winter months: 'I have the feeling that I'm not doing much because my work consists of sketches and watercolours that may come in useful to me in Paris.' Two months later to the day he was able to tell Signac that he had just shown Félix Fénéon his Collioure work: 'that is to say forty watercolours, a hundred or so drawings and fifteen canvases'. This compares with the output Derain told Vlaminck he had achieved over the same period: thirty canvases, twenty drawings and fifty sketches.

In writing to Signac in general terms about his output, Matisse uses the word sketch (*esquisse*) and what disturbed the public when they first saw the oils was precisely their sketchy quality. In that the very nature of the work done at Collioure – the first Fauve works – means that every mark of paint is exposed on the canvas in the manner of a drawing or a sketch, it challenges the whole concept of what constitutes a 'finished' work. The way in which Matisse himself

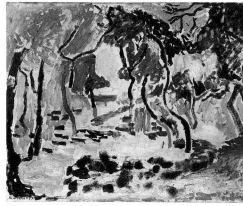

43 Henri Matisse *Landscape at Collioure* 1905
44 Henri Matisse *Landscape at Collioure* 1905

expressed doubts to Signac about what he was doing, his 'vague feeling' that his work was only a series of sketches that might or might not prove useful, is a measure of the experimental nature of the work. It seems likely that while Matisse was painting at Collioure he was thinking in terms of laying in a body of work on which he could later draw. The figures that Derain gave Vlaminck indicate that he produced exactly twice the number of canvases as Matisse. The significance of this is that Derain – more impatient and impetuous than Matisse – thought less in terms of working on studies for use later on and more in terms of completing work on the spot (it may be that Vollard's readiness to buy was an incentive here). Whereas Matisse was to use a couple of oils done at Collioure as the ground plan for his next large composition, there is no evidence that Derain made similar use of work done in the course of those summer months. Not only does his whole method of working appear to have been faster and more spontaneous, but he does not seem to have needed to feed off his own output to the degree that Matisse evidently did. Thus he appears to have done more work in Collioure than Matisse, although one would dearly like to know how much of that work was done in front of the motif, how much in the quayside studio with Matisse and how much of it was reworked after he had returned to Paris. The apparent spontaneity of many Fauve works invites the assumption that they were dashed off in a moment of inspiration whereas it can be the case that they were worked and reworked.

43,44

45 Henri Matisse *Beach at Collioure* 1905

46 Henri Matisse
Landscape, St Tropez 1904

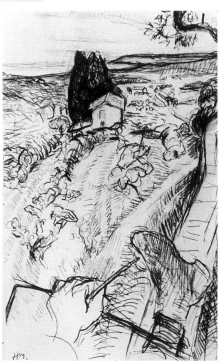

47 Henri Matisse *View of the Port, Collioure* 1905

While oil or watercolour were the media that Derain used most
often, drawing remained for Matisse a crucial activity: a pen-and-ink 46
study made on the beach at Collioure puts into practice a note he made 45
to himself at the time to 'use drawing to indicate the expression of
objects in relation to one another'. He was primarily concerned not
with recording a scene but with registering a space, a space created by
fishing boats pulled up onto the beach, baskets and nets: that large
area of white paper, written on in a language of dashes and squiggles,
and sliced through by one continuous stroke of the pen, is the real
subject of the drawing. The spaces between marks of colour were to be
made equally emphatic in the paintings. Drawing was also used in a
traditional way as the armature of a painting. X-rays taken of *View of* 47
the Port, Collioure show extensive use of pencil and in one of the

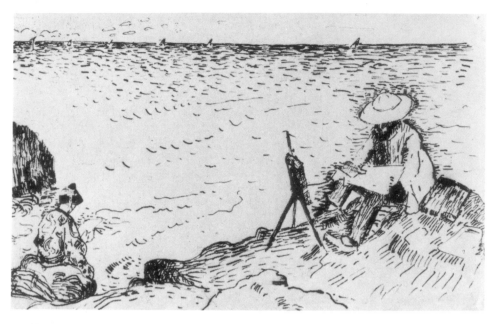

48 André Derain *Matisse Painting his Wife* 1905

49 Henri Matisse *Mme Matisse in the Olive Grove* 1905

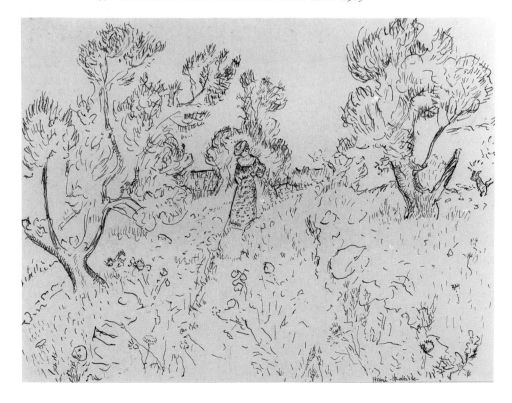

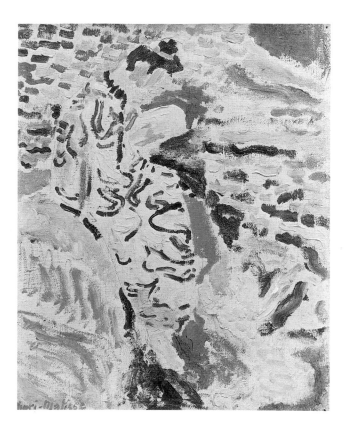

50 Henri Matisse *La Japonaise: Woman beside the Water* 1905

boldest works of that summer, *La Japonaise : Woman beside the Water*, 50
the roughly pencilled outline of the figure is still clearly visible. Derain,
who must have been painting alongside Matisse at the time, has left a
drawing of the scene which suggests that the distance between Matisse 48
and his subject was greater than that shown in the work itself. So close
is the figure to us in the painting, it is as though the artist were actually
in the picture and aware of what is behind him, a sensation that Matisse
often experienced. It is precisely this abolition of a conventional sense
of the distance that exists between the canvas and the spectator which 49
is one of the hallmarks of Fauvism. Local colour is suppressed, not
eradicated (the only trace here is found in the bare foot dangling like a
plumbline). And yet the newly invented linear script, made up of a
variety of strokes which seem to wriggle over the paper, strongly
evokes the sand, pebbles and rocks of the seashore. Indeed, all Matisse's
Collioure paintings are concerned with the substance of things.

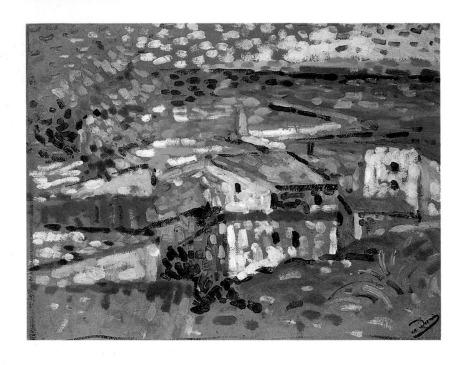

51 André Derain
Landscape at Collioure
1905

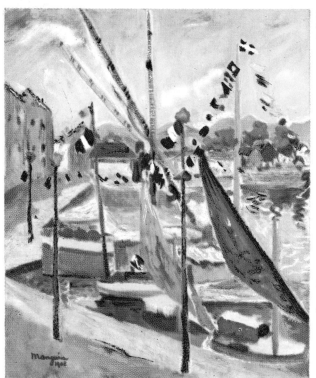

52 Henri Manguin
*The Fourteenth of July
at St Tropez* 1905

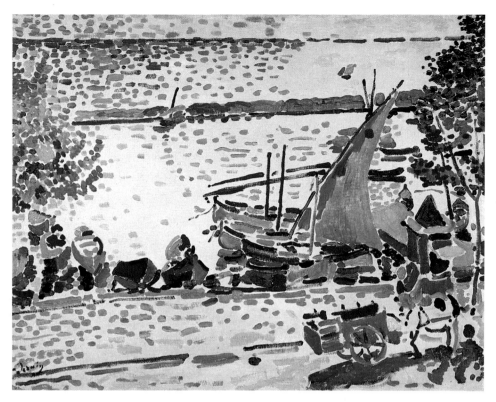

53 André Derain *The Port, Collioure* 1905

The paintings by Matisse and Derain executed that summer of 1905 are about the physical realities of the canvas and the paint. In Matisse's *Landscape at Collioure* the unpainted areas of canvas give off as much light as the strokes of colour; they are spaces which radiate the energy of colour while remaining colourless. Derain, who habitually used a cooler ground colour than Matisse, also makes the canvas contribute to the colour, although often, as in *Boats at Collioure*, he covers a greater area of the canvas surface with more uniformly applied blocks of colour. The drastic paring-down to which Matisse and Derain reduced their technique, to what Matisse called 'the purity of means', is immediately clear when compared with the sort of painting that Manguin, for example, was doing at the same time along the coast at St Tropez. Although his use of colour is bold, such as the violets and

43

55

52,54

69

54 Henri Manguin *The Vale, St Tropez* 1905

pinky reds with which he picks out the trees and the stubbly earth beneath, the easy temperament revealed in his caressing brush-stroke has little in common with the violence exposed in the exuberant, attacking brush-marks made by Matisse or Derain. More telling still is the difference in the conception of space: Manguin constructs the motif so that the distance recedes from foreground to background in a traditional manner, whereas Matisse and Derain blatantly deny this recession by making each brush-mark confirm the flatness of the canvas surface.

 The strokes of paint used by Derain and Matisse can sometimes be so assertive, so solid in themselves that they take on an almost three-

dimensional physicality. The blocks and wedges of colour in Derain's paintings of the period often suggest gouged out crevices filled with colour, while areas of unpainted canvas are like the untouched areas of a woodblock. Later, in their search for ways of paring the image down to essentials, Derain, Vlaminck and Matisse did in fact turn to woodcuts and to wood-carving. 140,143

The subject of the Collioure paintings is also nature. Matisse's remark about behaving like children in the face of nature gives an insight into the way he and Derain were aiming at a response to landscape which was at once spontaneous, uninhibited and innocent. A child's drawing often gives the same prominence to tiny details as it does to the main subject – the hairs on the arm of a figure, for example, 51,56

55 André Derain *Boats at Collioure* 1905

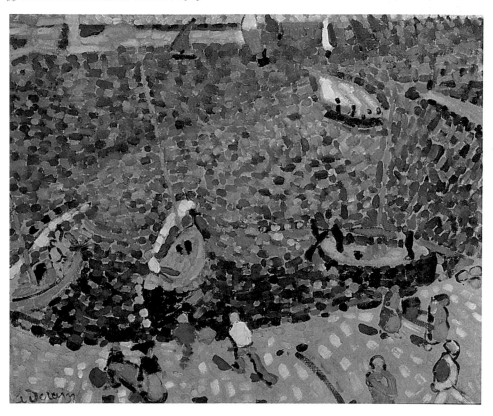

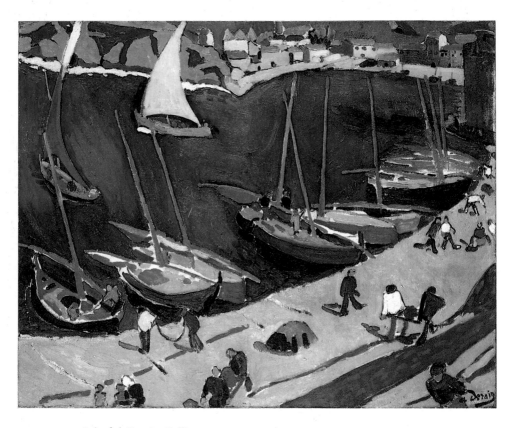

56 André Derain *Collioure* 1905

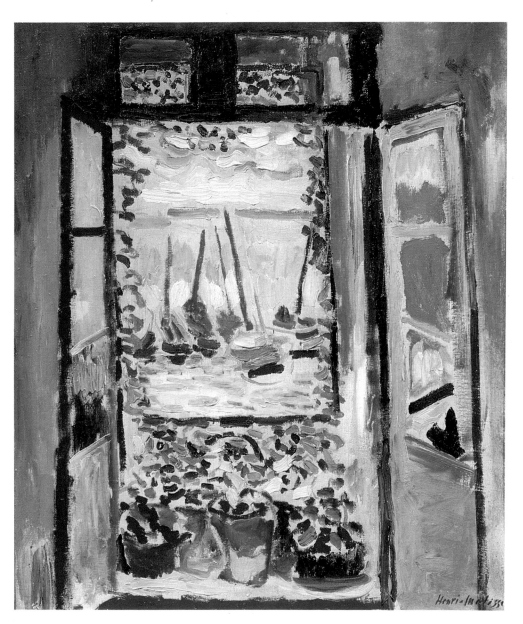

57 Henri Matisse *The Open Window* 1905

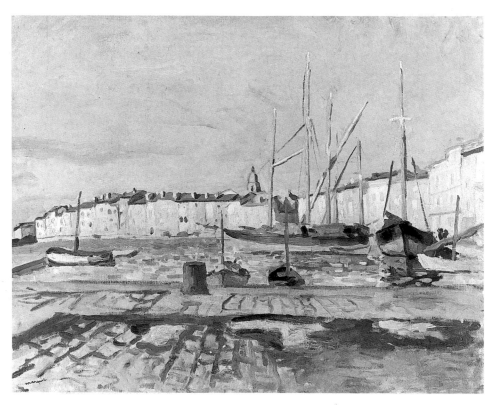

58 Albert Marquet *Port of St Tropez* 1905

59 Charles Camoin *La Place aux Herbes, St Tropez* 1905

60 Henri Matisse *Seascape* 1905

may appear as long and as spiky as a row of railings. When Derain 63
explained how they would give a grain of sand a heaviness it did not
possess 'in order to bring out the fluidity of the water, the lightness of
the sky', he was describing a conscious attempt to learn from the way
children invent equivalents for the world around them. Matisse's
Seascape is a literal rendering of this principle, where shadows and 60,62
flecks of foam are made of the same heavy dabs of thick colour as those
used for rock and stone, and where the horizon is hardened into one
long green slab of paint.

 The way in which even the most fragile elements of nature assume
unnatural weight and substance may have been inspired by Van
Gogh, but it is taken to unprecedented lengths in these Collioure
paintings. In Derain's view looking down onto the port, *The Port,* 53
Collioure, the solid, still and deeply heavy mass of the sea renders

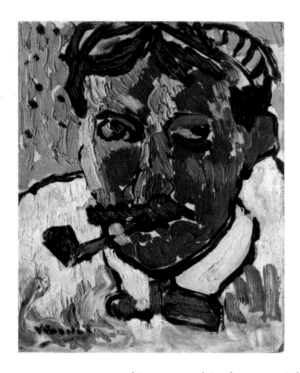

61 Maurice Vlaminck *Portrait of André Derain* 1905

62 OPPOSITE Henri Matisse *Beach at Collioure* 1905

everything around it almost weightless. The sheer energy the blue gives off, intensified by dashes of black and red, can be partly explained by the placing of another primary colour, yellow, at both top and bottom; but it is the transformation of the sea into matter as solid and as impenetrable as a stone wall which brings home to the spectator that the crucial substance here is the paint itself.

Nearly two months after his arrival in Collioure, Derain outlined to Vlaminck the main points that he considered had justified his trip to the south. The serious, studied explanation he gives is almost comically at odds with the dionysiac excitement which is communicated by the works themselves:

1. A new conception of light consisting in this: the negation of shadows. Light here is very strong, shadows very luminous. Every shadow is a world of clarity and luminosity which contrasts with sunlight: what is known as reflections.

Both of us, so far, have overlooked this, and in the future, where

76

composition is concerned, it will make for a renewal of expression.
2. Noted, when working with Matisse, that I must eradicate
everything involved with the division of tones. He goes on, but I've
had my fill of it completely and hardly ever use it now. It's logical
enough in a luminous, harmonious picture. But it only injures
things that owe their expression to deliberate disharmonies.
It is, in fact, a world that carries the seeds of its own destruction
when pushed to the limit. I am quickly going to return to the sort of
painting I sent in to the Indépendants that, after all, is the most
logical from my viewpoint and agrees perfectly with my means of
expression.

A reaction against the staccato rhythms of the Collioure work is
already evident in this statement. Derain's need to eradicate 'every-
thing involved with the division of tones' and the observation that it is
a 'world that carries the seeds of its own destruction' convey a sense of
unrest, even dissatisfaction. A shift back to his earlier, more decorative

63 André Derain *Fishing Boats, Collioure* 1905

64 OPPOSITE André Derain *The Mountains, Collioure* 1905

64 style comes in *The Mountains, Collioure*, which shows how, like Van Gogh, Derain could move easily and without contradiction between local and invented colour. The intensity of the greens used for the olive trees and the parched stubble of the grove are in complete union with the burning pink mountains behind, relieved by watery blue shadows. As Derain had noticed, 'every shadow is a world of clarity and luminosity which contrasts with sunlight'. The contrast between foreground and background is further marked by the strong, even strokes of green which fan out, opening up areas of primed canvas in the foreground – a technique taken straight from Van Gogh – and the smooth, thin area of pink and blue separated by undulating lines, in the background, flattening the surface in a style close to that of Gauguin. The most immediate difference between Matisse and Derain is that while the latter persisted with a surface held together by line balancing mass – a decorative surface – Matisse attempted to rid his painting of that sort of formal cohesion, stating, 'I spoiled everything on principle and worked as I felt, only by colour.'

Both painters searched for an equilibrium between nature and the imagination, but whereas Derain continued to believe in expression brought about by 'deliberate disharmonies', Matisse continued to aim

78

for expression through balance and harmony. Few works of this period achieve this as perfectly as *The Open Window*. Firstly, there is a balance of the two spaces, the exterior and the interior, which were, as Matisse told Louis Aragon, 'one unity from the horizon right to the interior of my work room . . . the boat which is going past exists in the same space as the familiar objects around me; and the wall with a window does not create two different worlds'. Secondly, and most crucially, there is the balance of colour, a process which Matisse described as follows: 'I had the sensation of the colouring of an object: this enabled me to set down my first colour, the first colour on the canvas. I would then add a second colour, and then, instead of painting it out when the second colour did not seem to go well with the first, I would add a third one, intending to harmonize them. And I had to go on like that until I got the feeling that I had created a complete harmony on my canvas and had acquitted myself of the emotion that had made me undertake it.' The painting is not and cannot be thought through conceptually, it has to be allowed to grow on the canvas, and the artist has to have the discipline to allow his initial sensations to be countermanded by the needs of other colours. When Matisse writes about his obligation to transpose, to allow one colour to take over

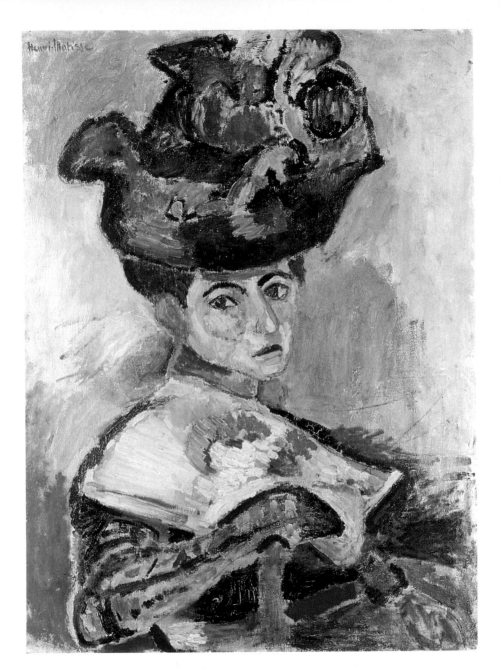

65 Henri Matisse *Woman in a Hat* 1905

from another, the implication is that the method itself becomes the subject. 'The picture', he told his son Pierre in a letter written during the Second World War, 'is not a mirror which reflects what I have lived through in making it, but a powerful, strong, expressive object which is as new for me as for anyone else. When I paint a green marble table and find that at the end I am obliged to make it red – I am not completely satisfied, it takes me several months to recognize that I have created a new object which is worth the one I wasn't able to do . . .' It was, he said, the eternal question of the objective and the subjective.

That each step in a painting may lead to unpredictable consequences is a commonplace, but to provoke deliberately the unpredictable with each mark on the canvas, as Matisse did, explains the frequent states of anxiety witnessed by his friends. His son-in-law Georges Duthuit has described (somewhat colourfully) how Matisse on occasion 'worked himself into a positive state of trance, with tears, groans and all the symptoms'. It may have been just such a critical moment that Derain recorded in a portrait he painted of Matisse sometime in the course of 1905, but the notion that any trace of that tension should be visible in the work itself was inadmissable. With *The Open Window*, Matisse announced the purpose of his art: that it should be 'an art of balance, of purity and serenity devoid of troubling or depressing subject–matter, an art which might be for every mental worker, be he businessman or writer, like an appeasing influence, like a mental soother, something like a good armchair in which to rest from physical fatigue'. The definition was formulated in *Notes d'un peintre*, which he published in 1908, but the concept was already there in the late summer of 1905.

The Open Window was one of the works Matisse sent to the Salon d'Automne that year. 'It was the first time in my life that I was glad to exhibit', he told Signac, 'for my things may not be very important but they have the merit of expressing my feelings in a very pure way. Which is what I have been trying to do ever since I began painting.' It is ironic that the first time Matisse took pleasure in showing his work he found not only the public against him but his peers also. Trouble began even before the Salon opened, for when he submitted his work to the jury strong pressure was exerted on him to withdraw one of his main exhibits, *Woman in a Hat*. It was, so he was told, entirely in his own interest not to show it. From what he told Signac, however, it

65

was not the only painting which alarmed the jury: 'My canvases have had no success and if I had not been on the committee, and strongly supported by friends, they would not have been accepted.' Fortunately for Matisse, the Vice-President of the Salon and the person in charge of the hanging committee was Georges Desvallières, a painter eight years older than Matisse, who had been a friend and private pupil of Gustave Moreau and, since the early years, a loyal supporter of Matisse and his friends. He now came to the rescue of Matisse and also made sure that the works of Matisse and those of his circle were hung together to present a united front. Thanks to him, the concept of Fauvism as a movement was born, for it was the sight of one room (Salle VII) hung with paintings by Derain, Matisse, Vlaminck, Manguin, Camoin and Marquet, and including a quattrocento-style torso of a child and a portrait bust both by the sculptor Albert Marque, which prompted Louis Vauxcelles to make his now celebrated comment: 'the artlessness of these busts comes as a surprise in the midst of the orgy of pure colours: Donatello at home among the wild beasts'. Even now, it is not difficult to imagine the indignation which greeted *Woman in a Hat*, the painting that excited the public the most. Matisse had also discovered that this indignation was by no means confined to the public. 'What is incomprehensible for the moment', Cross told a fellow painter, 'is that he is convinced that in a year he has progressed so much and knows himself more intimately.' The conviction Matisse showed in his recent work bothered fellow painters as much as the work itself.

Two influential writers, the painter Maurice Denis and André Gide, both admirers of Matisse's gifts, criticized the painting for being 'theoretical' – prompted perhaps by Matisse's reputation as a tireless debater about art: the recent memory of *Luxe, calme et volupté* and Matisse's association with the theories of Signac and the Neo-Impressionists would still have been fresh in their minds. It has to be remembered how often Signac and his fellow painters were accused of being too knowledgable (*trop savant*), and in the eyes of Denis and Gide, Matisse was already tarred with the theoretical brush of Divisionism. Not surprisingly, his recent paintings, despite their repudiation of the evenly textured Neo-Impressionist surface, inevitably smacked of a system. It was as though these critics were saying that an artist could not devote himself to colour without first

31

harnessing himself to a set of rules. As Matisse's works were obviously about colour, it followed that they must be the product of theory. Denis, as a painter, was able to see more clearly than Gide that this was painting pushing towards the abstract, 'painting in itself, pure painting'. Not long afterwards, however, Matisse taxed Denis with these criticisms and forced him to admit that the colour harmonies in a work such as *Woman in a Hat* were a feat of intuition rather than calculation.

Roger Marx was struck by Matisse's courage in showing what he called 'the lab experiments'. He pointed out that although painters like Cézanne, Degas and Monet had made paintings which resembled sketches rather than finished works, they had kept these to themselves. Now, for the first time, no sooner was an experiment tried out than it was presented to the public. This was not a hostile opinion. Thanks to critics like Roger Marx, old prejudices were slowly petering out, such as those expressed against the so-called sketchiness of the Impressionist paintings, a criticism levelled at them and at their followers right up to the turn of the century. An anonymous review of the 1904 Salon des Indépendants published in *La Nouvelle Revue* shows how attitudes were slowly changing: 'We grant the young the right to feel their way, to progress and so when the young painters show their efforts, their sketches through which they are finding themselves, they are asking for advice from critics and public alike. Let us then be in favour of granting the Indépendants this spirit of research and liberty.' The reviewer's tacit assumption that sketchy paintings were unfinished paintings shows a reluctance to accept that a finished work was not necessarily one that had been painstakingly worked up to a high state of polished detail. Nevertheless, what is new is the insistence on the right of an artist to show experimental work in public, as well as the recognition that art itself is a process of experiment.

Roger Marx did not distinguish between those works which were probably done *à la coup* (on the spot), like the Collioure landscapes for instance, and those canvases which had been worked up in the studio, such as *The Open Window* and *Woman in a Hat*, or a more conventional work like Puy's *Flaneries sous les pins*. These three paintings were among those which figured in the double-page spread given to the Salon in *L'Illustration*, a conservative picture magazine 66 which every year devoted an entire number to the official Salons

organized by the Société des Artistes Français and the Société Nationale des Beaux-Arts. It is a measure of the excitement generated by the freshly dubbed Fauves that the editors chose this year to turn their attention to the Salon d'Automne. Their motive, so they informed their readers, was to provide an introduction to some 'little-known masters'. This heavy irony spilled over not only into an untidy page layout, which contributed to the general message that modern art was an incoherent and messy business, but also into the choice of sympathetic captions to each painting which had been carefully selected from the press notices. Thus *Woman in a Hat* and *The Open Window* were accompanied by sentences from the reviews of Vauxcelles and Gustave Geffroy, both of whom had used the word 'gifted'. The editors could be sure that their readers would be amused at the idea of anyone using that sort of vocabulary about this sort of painting, for the purpose of the article was to send up the critics as well as the artists. There was nothing new in this. The editors of *L'Illustration* were merely echoing the opinion of prestigious con-servative critics such as Camille Mauclair who, alarmed at the growing popularity of new art, had accused the press of conniving with the artists for fear of seeming to be behind the times.

What critics like Mauclair found particularly offensive was precisely that quality which still endears these paintings to a modern audience – their unpretentiousness. The works seem to be painted more for the artist himself than for the public. This unpretentiousness, however, is anything but passive: the artists' seeming indifference to presentation, their contempt for finish, are characteristics of a fierce energy which borders on violence. Take the portraits they did of each other in the course of this momentous year, 1905, the most forceful of which is the one Vlaminck painted of Derain. It is brutally direct, the head is thrust forward by the shock of red paint, and the pipe, moustache and beret almost slapped on. It beautifully conveys the urgency of Fauve painting, for this is the sort of art which spurns the idea of correction or retouching. The invisible 'screen' which often intervenes between the spectator and the painting is obliterated; instead, the insistent presence of the sitter gives us the sense of occupying the same space as he does, a concept particularly dear to Matisse. It is hardly surprising then that when Matisse told Signac that he liked the sort of painting that Camoin and Marquet had brought

67,68
61

84

HENRI MANGUIN. — La Sieste.

M. Manguin : progrès énorme ; indépendant sorti des pochades et qui marche résolument vers le grand tableau. Trop de relents de Cézanne encore, mais la griffe d'une puissante personnalité, toutefois. De quelle lumière est baignée cette femme à demi nue qui sommeille sur un canapé d'osier!

LOUIS VAUXCELLES, Gil Blas.

GEORGES ROUAULT. — Forains, Cabotins, Pitres.

Il est représenté ici par une série d'études de forains dont l'énergie d'accent et la robustesse de dessin sont extrêmes. Rouault a l'étoffe d'un maître et je serais tenté de voir là le prélude d'une période d'affranchissement que des créations originales et des travaux définitifs marqueront. THIÉBAULT-SISSON, le Temps.

M. Rouault éclaire, mieux que l'an passé, sa lanterne de caricaturiste à a recherche des filles, forains, cabotins, pitres, etc. GUSTAVE GEFFROY, le Journal.

M. Rouault... âme de rêveur catholique et misogyne. LOUIS VAUXCELLES, Gil Blas.

HENRI MATISSE. — Femme au chapeau.

ANDRÉ DERAIN. — Le séchage des voiles.

M. Derain effarouchera... Je le crois plus affichiste que peintre. Le parti pris de son imagerie virulente, la juxtaposition facile des complémentaires, sembleront à certains d'un art volontiers puéril. Reconnaissons cependant que ses bateaux décoreraient heureusement le mur d'une chambre d'enfant. LOUIS VAUXCELLES, Gil Blas.

LOUIS VALTA. — Marine.

A noter encore : ... Valtat et ses puissants bords de mer aux abruptes falaises. THIÉBAULT-SISSON, le Temps.

M. Louis Valtat montre une vraie puissance pour évoquer les rochers rouges ou violacés, selon les heures, et la mer bleue, claire ou sombre. GUSTAVE GEFFROY, le Journal.

HENRI MATISSE. — Fenêtre ouverte.

M. Matisse est l'un des plus robustement doués des peintres d'aujourd'hui. Il aurait pu obtenir de faciles bravos, il préfère s'enfoncer, errer en des recherches passionnées, demander au pointillisme plus de vibrations de luminosité. Mais le souci de la forme souffre. LOUIS VAUXCELLES, Gil Blas.

M. Henri Matisse, si bien doué, s'est égaré comme d'autres en excentricités colorées, dont il reviendra de lui-même, sans aucun doute. GUSTAVE GEFFROY, le Journal.

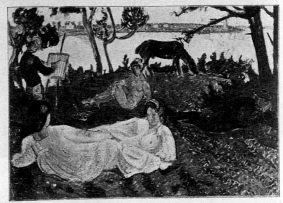

JEAN PUY. — Flânerie sous les pins.

... M. Puy, de qui un nu au bord de la mer évoque le large schématisme de Cézanne, est représenté par une scène de plein air où les volumes des choses et les êtres sont robustement établis. LOUIS VAUXCELLES, Gil Blas.

66 Page from *L'Illustration*, 4 November 1905

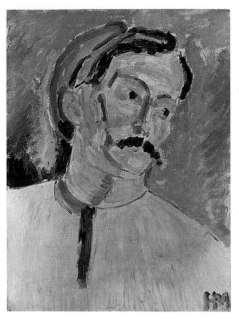

67 Henri Matisse *Portrait of André Derain* 1905
68 André Derain *Portrait of Maurice Vlaminck* 1905

58,59 back with them in September 1905 from St Tropez, he added: 'though
to tell the truth it is rather the opposite of mine'.

The group showing at the 1905 Salon d'Automne publicly
confirmed the distance which now separated the paintings of Matisse,
Derain and Vlaminck from those of Matisse's old associates. The
researches into Cézanne and the Neo-Impressionists applied by
69 Matisse, Marquet and Manguin until late in 1904 had fostered a group
identity which looks stronger than it actually was. For while their
mutual friendship remained as solid as ever, Matisse, bolstered by the
example set by the two young painters from Chatou, had moved right
outside the boundaries of Impressionism. The anarchic measures
introduced by Derain and Vlaminck to disturb and disrupt the picture
surface were a demonstration against what they regarded as the
refinement of the Impressionist sensibility. Camoin, with his convic-
tion that not only was Impressionism far from finished but that it was
up to his generation to go on and accomplish its task, belonged

86

intellectually to an older generation. His personal contacts with Cézanne confirmed his belief that everything must come from a study of nature and, naturally, Cézanne's friendly response and his appreciation of Camoin's painting encouraged his pursuit of the 'motif'. Camoin, like Manguin, Marquet and Puy, remained impervious to the idea implicit in Fauvism that a landscape was primarily an invention arrived at by transposing nature through a number of coloured marks: the notion that a stroke of paint does not imitate a branch or a leaf but acts as its equivalent was not so easily accepted. Above all he felt uncomfortable with what he later called 'the theory of exultation that turned into what we call Fauvism', meaning the way in which colour was filtered by emotion. In fact, Camoin did not consider himself a 'Fauve' and nor did Puy, who, according to his brother, was troubled by the experimental nature of the work going on around him.

69 Henri Manguin *Siesta* 1905

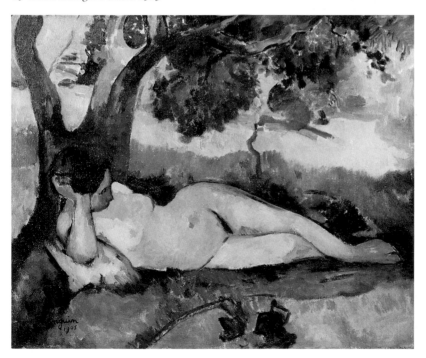

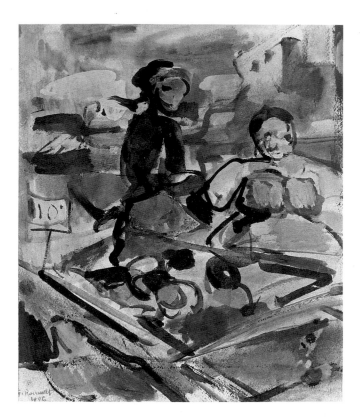

70 Georges Rouault *The Old Quarter* 1906

One of the painters showing at the Salon d'Automne who most
excited the mirth of the conservative critics was Rouault, who did not
show in the *cage centrale* but in a room apart (Salle XVI, with Carrière
and Desvallières and the Nabis painters). He figures prominently in
the spread in *L'Illustration*, even more so than Derain. It is not
surprising that he should. His scrawling line, which has the precipitate
quality of a graffiti scribble, and his scratchy surfaces and raw subject-
matter placed him firmly in the same camp as the Fauves as far as the
critics were concerned. Furthermore, he had been one of the original
band of Moreau students and so was naturally identified as belonging
to the group around Matisse. These were perhaps good reasons for
including him in a piece about the Salon d'Automne but they are not
sufficient to justify his inclusion in the Fauve group. Inasmuch as the

Fauves were landscape painters working directly from nature and preoccupied with how pigment can be transmuted into light, their work follows on from the Impressionists. This is why, in their experiments with colour, the predominating pigments are those which give off the greatest sensation of light, and why Fauve paintings, like those of the Impressionists, are buoyant and joyful. There is nothing of the Impressionist about Rouault. His subjects are the damned, his light richly artificial, his colour inky and aqueous, his mood evangelical. 'Art for you is serious, sober and in its essence religious. And everything you do will bear this stamp', Gustave Moreau had told him.

Rouault went further than Moreau had predicted. Following what he called 'a moral crisis of the most violent sort', he set out to create a religious art, replacing conventional religious subjects with modern ones. One of the works he sent to the Salon d'Automne in 1905 was a triptych based on a novel by Léon Bloy entitled *La Femme Pauvre*. Through Bloy's depiction of the misery and squalor experienced by society's condemned, Rouault found the perfect literary equivalent of his own religious instinct. Like Matisse, he did not distinguish between the feeling he had for life and his way of expressing it, but his literary style of painting was a long way from the rigorously pictorial form described by Matisse in 1908: 'Expression to my way of thinking does not consist of the passion mirrored on a human face or betrayed by a violent gesture. The whole arrangement of my picture is expressive. The places occupied by figures or objects, the empty spaces around them, the proportions, everything plays a part.'

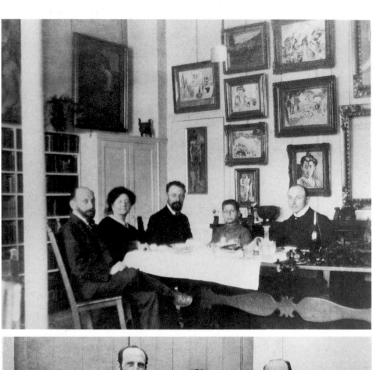

Marketing the New

Matisse's distress at the hostility manifested by visitors to the Salon d'Automne against *Woman in a Hat* was mitigated by the last-minute purchase of the work by Leo Stein and his sister Gertrude. It was the boldest acquisition yet made by these collectors, new to modern art, and set them and their brother Michael on their path of buying many of Matisse's most important paintings over the next few years. Suddenly, it seemed as though Matisse's faith in a market for modern art had at last paid off. While Vollard slowly began to unload his small hoard of early Matisses, another dealer, Antoine Druet, a supporter of the Neo-Impressionists, risked a large one-man show the following March, and Félix Fénéon, who was now the manager of the Bernheim-Jeune Gallery, started to buy directly from Matisse following the 1905 Salon d'Automne (Matisse signed a three-year contract with Bernheim-Jeune in September 1909).

 The outcome of the sensation caused by the Fauves was a greater overall critical tolerance despite predictable conservative grumbles, and significant commercial success: Fauvism was the first movement in modern art to benefit from scandal. No one could have guessed from the casual way in which the eager, young Louis Vauxcelles let drop the witticism which gave rise to the name that it would stick. 'What a scandal!' Matisse told the writer Francis Carco. 'Frankly it was admirable. The name Fauves was perfectly suited to our feelings', leaving no doubt that in his mind the success and the name had depended on each other. Besides that, the painters had no use for the epithet itself; Matisse said on several occasions that they never used it among themselves, never 'accepted' it: 'It was always considered just a tag used by the critics.' Still, however much in later years some of the painters bucked under the yoke of a label that had long ceased to have any relevance to their work, at the time they welcomed the identity it foisted on them: 'The Wild Beasts' or 'The Wild Men of Paris', as Gelett Burgess, an American journalist, was to call them only a few years later, was an identity which helped to sell paintings.

72,73

71

71 Henri Matisse in the apartment of Michael and Sarah Stein, 58 rue Madame, *c.* 1908

72 Leo, Gertrude and Michael Stein, early 1906

In the 1900s, modern art was a commodity associated more with hardship, sacrifice and obscurity than with success. The Impressionists had worked for over twenty years for public recognition and even while Monet found a measure of success in the 1890s, Pissarro was still struggling to make a living. Van Gogh and Gauguin had experienced years of artistic isolation, cut off from any sort of public outside their immediate circles and they died virtually unknown. Cézanne lived to appreciate the admiration of a few collectors and younger painters, but he too died without experiencing public recognition. The Neo-Impressionists, marshalled together by Signac, fared better, as did members of the Nabis group such as Bonnard, Vuillard and Maurice Denis. But before 1905 no young, avant-garde painter could have measured tangible success in terms of the outcry his work had created.

So why, by 1905, did the critical derision, expressed in many of the well established journals of the day, now carry so much less weight with collectors, indeed, have the reverse effect? The Fauves were the first group of painters to benefit from changes in the visual arts which had been steadily evolving over the previous twenty years or so. Mostly these were market changes, such as the rise of the art dealer, the emergence of a new art-buying public and new exhibition facilities. But another, perhaps less concrete factor, was the simple psychological effect of moving into a new century, which seems to have let loose high expectations and boundless optimism, to judge from the almost messianic tone of the critical writing of the period. 'We are at the end of "something". This is why we can believe that we are at the beginning of "something else" because it can be seen that the will and the strength are not lacking. . . . This chaos will sort itself out and the moment is ready when we will see a splendid *aurore* shine forth', is how the critic Charles Morice reacted when he visited the 1905 Salon des Indépendants, where he would have seen the first joint exhibition of the work of Matisse and his friends. As a young, identifiable and radical new group, they seemed to fulfil a widespread need to make sense out of what Morice called the 'chaos' of modern art. They arrived just at the time when a new confidence in young art was growing, a confidence which created opportunities for artists to exhibit and to sell.

Exhibition space for young artists improved dramatically between the early 1890s and the early 1900s. Besides the official Salon des

73 Pablo Picasso *Portrait of Leo Stein c.* 1906

Artistes Français, where the work of academic painters like Bouguereau, Cabanel and Gérôme was shown, there was the Salon Nationale, which had been founded in 1890 and catered for the middle ground between stalwart academicians and uncomfortably modern artists, such as Cézanne and the Neo-Impressionists. The sort of painters who showed there – Jacques-Emile Blanche, Boldini and Sargent – were modish but not radically modern; their works had a dashing mixture of informality and bravura which appealed to a young, smart, wealthy clientele. It was to this Salon that Matisse sent his first major painting, *The Dinner-Table*. There was also the more experimental Société des Indépendants founded in 1884 by a group including Signac, the leader of the Neo-Impressionists. Their Salon had the advantage of being open to everyone but, although it was unique in having no jury, the committee in charge of hanging the paintings effectively acted as a sort of jury. Thus Matisse's appointment in 1905 as chairman of that committee was a highly significant one for the emergence of the Fauves as a group: during the next few

3

crucial years, he made sure that one or more of his friends served on it. The sheer number of pictures – the 1905 Indépendants hung 4269 works by 669 artists – gives some idea of the gap in contemporary art filled by this exhibiting body and of the advantage for artists of organizing themselves into recognizable groups.

The season for the Salon shows, in March and April, was traditional: the artists spent the winter months preparing major studio pieces for exhibition in the spring. The Neo-Impressionists, who continued to dominate the Indépendants, kept to this tradition: the sketches they made in the open air during the spring and summer months were used to construct at least one major work which was painted in the studio during the autumn and winter months. In 1903 a new Salon was formed to which artists could send their work of the summer months without waiting until the following year for a chance to exhibit. As its name suggests, the Salon d'Automne took place in October and November. Committed members of the Salon des Indépendants, such as Signac and his followers, objected on principle to the jury system adopted by the new Salon and refused to join. But the whole point of the Salon d'Automne was to make a selection from the thousands of paintings which flooded in and thus avoid the confusion of the Indépendants. The jury were ruthless in their weeding: on 15 October 1904 *La Nouvelle Revue* reported that 4500 paintings had been submitted to the second Salon d'Automne but the limited space allowed for only 1500.

Some critics were dismayed at this proliferation of exhibitions for new art but the general mood was a welcoming one. The older Fauves, who had started to send regularly to public exhibitions around the turn of the century, benefited from the extra publicity the Salon d'Automne afforded. By showing together twice a year, they obviously stood a better chance of catching the attention of the critics and the public. The fact that the Salon d'Automne was also an immediate success with the public is a significant one in understanding how attitudes were mellowing towards new and experimental art. Far from struggling for recognition, which the Salon des Indépendants had had to do nearly twenty years before, the new Salon, although officially snubbed at the start (the President of the Republic, Emile Loubet, declined the customary invitation to open it) was received by a rapturous audience made up of fashionable Paris, so press notices

indicate, and soon had the added prestige of moving into the Grand Palais, the vast exhibition hall which had been built for the World Fair of 1900.

The Salon d'Automne was also crucially important for the younger generation in the way it actively campaigned for the acceptance of modern art by staging exhibitions devoted to the masters among contemporary artists. These were organized from 1904 onwards by one of the founders of the Salon, Frantz Jourdain (the architect of the Paris department store La Samaritaine).

The first was a retrospective of Paul Gauguin, who had died miserably on the island of La Dominique in May 1903. It was so well received that the following year similar shows were given to five other modern masters – Puvis de Chavannes, Odilon Redon, Cézanne, Renoir and Toulouse-Lautrec. The next four years saw shows of Ingres, Manet, Courbet and a further, much bigger, show of Gauguin. These and similar retrospectives mounted by the Salon des Indépendants did more than give substance to legendary figures: they reinforced the purpose and confidence of painters feeling their way along similar paths. 'If Cézanne is right, I am right', Matisse used to tell himself in his many moments of doubt.

The practice of presenting the work of an artist in one-man exhibitions was originally that of commercial galleries. Dealers in modern art, such as Paul Durand-Ruel, who handled the work of Pissarro, Sisley, Monet, Degas and Renoir, used it increasingly to promote their artists – yet another factor which contributed to the growing acceptance of avant-garde art. The success of a dealer in new art was also unprecedented, and in Durand-Ruel's case it had only come after many discouraging years of hard grind with little reward. By the mid-1890s, however, he was well established, dealing from prestigious premises in the rue Lafitte and determined to make Impressionism accessible to as wide a public as possible (he even opened his own private collection to the public for two hours each Wednesday afternoon). His rival, Georges Petit, also showed Impressionist works, but mixed them with the more obviously commercial artists from the Salon Nationale. Durand-Ruel's success with Monet in the early 1890s introduced the possibility that modern art might be regarded as an investment. By 1912, Derain and Vlaminck, for example, were able to 'invest' together in a Courbet landscape for 100

francs and instantly make a handsome profit of more than ten times that figure. The same year, an American journalist reported the rumour that the majority of Matisse's works were being snatched up by speculators. A key figure in the growth of the idea that new art might be a commodity in which to invest was Ambroise Vollard, the dealer who did most for the young Fauves. He too dealt from the rue Lafitte, but from much smaller premises than the imposing show-rooms of Durand-Ruel. Gertrude Stein remembered that his shop did not even look like a picture gallery: 'Inside there were a couple of canvases turned to the wall, in one corner was a small pile of big and little canvases thrown pell-mell on top of one another', she wrote. Vollard had built up a large stock of works by Cézanne and Gauguin by buying in bulk, a method he also employed with Manguin, Puy, Derain and Vlaminck between 1905 and 1906. Matisse never forgot the sight of Vollard driving off in a cab loaded with 150 canvases he had just bought from Manguin.

Vollard's idiosyncratic way of buying was viewed with mixed feelings; Cézanne valued his moral support, even though he called him 'a slave trader', Gauguin called him 'a rapacious crocodile' and Matisse regarded his method of laying in stock as a form of 'burying' painters. But there is no question that the deals he made first with Derain, in February 1905, and with Vlaminck, early in 1906, buying their work on a monthly basis, made it possible for them to devote their time to painting at a critical moment and even may have created an urgency in their production. The spate of full-blooded Fauve works that followed his intervention was not just coincidental.

The market that Durand-Ruel in particular (but also Vollard) created for new art encouraged entrepreneurs who had little or no experience in dealing to try their hand at selling the work of young painters. So, for example, the young Fauves benefited from the small gallery in the rue Victor-Massé which Berthe Weill opened in December 1901; it was the first private gallery to show Matisse and also the first to show Picasso. Her readiness from the start to show the work of the group of Moreau students assembled around Matisse must have given them a strong boost in morale, if not in sales, although when she did sell a painting, it was usually for a good price. Matisse and Marquet were included in an exhibition she organized in February 1902, and in a further group show in April 1904 when

74 Georges Rouault *At the Galerie Druet* 1906

Manguin, Camoin and Puy were also invited to take part. In October 1905, she showed those same artists again, together with Vlaminck, Derain and Dufy and saw the group hailed by Vauxcelles in his review of it as 'our young victors from the Salon d'Automne'. Thus at the critical moment of public recognition, the Fauve painters could be seen showing as a group in a dealer's gallery as well as at the Salon d'Automne. Another dealer who helped them in these early stages was the former bistro owner Antoine Druet, who in 1903 had opened a gallery in the rue Matignon, where he showed the Neo-Impressionists 74 and the Nabis. Matisse remembered the way that Druet, afraid that his artists would spend the money from the sale of their works too quickly, handed it out to them in small instalments; but he also remembered that Druet 'had a genius for making collectors enthusiastic, and thus performed a great service for painters'. Another service he performed was to allow his premises to be a regular meeting place in the late afternoons. It was here that the Fauves were able to mix with Signac, Bonnard, Denis and others. The drawback of these courageous but under-financed dealers was their inability to offer the artists they showed financial security. This was where the comparatively affluent dealer Daniel-Henry Kahnweiler made all the difference.

97

The arrival in Paris of the twenty-three-year old Kahnweiler, who was determined right from the start to deal only in the work of young artists, created novel conditions for the competitive acquisition of new art. Kahnweiler opened his first gallery in 1907. In the following year he started buying direct from the Salon des Indépendants, including works by Derain and Vlaminck. That same year he made arrangements with these two artists and Van Dongen, and late in 1908 with Braque as well, to buy their entire production. This in itself was very significant, for dealers at that time did not commit themselves to artists in this way (Druet was an exception). The fact that Kahnweiler did so suggests that he was protecting himself from competition. According to Vlaminck, when Kahnweiler first approached him, Vollard, with whom Vlaminck was dealing at the time, was perfectly happy to see him come to terms with Kahnweiler and actively encouraged him to do so: ' "Accept", he told me, "it'll be very good for you. Painting should keep moving, get around, have a change of scene." ' As Kahnweiler always acknowledged, the increasing success of modern art had been largely due to Paul Durand-Ruel who, almost single-handed, had created a new public. Durand-Ruel's collectors were from the new professional class – doctors, lawyers, dentists and publishers – a class which had prospered in the last quarter of the nineteenth-century and who were now able to buy paintings with their earnings. The less extreme Fauve painters, Marquet, Camoin, Manguin and Puy, were particularly successful with this sort of client who, by the early 1900s felt comfortable with the relaxed, cheerful, undemanding landscapes and scenes of middle-class life which had followed in the wake of the pioneering Impressionists. They were painters who sold well and who were therefore popular with the dealers at a time, as Matisse remembered, when the art trade depended on a quick turnover.

Critics were hardly less important to the younger artists, particularly then when the press devoted much more space to the visual arts than they do today. Modern art was then a live issue. Vauxcelles, who wrote for the popular daily *Gil Blas*, made a point of defending painters of his own generation and was given plenty of room to do so. His reviews often appeared on the front page and some, like his review of the 1905 Salon d'Automne, were two-page supplements. He brought art closer to the public by allowing the reader to feel

75

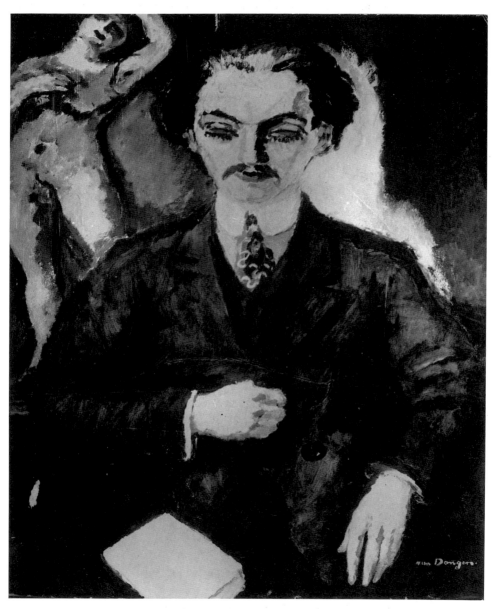

75 Kees Van Dongen *Portrait of Kahnweiler* 1907, original state before cut down

personally acquainted with the most advanced artists of the day. In his review of the 1905 Salon des Indépendants, for example, he describes how at the end of a feverishly busy day getting ready for the opening, he was able to relax in the company of Matisse and Marquet at the special preview. This made very different reading from the regular blasts of hostility suffered by the Impressionists over the previous twenty-five years. The Fauves certainly had their share of bad notices, but the cautious encouragement shown by the better-known critics did much to influence public opinion. Some critics did more than just keep the artists in the public eye. Roger Marx, an older and more established writer than Vauxcelles, who had been instrumental in persuading Vollard to give Matisse his first one-man show, used his position on the Commission appointed to buy contemporary art for the State to give practical help to the future Fauves when they were barely more than students. He bought the odd work from them, and more lucratively, bought the copies they made at the Louvre: he made a point of helping Matisse in this way right up to 1905.

Years later, when Matisse told the publisher Emmanuel Tériade the story behind the origin of the name Fauvism – 'a word which was found so intriguing and which became the subject of many more-or-less apt witticisms' – he pointed out that 'one must not attach more than a relative importance to the qualifying characteristics which distinguish such and such a school, and which, in spite of their convenience, limit the life of a movement and militate against individual recognition'. Although at times it may seem as though Matisse wanted it both ways, his fight for the recognition of the group was in fact a fight for the recognition of the individual artist. Few artists understood the market for modern art better than Matisse, and few fought harder for the right of the modern artist to be seen, and for his right to be able to make a living from his art. He knew that the only hope of winning recognition was to be associated with an easily identifiable group – and the only way to do that was to make sure that the group showed their work together. Hence his determination to exploit the jury system of the Salon d'Automne, and his exasperation when his friends did not put all their weight behind him: 'Damn it', he wrote to Manguin just before the Salon d'Automne of 1906, 'if it was your intention to be considered for election to the jury, then why push off for three days, at a time when one might have got in touch with

you about your nomination. It's not very good thinking. Especially when you stood the best possible chance of being elected . . . Given that all our friends have already been on it, one could be sure that they wouldn't have been this year.' Some resentment was now building up against the Fauve success, particularly among Signac and his fellow Neo-Impressionists. As early as January 1906, only a few months after the stir created at the 1905 Salon d'Automne, Signac had observed wryly, 'Our young painters, a little ravenous, manage to exhibit all the time and everywhere and to bowl over collectors.' Near the same time he was also complaining to his fellow Neo-Impressionist Theo Van Rysselberghe about 'the prattle of upstart painters' and telling him that another member of their fraternity, Maximilien Luce, was also 'in an unspeakable fury over the Fauves'. Resentment was also felt over what was increasingly seen as the Fauve stranglehold on the Société which organized the Salon d'Automne. When Fernand Léger failed to gain election as sociétaire in 1907, he told a friend that he had been 'devoured by some wild beasts'. But Matisse knew that once they had established a market they would be free to dispense with the group identity. This, as it turned out, they did with remarkable speed. Contrary to what Signac appears to have thought, or feared, they had no ambition to create a school.

From 1907 each Fauve painter, except Matisse, was with a dealer and was able to live, if only very modestly, from the proceeds of sales. This fact prompted Apollinaire to comment, in his catalogue preface to Braque's show at Kahnweiler's gallery in November 1908, on how success had rewarded 'the Picassos, the Matisses, the Derains, the de Vlamincks [sic], the Frieszs, the Marquets and the Van Dongens'. Success brought its own problems, however. In a letter written in August 1909, Derain complained to Vlaminck that his only source of income was the money he received from Kahnweiler (obviously so, since Kahnweiler had contracted to buy his entire output) and since what he was given was only just enough to live on, he suggested slipping a couple of works to Vlaminck to sell privately. The reason that Matisse did not sign a contract with a dealer until 1909 may well have been because he had anticipated disadvantages of this kind (as a trained lawyer capable of drafting his own contract, he had the edge over other artists). When Kahnweiler was negotiating with painters between 1907 and 1908 he found that Matisse, whose success was fast

outstripping that of his friends, was already beyond his means. This was because Matisse could now sell much of his work privately. When Leo Stein bought *Woman in a Hat* in the autumn of 1905 he could have had his pick of Matisse's production; in the autumn of 1907, however, when he wanted to buy a number of landscapes which Matisse had just brought back from Collioure, he found that he could acquire only two of them 'as the others were already promised'. No wonder then that Matisse could afford to hold out for the best possible deal.

65

The most significant sign of the success the Fauve sensation had brought Matisse was his move, in late 1905, to a studio in an old convent – the Couvent des Oiseaux – on the corner of the rue de Sèvres and the boulevard du Montparnasse. He set up his own academy there in January 1908. This was achieved thanks to the efforts of Sarah Stein, the wife of Michael Stein, and the American painter Patrick Henry Bruce. Matisse's academy immediately became a symbol of the success of Fauvism – much to his consternation. He found that the idea that all new art was automatically good art was rife among his students: 'What are you looking for?' he asked one earnest young woman student. 'Monsieur, je cherche le neuf.' The painter Maurice Sterne, an occasional visitor to the Academy, remembered how aghast Matisse had been when he turned up for his first class and saw 'an array of large canvases splashed with garish colours and distorted shapes'. The irony of having fought so hard, so doggedly, for the right of the artist to express himself freely through paint, only to find that right abused, cannot have been lost on him.

Landscape into Fauvism

In 1906 the Fauves seized every advantage generated by their well publicized showing at the 1905 Salon d'Automne. Their confidence in their own work was certainly increased by the knowledge that they were beginning to acquire a small but appreciative audience. It was this new audience that Vollard surely had in mind when he commissioned a series of London views from Derain. Vollard had sent him to London, Derain was later to say, 'in the hope of completely renewing at that date the expression which Claude Monet had so strikingly achieved and which had made a very strong impression in Paris in the preceding years'. This was a reference to Monet's paintings of the Thames done between 1899 and 1903, thirty-seven of which were shown at the Durand-Ruel Gallery in Paris in 1904: no doubt, it 76 was the success of that show which lay behind Vollard's initiative. Monet had made his first paintings of the Thames in 1871, in turn inspired by the popularity that Daubigny was then enjoying with his Thames scenes; it was almost as though French painters – and now dealers – could count on this subject to bring success. It is possible that Derain made two trips to London but only one, in spring 1906, is recorded. The paintings, like so many of Derain's Fauve works, defy precise datings, but their range of style, from a dense, richly coloured Divisionist brush-stroke, compatible with works of late 1905, to the broad flat areas of colour typical of 1906, suggest work done on two separate visits. However, so little is still known about Derain's working methods that it is impossible even to hazard a guess at how many London canvases he painted there and how many in Paris. A single visit may have given him all the information he needed.

In taking on such a commission, Derain committed himself to tackling cityscapes, a shift away from the landscape painting he had been doing around Chatou and Collioure. Just as the Impressionists had been equally at home painting urban or rural scenes, so did Derain

prove to be. Vollard's motives for commissioning this project perhaps had some element of competition, besides the obvious eagerness to repeat the commercial success of the Monet exhibition. Whether it was competition between himself and Paul Durand-Ruel, or between the newly dubbed Fauves and the Impressionists, is a matter for conjecture. Perhaps the motivation was to highlight the precise nature of the Fauves' opposition to Impressionism, for they were definitely opposed to the Impressionists' way of measuring reality in terms of place and time. While, for example, there is rarely any confusion as to whether an Impressionist landscape was painted in the north or in the south of France, there are quite a number of Fauve landcapes which cannot be so confidently identified. If we did not know that during the Fauve years Vlaminck painted almost exclusively in the Seine valley, we might easily mistake some of his vigorously coloured landscapes for works done in the south. Similarly, some of Marquet's cool, almost muted, yet still Fauvist, studies of the Mediterranean could be mistaken for northern sea-ports – particularly, of course, after Fauvism had been laid to rest. Hence the story of Monet's discomfiture when in his late years he bought a landscape by Marquet only to discover that it was not what he had thought it was: 'ever since I was told it was the south, it has really put me off. I had taken that tender *grisaille* to be Brittany.' The fact that the painting in question was not a Fauve work but one of the 1920s is of no great importance, for what is interesting about Monet's disappointment is that it was rooted in his belief that an integral part of landscape painting was to convey to the spectator a sense of a particular place.

Derain harboured competitive feelings towards Impressionism: he admired it and yet considered himself opposed to it, as did Matisse who considered the idea of registering fleeting impressions to be 'almost dishonest'. He wrote that 'a rapid rendering of a landscape represents only one moment of its existence. I prefer, by insisting upon its essential character, to risk losing charm in order to obtain greater stability.' These criticisms, published in his *Notes d'un peintre* in 1908, may possibly have been fuelled by the lengths to which Monet had taken Impressionism in his recent Thames paintings. Matisse, who always respected the presence of the object, found that Impressionism robbed form of 'essential character'. Other painters had agreed with him: Kandinsky, after seeing one of Monet's haystacks in 1895, had

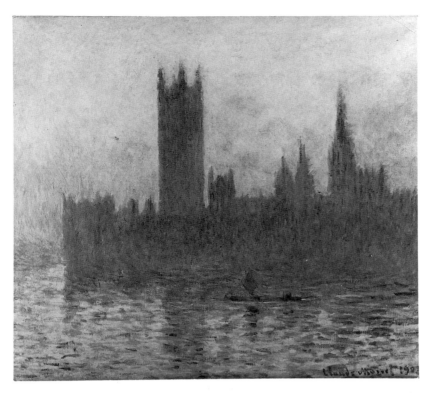

76 Claude Monet *The Houses of Parliament* 1903

written of his 'muffled sense that the object was lacking'. Whereas this had awoken Kandinsky to what he called the 'unsuspected power of the palette', Matisse and Derain, with their practice of locating and defining objects through means of colour (a practice nourished by the example of Cézanne, Gauguin and Van Gogh) could only be hostile. Nevertheless, to judge from the larger scale of the canvases and the increased monumentality of the image which the London episode initiated, Derain was not indifferent to the grandure of Monet's Thames series. He later admitted to Vlaminck: 'As for Claude Monet, in spite of everything I adore him, for the sake of his very mistakes, which are a precious education to me. But, all in all, is he not right to render with his fugitive short-lived colour the natural impression

which is only an impression and which does not last, and may he not thus augment the distinctive character of his painting? I myself would seek something else: something which has to do, on the contrary, with the fixed, the eternal, the complex.'

Whereas Monet had chosen uncluttered views of bridges or of the Houses of Parliament, and in some instances even edited out intrusive elements, Derain revelled in the disorder of the flow of traffic up and down the river, across the bridges and on the quayside. The disorder is reined in, however, by large formal devices, such as the boat which 77 ploughs into the centre of *The Pool of London*, or the heavy iron mass of 79 the bridge which acts as a pictorial wedge in *Charing Cross Bridge*. Derain's search for fresh viewpoints is a rejection of the hallucinatory steadiness of Monet's gaze. Derain tackled the same subjects (perhaps at Vollard's suggestion), Charing Cross and Waterloo Bridges and the 78 Houses of Parliament (and followed Monet's example of painting

77 André Derain *The Pool of London* 1906

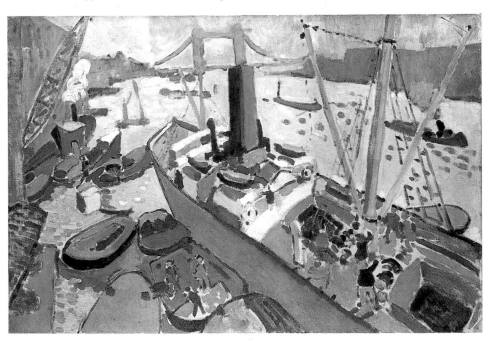

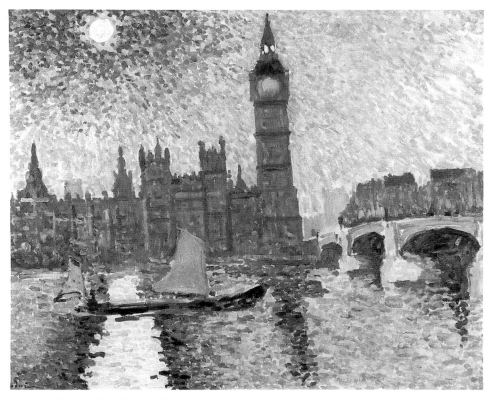

78 André Derain *The Houses of Parliament* 1905–06

from an elevated perspective), but did not restrict himself to them. *Hyde Park* may possibly have been suggested by the views Monet had painted there in the course of his visit to London in 1871, or it may have been simply the proximity of Hyde Park to Blenheim Crescent in Notting Hill, where Derain had taken lodgings. Monet, whose elaborate enterprise had nearly been undermined by the unpredictability of the English weather, related in an interview given immediately after the Durand-Ruel show how, with four years' work behind him and constant retouching on the spot, he had had to resign himself to taking notes and finishing the work in the studio. Just how much Derain painted on the spot and how much he left to be finished on his return is not known. Since one work at least, *The Pool of London*,

79 André Derain *Charing Cross Bridge* 1905–06

was finished in Paris, it is reasonable to suppose that there were others. The Fauve manner of organizing colours on the canvas in relation to each other naturally led to a much greater independence from the demands of directly transcribing nature. It may even be the case that quite a number of the London paintings were not realized on the spot.

80 Nowhere is this independence more evident than in *Effect of Sunlight on Water*, one of Derain's finest Fauve works. It is a landscape that has no sense of place: it could be London (a vaporous mist hanging over the Thames perhaps), or even Paris, or a view from one of the fishing ports along the southern coast of France. This, however, is not a painting about the particular place, or about the motif; it is an

80 André Derain *Effect of Sunlight on Water* 1905–06

expression of pure sensation, a dramatic celebration of nature which is much closer to Turner than to any French landscape artist. Remembering his own visit to London in January 1898, Matisse must surely have talked to Derain about Turner. Matisse had been more enthusiastic about Turner's watercolours than about the oils; Derain, by contrast, appears to have responded wholeheartedly to the density of expression contained in Turner's use of oil paint. Although the drama of the paint is unmistakably Fauve, this work stands out as an isolated example in the Fauve œuvre. It is as though Derain's reaction to seeing the contained violence in Turner's work was so sharp that he had to respond in equal measure.

109

81 Derain's *Seine Barges*, painted on his return to Paris from London, is one work in which he makes conspicuous use of the subtle interchange between form and space found in Japanese prints and which had so deeply marked the work of the Nabis painters Vuillard, Bonnard and Denis. Derain would also have been aware that Monet too had used Japanese prints as models for placing and balancing objects in large areas of flat, open space. The aerial view helps Derain to play with the balance between the highly packed masses of the cluttered barges and the openness of the water in which they move, a balance reminiscent of Monet's river paintings of the years 1889 to 1891, such as *The Boat*. Further signs of Derain's reluctant admiration for Monet can perhaps be seen in the loose scumbling of the yellow and green passages in the painting of the water, which strongly recalls Monet's late Impressionist style.

Seine Barges appears to be such a confident and daring work that anxieties Derain confided to Vlaminck in a letter, probably written during the summer of 1906 while he was staying at L'Estaque, come as something of a surprise: 'Truly we are at a stage of the problem which is really arduous. I am so lost that I wonder in what terms I am going to explain to you . . . If one doesn't use decorative coats of paint the sole tendency one may have is to purify this transposition of nature more and more. Well, up to now we have only done this intentionally for the sake of colour. There is a parallel intention. There are many things that we lack in the broad conception of our art. All in all, I see no future except in composition, because in work done from nature I am the slave of things so stupid that my feeling recoils from them. I just do not see the future as being in harmony with what we are expressing: on the one hand we seek to detach ourselves from objective things, on the other we hang on to them as cause and as end.' And he finishes by admitting 'I just do not see what I must do in order to be logical.'

Nowhere is the anxiety experienced by the Fauve painters more poignantly expressed. Derain's *cri de cœur* brings home the extent to which Fauvism was a group of artists in search of a style (unlike Neo-Impressionism, which as Signac's behaviour towards Matisse indicated, had become a style in search of artists). No Fauve felt the need to find his own style so keenly as Derain; hence his restless foraging among the work of other artists at this period – Cézanne, Van Gogh, Gauguin, Monet, Turner, the Nabis, Japanese printmakers – they all

81 André Derain *Seine Barges* 1906

had to be tried. Derain's strong dissatisfaction with his work was due to its lack of precisely those qualities for which he had vainly searched in Monet's work, 'the fixed, the eternal, the complex'. The work he now began was a concerted attempt to detach himself from objective things, as he put it, and to invest landscape painting with the inventiveness of imaginary compositions. Thus the landscapes which resulted from the summer he spent at L'Estaque in the south of France in 1906 are very different in intention from those done at Collioure twelve months before. The most ambitious of these, *The Bend in the Road, L'Estaque* is in the spirit of a painting about the ideal. There was, 82

82 André Derain *The Bend in the Road, L'Estaque* 1906

after all, a strong tradition in France of landscape painting as an expression of humanitarian if not outright political ideals – one only has to think of Millet and Seurat and the utopian vision of Signac's *Au temps d'harmonie* – and here the sense Derain conveys of a rural community totally integrated into the landscape could be interpreted as very much a part of that tradition. Just as those painters composed their large set-pieces in the studio, so did Derain: *The Bend in the Road* has little to do with painting 'in the face of nature'. This grand, monumental landscape has become suffused with heat. The pockets of air which separated the blocks of fierce colour in the comparatively small-scale works of the previous year have been eradicated, leaving this very large surface almost stifled with colour.

83,84

83 André Derain
Landscape at L'Estaque
1906

84 André Derain
Trees, L'Estaque 1906

Unlike Derain, Vlaminck never seriously doubted his vocation as a
landscape painter, and of all the Fauves his commitment to landscape is
by far the greatest mainly because it carried for him a strong moral
significance. Among the aspirations which he had recognized in Van
Gogh as mutual 'nordic affinities' was 'a revolutionary feeling, an
almost religious feeling for the interpretation of nature'. The
'religious feeling' of the works comes across as a profound empathy
more with place than with nature. Van Gogh's passionate concern
85 with each blade of grass, each flower, each branch, his obsession with
the separateness of every element in nature reveals a truly religious
view of nature as the product of divine inspiration. Nature for
Vlaminck meant the countryside around Chatou and the rural life of
peace, solitude and above all of simplicity. During the Fauve years, he
never once made a trip to the south.

'I am living in the midst of the countryside. What grandeur does
solitude express! What sincerity it compels! Thanks to it, one

114

understands, or rather one feels more deeply the true values, the kernel of life, inner peace . . . How much closer to humanity I feel in contact with a peasant, or a highway vagrant, than beside any representative of the privileged class!' Nature was a moral code rather than a religious faith. In fact, to begin with, it was Derain rather than Vlaminck who came closest to the pathetic fallacy implicit in Van Gogh's interpret- ation of nature. By isolating a single, old, worn, dying tree and 86,87 painting it from a close range, Derain is treating it as an animate object with which we can identify as we might with a portrait. While Derain did not pursue what is an essentially Romantic view of nature, developing instead the more detached attitude that the painting exists primarily as an object and as a vehicle for colour, the spirit of his *The Bend in the Road* is very close to the faith in rural life voiced by Vlaminck. For all Derain's greater willingness to experiment with style and to search in more than one direction rather than to rely solely on his instinct (unlike Vlaminck, Derain seems to have mistrusted his own instinct), he remained very attached to the ideas of his old friend. Their shared experience of painting round Chatou was not to be shrugged off or forgotten and it is interesting to find Derain, after those early years were well behind them, writing to Vlaminck in terms that were concerned less with the work he was doing at that moment than with the sentiments they had shared for so long.

I grow more and more in love with the open country. You too know it well, that open country: the countryside of rivers, of willow trees, of village lanes at noon, out in the sun, with no one in the street.
. . . A strong smell of wine and absinthe tells you you're passing by an inn.
. . . The countryside of wild woodland where one feels utterly alone, with pools of sunlight clinging to the branches.
The countryside of churches ringing, the dead man being buried, and the *curé* making off, all black, along the path all white, once having said his mass.
The countryside of meadows too, and little valleys with cows . . . then a canal, factories all dark and smoking . . . then the town, with tradesmen, townspeople, soldiers, lawyers and men who are for principles and practical demonstrations.

86 André Derain *The Old Tree*
1904–05

87 André Derain *Banks of the
Seine* 1905

This fierce identification with a countryside which was fast disappearing – particularly the countryside of the Seine valley which was being eroded by the expanding metropolis – was also an identification with a threatened rural life. It was a sentiment that gave Derain's interest in various forms of popular art a particular intensity; for instance, his belief in the purity of the rural life led him to value popular art and literature as intrinsically pure forms of expression. He once said: 'It is the people who create words and give them flesh even if it is the poet who finds their rhythm.' As it turned out, Vlaminck was to be the more faithful to his roots, almost aggressively so, but none the less, up to late 1906, evidence of Derain's attachment to the early years of their friendship, to the countryside they both knew so well and to the beliefs they had shared, continued to make itself felt in his landscape painting. At the close of the summer of 1906, on Derain's return from L'Estaque, he and Vlaminck once again took up painting 88 around Chatou. By now, thanks to Vollard's timely intervention

88 Maurice Vlaminck *The Seine at Chatou* 1906

89 Maurice Vlaminck *The Seine at Chatou* 1906

earlier in the year, Vlaminck was able to give up a succession of part-time jobs as a violinist and devote his time to painting. The strong physical force of his art – the very quality that attracted Braque to Fauvism – was now matched by a prodigious output, a telling contrast to the more measured, controlled production of Matisse and Derain.

All Vlaminck's energy went into oil painting (he did very few drawings or watercolours in the Fauve years), and the mass of work dating from just two years between 1905 and 1907 suggests that he destroyed little of his production. It is as though he allowed no critical brake to come between himself and the finished canvas – everything, good, bad or indifferent was allowed through. This is entirely in keeping with his belief in the sanctity of self-expression: to destroy a canvas because he judged it 'bad' would be like destroying a part of himself; moreover it would be dishonest. 'I wanted to reveal myself to the full, with my qualities and my defects', he wrote. This uncensored self was nurtured by isolation from outside influences, past and present: 'You have to go it alone, to count only on yourself, follow

90 Maurice Vlaminck *Boats on the Seine* 1906

your instinct and the natural laws.' Such an insistence on human as opposed to artistic will led him to work instinctively and, as he liked to think, independently of theory or method. But it would have been impossible for him to have remained unmarked by the discoveries made by the Post-Impressionists; they were as much his legacy as any painter's of his generation. He made no systematic study of them – they erupt in his paintings almost unbidden.

In the landscapes painted in Chatou in the summer of 1906, the sort of notations used by Van Gogh, such as curving broken lines, or a rash of small, jabbed dots, alternate with the brick-like strokes used by the Neo-Impressionists, or with the broad, flat areas of colour used by Gauguin. There is little consistency: each picture surface is painted differently – obviously so, since it is temperament and not intellect that is in charge. Vlaminck worked deliberately against unity, whereas Matisse insisted that Fauvism was not so much about colour as about the spatial forces created by areas of colour, which hold the surface together not unlike the way a molecular structure holds

89,90

91 Claude Monet
Banks of the Seine
1878

92 Maurice
Vlaminck
Landscape, Chatou
1906

93 Maurice
Vlaminck *The Red
Trees* 1906

together. Even more so than Derain, Vlaminck used his marks of
colour to upset the equilibrium of the picture suface – his landscapes
pitch and roll, as in *Landscape at Chatou*; they emit bursts of energy 97
between areas of stillness, as in *Under the Bridge at Chatou*; they are
subjected to a faint, overall vibration; some are held in suspension as
though subjected to a tremendous gust of air; in short, they rebel
against the stability of an ordered world. Yet at times Vlaminck made
use of the structure of early Impressionist landscape compositions:
Landscape, Chatou, for instance, is essentially the same composition as 92
Monet's *Banks of the Seine* of 1878. It is as though he was consciously 91
wiping the bloom off the Impressionists' surface and replacing it with
the jumbled mosaic of his own colour. In *The Red Trees* he follows the 93
example of Derain's recent L'Estaque landscapes – themselves a
reflection of the growing enthusiasm among the Fauves for Gauguin's
later landscapes – by flattening the surface and reducing the profusion
of marks on the canvas. The paint is laid on with broad strokes,
constructing with large patches of colour rather than punctuating the
surface with small, randomly placed charges. Because of its flatness,
the painting itself seems much nearer to us; Vlaminck's tendency to
stand back and view the landscape is overruled by the demands of
decorative unity.

94 Maurice Vlaminck *Banks of the Seine at Chatou* 1905–06

The other Fauves, according to one of their first historians, Georges Duthuit, criticized Vlaminck's use of colour for not being 'organized' and for going against their intention which, as he put it, was to 'absorb discord in a harmonic order'. This sounds very much like Matisse talking, but then Matisse and Vlaminck represent the two poles of Fauvism; calm and commotion. Just as they found it impossible to play violin duets together (Matisse complained of Vlaminck's relentless fortissimo), they could never have found painting together a pleasure. The point about Vlaminck is that he revelled in nature's
94 abundance of disorder and accordingly used colour not as a means of making order out of chaos, as Matisse did, but as a further means of disruption: hence the persistently broken rhythm of his brush-stroke. This is why he could speak about satisfying his urge 'to destroy old coventions, to "disobey" in order to create a tangible, living, and

95 André Derain *Three Figures Sitting on the Grass* 1906

liberated world'. It is also understandable that Matisse should regard such a creed as anathema.

The most consistent factor in Vlaminck's works is his range of colour which chiefly consists of the three primaries, red, yellow and blue, and green which is the complementary of red. The palettes of Matisse and Derain were similarly restricted: vermilion, scarlet lake, veridian green, cadmium yellow, ultramarine, cobalt blue and cobalt violet are the colours most commonly found in their Fauve paintings. But whereas both those painters, Derain in particular, mixed their colours with liberal amounts of white and even occasionally mixed two colours together, Vlaminck was liable to use paint straight from the tube. Less consistent is the way in which he used these colours, sometimes purely descriptively and sometimes imaginatively to enhance expression. For instance, in *The White House*, the heightened

95

96

96 Maurice Vlaminck *The White House* 1905–06

colour is essentially local colour: whitewashed houses with red tiled roofs, warm autumn foliage, blue river, white clouds. This simplification of colour is a deliberate move away from the subtleties of the Impressionist palette towards the more restricted and harsher colours commonly found in popular art. The way in which Vlaminck deployed this restricted palette was less extreme than Matisse, who told Pierre Courthion, 'when I put down a green, it doesn't mean grass, and when I put down a blue, it doesn't mean sky.' By this he meant that the colours were there in their own right, and that green means green before it means grass. Vlaminck resisted this form of reasoning just as he resisted any form of theory, but this is not to say that he did not possess a highly developed instinct for colour harmony.

97 Maurice Vlaminck *Landscape at Chatou* 1906

98 Maurice Vlaminck *The Olive Trees* 1906

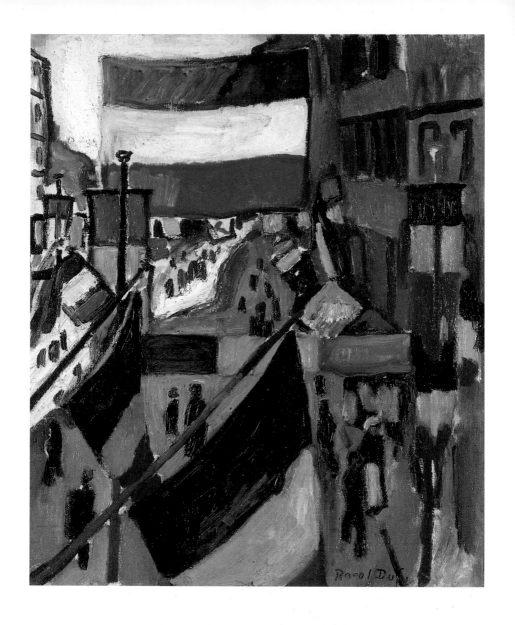

99 Raoul Dufy *Street Decked with Flags (The Fourteenth of July at Le Havre)* 1906

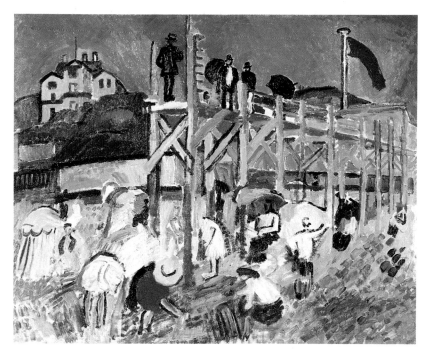

100 Raoul Dufy *Sainte-Adresse* 1906

101 Albert Marquet *The Pier at Sainte-Adresse* 1906

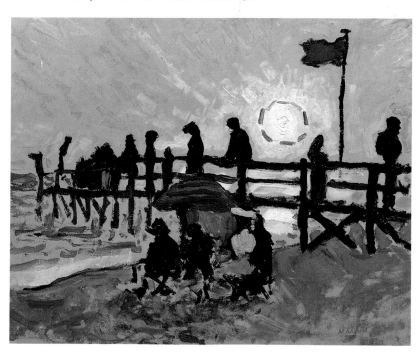

102 The celebration of colour in *Poppies*, for instance, reveals an affinity with a renowned colourist, Odilon Redon, an artist much admired by the Fauves. Here Vlaminck treats the paint more gently, almost as though he is using pastel, and plays the colours off against each other in a way that suggests a greater range of pigments than is actually the case. From the small number of works of this kind which appear to have been done, the assumption must be that Vlaminck only rarely gratified his natural talent for decoration, a word which, in marked contrast to Matisse, he considered almost disparaging.

 The landscapes that Derain and Matisse had done at Collioure in 98,103 1905 and those that Derain and Vlaminck did at Chatou in 1906 have the genuinely untamed quality the name Fauve implies. Very different from those are the scenes of leisurely days spent at seaside

128

103 Maurice Vlaminck *Landscape, the Bois Mort* 1905–06

resorts, which Raoul Du.y and Albert Marquet painted on a visit to 105
the Channel coast in the summer of 1906. It is their light-hearted
observations of holiday crowds which have helped fix the blithe and
joyous image that Fauvism enjoys.

 Marquet and Dufy matched their subjects to the demands of the
new painting – strong, syncopated colour, reinforced by energetic
lines drawn with the brush, and an uneven and lively surface. Marquet
was familiar with recording scenes of bustling activity. In his student
days, sketching in the streets of Paris had been a daily routine, and he
always kept his facility for catching a movement and a gesture with a
minimum of line. Dufy, younger by two years, was quick to adopt a
painting style that aimed for a similar kind of visual shorthand. His gift
for notational brevity gave him a natural affinity with the first Fauve

pictures Matisse and Derain showed at the 1905 Salon d'Automne. Even in the early beach scenes he painted at the popular seaside resorts along the coast from Le Havre, clear intimations of his own calligraphic Fauve style come through the loose, Impressionist technique. 'One must paint as one draws', he was to say, echoing what Cézanne had told Emile Bernard: 'Drawing and colour are not at all separate, while one paints, one draws, the more the colour harmonizes, the more the drawing becomes precise.' The play of short, emphatic strokes of dark colour against wide, pale spaces, which gives his paintings their characteristic rhythm, is derived from the way the Fauves drew as well as painted with their brushes, though the technique is different.

50 In a painting such as *La Japonaise: Woman beside the Water*, where a calligraphic style is very much in evidence, Matisse did not work with isolated marks of colour; it was the reverberation across the space separating one colour from another which concerned him. Whereas he began by laying down patches of colour, Dufy began by laying in the contours. Although he had been very much aware of the work of Matisse and Derain, especially after seeing Matisse's *Luxe, calme et volupté* at the 1905 Salon des Indépendants, it was only after the emergence of a Fauve group at the Salon d'Automne of the same year, that he gained the confidence to join in their celebration of colour. Marquet too seems to have been galvanized by those exhibitions, opting for a stronger, brighter palette, which together with his existing flat style of painting mark the summer of 1906 as his most authentically Fauve period.

In contrast to Matisse or Derain, Marquet and Dufy did not invent colour so much as go in search of it and the festive surroundings of yachting regattas at Sainte-Adresse and the thriving new tourist trade at Trouville presented them with an ample store. A look at Monet's
104 *Beach at Sainte-Adresse*, an early work of his, shows how much Sainte-Adresse had changed in the forty-year interval which separates that
100 work from similar views painted by Dufy. Tricolours and yachting flags, bathing tents and hoardings covered with posters — these manufactured attractions provided the primary colours which nature
99,101 did not. If Dufy's and Marquet's use of colour is mainly descriptive, their understanding of how its force depends as much on the rhythm of its passage across the canvas surface as on its brightness more than

130

104 Claude Monet *Beach at Sainte-Adresse* 1867

compensates for a surfeit of bunting and billboards. Dufy's *The* 106
Regatta gives off the formidable energy of true Fauve painting, an
energy generated by the intervals of space between the notes of
colour, and the rapid jottings of the brush. His recognition of the
potential dynamism of the spaces between objects came, so he said,
from his understanding that in Cézanne's still lifes, the spaces between
the apples were as beautiful and as important as the apples themselves.

At Trouville, Marquet and Dufy were attracted by a street lined 107,108
with posters; at Le Havre by the streets decorated with flags for the
Fourteenth of July celebrations. The posters and the flags did more
than provide an excuse for heightened colour, they gave the strong
vertical, horizontal and diagonal emphases needed to reinforce the
flatness of the picture surface in which both painters delighted. In
Dufy's *Street Decked with Flags*, for instance, this flatness is achieved by 99
making the fullest use of the broad bands of the tricolour, playing
them off against the vertical accents of the houses lining the road. The
purpose of flags and posters generally is to arrest attention, and so it is
of these paintings which signal to their viewers with all the urgency of
a billboard.

105 Albert Marquet *The Beach at Fécamp* 1906

106 Raoul Dufy *The Regatta* 1906

107 Raoul Dufy *The Beach and Pier at Trouville* 1905

108 Raoul Dufy *Trouville* 1906

The Fauves had learnt how to put an image across from poster artists and this had not been lost on Louis Vauxcelles, who, in his review of the 1905 Salon d'Automne, took Derain to task over *Drying the Sails*, saying that it was more the work of an *affichiste* (poster artist) than of a painter. Such a strident, assertive style was not suited to Marquet's contemplative and self-effacing nature, however, and he soon reverted to the limpid, subdued landscapes which characterize his later work. Having found confidence in his own quiet voice, his output, as Dufy was to remark years later, 'held no surprises for us'.

Just as the group from Moreau's studio had been linked by friendship, so were the three painters from Le Havre, Dufy, Emile-Othon Friesz and Georges Braque. Friesz and Dufy met at the Ecole Municipale des Beaux-Arts in Le Havre, where Dufy, who was employed by a coffee exporting business, attended evening courses. Even at this early stage, the natural charm of his painting attracted buyers, one of whom was Braque's father, a local building contractor (Dufy's brother Gaston gave flute lessons to the young Braque). First Friesz, then Dufy left to study at the Ecole des Beaux-Arts in Paris, where they both later gained entrance to the studio run by Léon Bonnat. The landscapes of Boudin, Jongkind and the early Impressionism of Monet – all Havrais artists – were a natural source of inspiration for Friesz and Dufy, for by the early 1900s a mild, plein-air style of landscape painting had become an Havrais tradition. Friesz, like Dufy, had begun to tire of 'the mediocrity of direct emotion through a showy technique' that he found in Impressionism: 'It seemed to me that its pictures were not constructed, but merely amounted to an active documentation of nature: they were arrangement and not composition.' 'Colour', he added, 'appeared as our saviour.'

Since the early 1900s, Friesz had been on friendly terms with many of the artists grouped round Matisse, but it was not until 1905 that he was able to break the Impressionist style that he had been practising until then. The conversations he remembered having with Matisse around 1904 'about the laws of colours and contrasts', as well as about Seurat, Van Gogh, Cézanne and Renoir, must have accelerated his conversion to Fauvism. Friesz's understanding of the Fauve experiments in transposing sensations in front of nature rather than

109 Emile-Othon Friesz *Stevedores in the Port* 1906

recording them, coupled with his desire to remain within a tradition, posed no contradiction for him; like the more conservative Fauves, Camoin or Manguin, for example, he was able to assimilate the gestures of Fauvism into his own style, accommodating them to his own temperament. In *Stevedores in the Port*, one of his dock scenes 109 painted at Antwerp in 1906, there is a deliberate brutalism both in the abrupt, angular drawing and in the handling of the paint, but there is little sense of the interplay between colour and line, or the spaces so central to the Fauve work of Matisse and Derain. The Fauve painter Friesz is closest to is Vlaminck, with the rough, unpolished surfaces of the Chatou landscapes and Vlaminck's direct appeal to emotion through a strong identification with the subject. The dark, thick outlines and the way the paint is dragged over parts of the surface in *The Port, Antwerp*, leaving small ridges of colour, suggest that Friesz 110 was also an admirer of Rouault, a painter whose considerable presence during these years is easily overlooked.

Braque, Vlaminck told Georges Duthuit, launched into Fauvism with no preparation, 'avid to carry on the battle alongside us, his elders'. His robust temperament, according to Vlaminck, made him a natural Fauve. Certainly, the unmistakable vigour of Fauvism was precisely the quality which attracted Braque: it was, he said 'physical painting'. *Antwerp Docks*, painted at the same time as Friesz's *Stevedores in the Port*, shows the immediacy and the strength of Braque's commitment to a Fauve style. Rectangles of colour are laid on horizontally and vertically, a way of composing in colour which is taken directly from the Collioure landscapes of Derain, and they show how, of the three Havrais painters, it was Braque who made the closest study of the Fauve brush-stroke, particularly that used in the broken, vibrating surfaces of the Collioure works. Two small canvases painted at La Ciotat in 1907 show how well both he and Friesz had come to appreciate how Matisse and Derain had created equivalents of sun, water, light and air in those Collioure landscapes. The significance that *The Small Bay, La Ciotat* always had for Braque is shown by his acquisition of it many years later: he had sorely missed it, he said, and had often thought about it 'as one thinks about someone whom one loves and who is far away'.

Unlike Friesz, Braque did not feel tied to a tradition of painting, which is why he was better able to dispense with conventional pictorial space. In the views of Antwerp that Friesz painted in 1906, the space he creates is one of depth and recession, establishing a foreground and a background; it is a conception which ties the painting to representation, for it invites the spectator to look through into the picture rather than, as a truly Fauve work does, to rest the eye on the canvas surface. Braque's view of the hills at L'Estaque, which introduces his soft, lyrical, rounded landscape style, insists on the flatness of the picture plane in a way that invites close comparison with the landscapes of Cézanne. His adoption of the high horizon, which works against recession, is also a device used by Cézanne. Braque and Friesz first visited L'Estaque in the autumn of 1906 and the painting they did there seems to have been inspired in part by the major work Matisse had shown at the Indépendants in the spring, *Le Bonheur de vivre*. The absence of discord and the calm, soothing colour of that large composition are echoed in landscapes such as *L'Estaque*, but there is a fullness, a plenitude in their forms which is not found in Matisse's

110 Emile-Othon Friesz *The Port, Antwerp* 1906

111 Georges Braque *Antwerp Docks* 1906

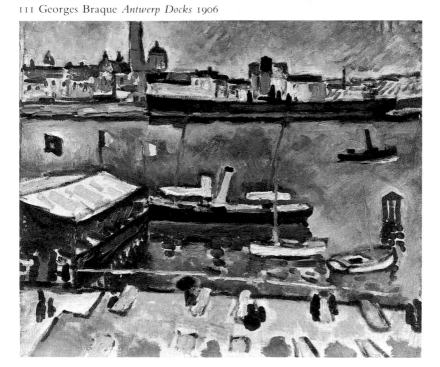

112 Georges Braque *The Small Bay, La Ciotat* 1907

113 Emile-Othon Friesz *The Small Bay, La Ciotat* 1907

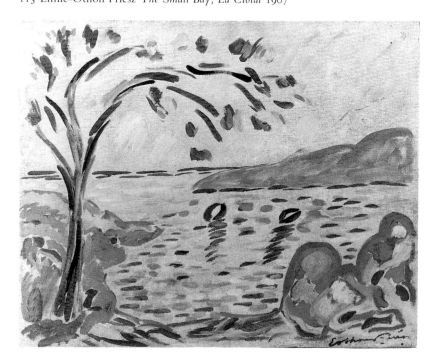

114 Emile-Othon Friesz
La Ciotat 1907

115 Henri-Edmond Cross
Le Cap Nègre 1906

resolutely flat surface. Interpreting nature through bountiful, fertile, enveloping forms is not something readily associated with Fauvism, but in 1906 and 1907 the landscapes of Friesz and Dufy, as well as Braque, are characterized by this almost sensual fullness. A comparison with the landcape painting that Cross was doing at the same time, such as *Le Cap Nègre*, suggests that the rejection by the Havrais painters of the staccato brush-marks of Derain and Vlaminck in favour of a more fluent stroke, which softly shapes the contours of rocks and hills, may have been prompted by the still vital force of Neo-Impressionism.

 Braque and Friesz were moving towards the concept of landscape as composition rather than a study made in front of nature. As Friesz later explained, it was through Matisse and Derain that they retrieved the idea, abandoned by the Impressionists, that in order for it to be 'authentic' a work of nature had to be 'rethought' in the studio (Matisse had conceived *Luxe, calme et volupté* in precisely this spirit). In fact, Friesz's belief that the Impressionists had abandoned the studio

114,122
116

115

31

139

116 Georges Braque *La Ciotat* 1907

117 Georges Braque *Countryside at La Ciotat* 1907

was a widespread misconception (and not one that Monet had hastened to correct). Nevertheless, it is interesting that Friesz regarded Matisse and Derain as the catalysts in this matter, even though the practice of rethinking nature indoors was common, and had been for some time, among the Neo-Impressionists. A vital part of this rethinking was a search for new subjects, particularly in the field of figure painting. Small landscape paintings characterize Fauvism, but every bit as important for Matisse and Derain even at an early stage, and certainly for the younger Fauves at a later one, was finding a solution to the problem of reviving the large figure composition, itself a part of the classical tradition. As the heirs to Cézanne, the Fauves could hardly avoid meeting the challenge of unifying figures and landscape presented in his numerous studies of bathers. Curiously, Friesz found that the landscape of Provence – a landscape Cézanne had

118 Georges Braque
L'Estaque 1906

119 Georges Braque
L'Estaque 1906

120 Georges Braque *L'Estaque* 1906

121 Georges Braque *L'Estaque* 1906

122 Emile-Othon Friesz *La Ciotat* 1907

made very much his own – needed the presence of figures to give it life: 'Provence gave us back this classical idea of painting, and Cézanne of course. This is why nude figures standing or reclining arrange themselves in this sort of arid and wholly intellectual landscape, where the only expression of vegetation is the pine and the cypress. In such places we need the human presence, even though it would be quite superfluous in a pasture in Normandy or on the banks of a river in Brittany where nature is sufficient in herself.' This revealing passage shows how Friesz found the justification for moving away from the implications of Fauvism towards a more traditional way of painting through Cézanne and the landscape of Provence, guided, as he believed, by Matisse and Derain. But while these two painters continued to respect the familiar traditions of Western art, their passionate curiosity about the unfamiliar led them to look elsewhere.

144

Dreams of Other Spaces

'Having worked fifty years in European light and space I always dreamed of other proportions which might be found in the other hemisphere. I was always conscious of another space in which the objects of my reveries evolved. I was seeking something other than real space. Whence my curiosity for the other hemisphere, a place where things could happen differently.' So Matisse told an interviewer in the 1930s some years after he had made a trip to the South Seas. That 'dream of other proportions', of 'another space', a curiosity for 'a place where things could happen differently' had been an essential part of the Fauve world. Since the latter half of 1904 Matisse and Derain had both been engrossed in finding ways of expressing the physical presence of a landscape while retaining the freedom to interpret its appearance; at the same time they had both been committed to imaginative figure compositions. There was no contradiction in this. Derain's *The Bridge at Le Pecq* of 1904, a seminal work of Fauvism, 41 forcefully shows that what is imagined by the painter in his rendering of a particular landscape outweighs what he takes directly from nature, and the similarity of construction between this landscape and his first major figure composition, *The Golden Age*, emphasizes the 124 way in which Fauvism could bring together these two, traditionally very different, genres.

The size and concept of *The Golden Age* are equally ambitious and it is hardly surprising that Derain appears to have worked on it over a period of many months beginning well before he left for Collioure. The sharp division created by the heavily shadowed foreground of *The Bridge at Le Pecq* provided Derain with the formal solution for *The Golden Age*. Three static figures act as a screen against the two dancers barely seen in the background. This sharp division between foreground and background is further increased by the rigorous separation of technique: broad flat painting for the blocked-in figures in front; light, sparse touches of paint for the dancers behind. In the

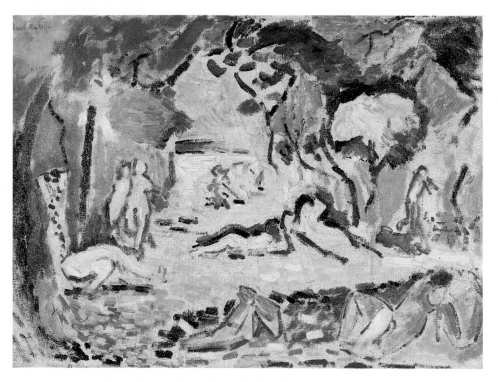

123 Henri Matisse, sketch for *Le Bonheur de vivre* 1905–06

123,126 finished work, Derain opted for the unity of the small Divisionist brush-stroke but used it with a liberty that a Neo-Impressionist might well have questioned. The title of this painting, like *Le Bonheur de vivre*, that chosen by Matisse for his second major figure composition, conjures up an ideal state of being, but unlike *Le Bonheur de vivre*, if we did not know the title of *The Golden Age*, the subject would not be self-evident. Whereas the former is about stillness and repose, *The Golden Age* is about dramatic action and gesture. The pace is set by the pair of dancers who, caught up in an ecstatic trance and propelled forward by billowing drapery, are a part of that 'other space', that 'other place where things could happen differently'. Derain, in contrast to Matisse, conjures up his imaginary world through theatrical effect: thus the three nudes, who form a sculptural frieze, rise up like a shadowy rock formation, craggy and forbidding, obstructing our progress into the golden age beyond.

146

Derain's taste for the theatrical recalls Delacroix, and his admiration for that master of the grand gesture is documented in sketchbook drawings made from Delacroix's figures and groups in celebrated works such as *The Massacre of Scio*. With his wide knowledge of literature, Derain would have known and shared the sympathy and admiration with which Baudelaire had observed Delacroix's painting: 'It is the invisible, the impalpable, the dream, the nerves, the *soul*: and this he has done . . . with no other means but colour and contour.' The strong streak of Romanticism in *The Golden Age* surely comes from Derain's appreciation of how Delacroix could communicate the heroic nature of an event without losing sight of his role as a modern painter. Derain's own ambitious attempts to realize large compositions, while at the same time painting some of the boldest, most spontaneous works of Fauvism, are evidence of a conflict which lies just beneath the surface, a conflict between his recognition of the need to be a painter of his own time and the desire to be a painter in the grand tradition.

125

There is no record of how Matisse, who disliked gesture and overt drama in painting, responded to *The Golden Age*, but it was alien to his own striving for a lucid and harmonious order of expression. 'What interests me most is neither still life nor landscape, but the human figure. It is that which best permits me to express my almost religious awe towards life', he wrote in *Notes d'un peintre*. *Le Bonheur de vivre*, which Matisse sent as his only entry to the 1906 Salon des Indépendants, is the first full realization of that 'religious awe'. While it was as carefully planned as *Luxe, calme et volupté*, its progress was less smooth. Leo Stein, who was then seeing Matisse regularly, remembered that *Le Bonheur de vivre* gave him 'no end of trouble'.

126

Taking as his starting-point a landscape painted at Collioure, Matisse began work on *Le Bonheur de vivre* in October 1905, right in the midst of the furore over his exhibits at the Salon d'Automne. When Signac wrote to his fellow Neo-Impressionist Charles Angrand about it on 14 January 1906, he must have seen it in its completed state: 'Matisse, whose attempts I have liked up to now, seems to me to have gone to the dogs. Upon a canvas of two and a half metres, he has surrounded some strange characters with a line as thick as your thumb. Then he has covered the whole thing with flat well-defined tints which – however pure – seem disgusting . . . ah! those rosy flesh tones!

123

147

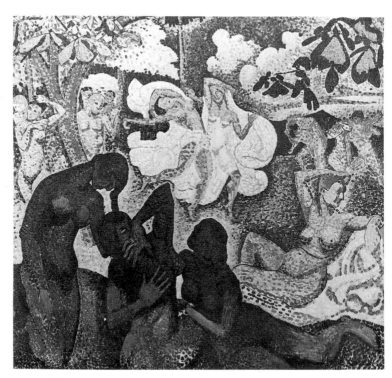

124 André Derain *The Golden Age* 1905

125 André Derain, page from a sketchbook, *c.* 1904

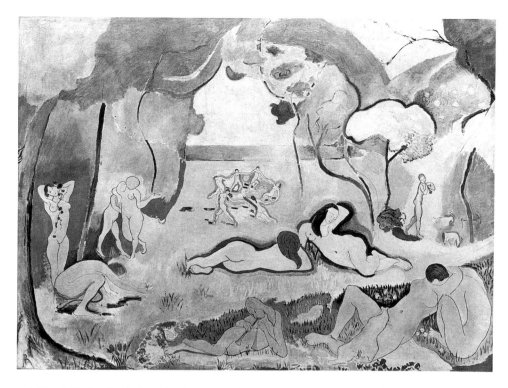

126 Henri Matisse *Le Bonheur de vivre* 1905–06

It evokes the worst sort of Ranson (of the "Nabi" period) the most detestable of late *cloisonnismes* and the multi-coloured shop-fronts of the merchants of paints, varnishes and household goods!'

Signac's hearty dislike of the *Le Bonheur de vivre* is understandable. His disparaging comparisons with enamel work and brightly painted shop-fronts betray his distress at the openly decorative qualities of the painting which were as much a refutation of Divisionism as *Luxe, calme et volupté* had been a confirmation. For all their admiration of Signac, the Fauves, if not actually opposed to his beliefs, remained sceptical of them and they consistently shied away from his dogmatic approach to colour theory, preferring to be guided by instinct and feeling. *Le Bonheur de vivre* made this very plain.

It is no coincidence that the two painters whom the Salon d'Automne had chosen to honour in 1905 with exhibitions were Ingres and Manet. As the Symbolist critic Gustave Kahn observed at the time, this choice set an example of 'artistic tolerance', healing the rift caused by the official championing of Ingres at the expense of Manet: 'Time calms down differences, smooths out discord and harmonizes nuances', he wrote. Matisse's reconciliation of the sensuality of Ingres's rounded forms with Manet's poster-like flatness of paint in *Le Bonheur de vivre* was a perfect illustration of Kahn's point. From the device of a ring of dancers, which is pushed right to the back, and a semi-circle of figures in the foreground, it looks as though Matisse had found the rhythm for his own composition through 127 Ingres's *L'Age d'or*. By adding two central reclining figures, Matisse suggests one more circle. These gentle curves echo through the linear shapes of the figures and the trees binding them together. While Delacroix stands firmly behind Derain, it is Pierre Puvis de 128 Chavannes, the great decorative painter of the last quarter of the nineteenth century, who with Ingres hovers over Matisse. Puvis's ability to avoid the grand manner while working on a grand scale had 28 been a lesson which Signac himself had followed in *Au Temps d'Harmonie*. By emulating Puvis's timeless, dreamlike scenes, Matisse asserted one of his most cherished beliefs, namely that a new vision of painting, far from implying a break with the past, must use that past in order to ensure the continuity of art.

It was not the pastoral subject of *Le Bonheur de vivre* which offended Signac, it was the way in which it was painted. The thick outlines and the flat areas of colour struck him as 'disgusting'. He was unable to see that the heavy line 'as thick as your thumb' is used as a sort of musical stress holding together the rhythmic unity of the picture. His dismay at the 'rosy flesh tints' was perhaps provoked not by the colours themselves but by the smooth, flat surfaces of strong pinks, yellows and greens, which have the translucency and luminosity of delicate porcelain glazes: it was just this brittle smoothness of the surface which prompted Signac's jibe about enamel. It was Matisse's intention to make the surface look hard. He once criticized the murals that Puvis de Chavannes had done in the Panthéon for looking too soft, saying that they did not have the strength to match the stone walls on which they were painted. That criticism helps us to understand that

127 Jean-Auguste-Dominique Ingres *L'Âge d'or* 1862
128 Pierre Puvis de Chavannes *Le Doux Pays* 1882

whereas the broken brush-stroke of *Luxe, calme et volupté* had given the painting the illusion of substance and weight, once Matisse had dispensed with the staccato marks so typical of the early stages of Fauvism, as he has here, the softness inherent in large, wash-like areas of colour had to be compensated for. This he does by 'enamelling' the surface. That flat areas of colour could be used to emit light was the most difficult point for Signac to accept, for it was a brutal denial of everything that he had been working for over the last twenty years. It was heresy. Worse, it was heresy perpetrated by the one new painter he both admired and trusted and almost certainly regarded as a protégé. News of Signac's displeasure was soon relayed among the band of Neo-Impressionists. Thus, when Cross told the Belgian painter Theo Van Rysselberghe that Signac had not approved of Matisse's large canvas 'for all sorts of good reasons', it is apparent that Matisse had more than Signac against him. The disappointment voiced in Signac's letter to Charles Angrand disguised real anger. After the opening of the 1906 Salon des Indépendants, the members repaired as usual to a nearby café and Signac, having seen the painting again, presumably after an interval of several months, lost his temper and publicly attacked Matisse.

The closest we can get to what Matisse himself might have said about the painting is an article by Apollinaire published the following year, in a new magazine, *La Phalange*. Apollinaire, who was closely in touch with the Paris avant-garde, wrote it after some lengthy conversations with Matisse, using several of his remarks, and it is in the form of a dialogue between painter and critic. (It may have helped Matisse to overcome his reluctance to justify his work publicly: *Notes d'un peintre* was published almost exactly a year later.) Matisse's decision to defend his work through Apollinaire was against his instinctive belief that a work of art should speak for itself. It is therefore a measure of his distress at the outcry, not from the critics so much as from his peers, that he chose not to remain silent. He made sure that the article answered the sort of objections Signac had raised. Indeed, one of the strongest points it made was on the very topic which had vexed Signac so much, colour and line: 'Henri Matisse makes a scaffolding of his conceptions', wrote Apollinaire. 'He constructs his pictures by means of colours and lines until he gives life to his combinations so that they will be logical and form a closed

composition from which one cannot remove a single colour or line without reducing the whole to a haphazard meeting of lines and colours.' A further point went straight to the centre of Matisse's philosophy about art: 'To make order out of chaos – that is creation. And if the goal is to create there must be an order of which instinct is the measure.' The nub of the meaning of *Le Bonheur de vivre* is contained in the last paragraph which rings with the artist's own conviction: 'When we speak about nature we must not forget that we are part of it and that we must look at ourselves with as much curiosity and sincerity as if we were looking at a tree, a sky, or an idea. Because there is a relationship between ourselves and the rest of the universe, we can discover it and then no longer try to go beyond it.'

126

The turbulence of Derain's *The Golden Age* may be at odds with the tranquillity of *Le Bonheur de vivre* but the two works share a desire to make painting as much an expression of the spirit as music is. It is not simply a coincidence, therefore, that the focal point in both works is a dance – and it is not just coincidence that the early 1900s saw an explosion of new dance forms. The popular 'Egyptian', 'Hindu' and 'Oriental' dances performed by the American dancer Ruth St Denis were typical of this time when the tendency of Western dance, like Western art, was to investigate other cultures. The increasingly ambitious scale of events like the World Fair of 1900, held in Paris, and the Colonial Exhibition of 1906, held in Marseilles, gave the public opportunities to see rare, imported spectacles from non-European cultures, such as the performances given by the dancers in the retinue of the Cambodian King Sissowath, which Derain saw on a visit to Marseilles in the summer of 1906. The most celebrated of the new wave of dancers was Isadora Duncan, who through the first years of the new century had taken Paris, London and then Moscow by storm with her dramatically expressive solo performances. Dancers like these, who were exploring ways of channelling emotion directly through the rhythms of movement, often modelling themselves on 'exotic' sources, were making as complete a break from classical ballet as that made by avant-garde painters from the academic tradition of the Ecole des Beaux-Arts. When the Cambodian dancers performed at the Théâtre de Verdure in Paris before going to Marseilles, ballerinas from the Opéra crowded into the wings, transfixed by what one critic described as 'a strange and barbaric show'.

124

One of the main sources of inspiration for new dancers was the sacred dance. Through dance as a means of worship, as ecstasy and release, dancers came as near as they could to the oldest and, as they thought, the purest form of ancient ritual. Just as Isadora Duncan said that the body acting as a medium for the mind and spirit becomes transparent, so the bodies of Derain's dancers appear to dissolve in the rhythm of their ritual dance. Indeed, the similarity between Isadora Duncan's aims in her art and Matisse and Derain's in theirs is striking. In 1906, the same year that *Le Bonheur de vivre* was completed, Edward Gordon Craig published in Leipzig *Isadora Duncan: Six Movement Designs*, a series of drawings preceded by an introduction, which reads:

> Is it not far more certain that Life is made up of
> Four Beauties
> of Calmness. Joy. Harmony. Rhythm. The truest Reality.
>
> I see Calmness and Beauty both the Strong and the Sweet
> advancing now with perfect ease.
> All makes way for this spirit.
> Nothing can hinder it.
> Three marks of a pencil, or three hundred
> It is ever the same Picture.
> A note sounded, or a fall of notes,
> It is the same Song.
> A step, or a hundred steps
> It is the same Dance.
> Something put down
> a Record
> Something uttered on that divine theme understood
> so easily, and only with ease
> that theme which commences
> I AM HAPPY
> and which ends in
> *it is Beautiful*

Craig's vocabulary, 'Calmness', 'Joy', 'Harmony', 'Rhythm', is Matisse's vocabulary; Craig's conclusion that these make up 'the truest

reality' is Matisse's conclusion. The dance in *Le Bonheur de vivre* and the dance in Derain's *The Golden Age* are not essentially very different, although at first sight they may look so. At the back of Matisse's painting and right at the centre is a ring of dancers performing a Sardana, the folk dance which Matisse and Derain had watched the fishermen perform at Collioure. The energy radiated by Matisse's dancing figures recalls his observation that the dancing of the Catalan fishermen was far more violent in character than the usually measured step of the Sardana (Dufy, watching this dance at Perpignon thought it 'as beautiful as Bach').

The Sardana is one of the oldest surviving forms of ritual dance. The dancers embody a variety of suggestive images; for example, the constellation of the planets in relation to fixed stars, echoing the harmony of the spheres; the ring encloses and it excludes, it enforces a rhythm and a stride. The Sardana had also become a part of traditional iconography: rings of dancers could be expected to make regular appearances in paintings hung in the Salons. For example, P.-A. Laurens showed *Ronde*, a group of girls dancing in a circle in front of an Italianate villa, at the 1904 Société Nationale des Beaux-Arts; while in René Ménard's *Nymphs*, painted around 1900, the distant ring of 129 dancers, like Matisse's ring, indicates a celebration of nature Indeed, it

was a particularly popular image at the turn of the century in expressing the idea of harmony between man and nature. Matisse appropriated this common image and turned it into one of pagan energy. In *Le Bonheur de vivre* the ring is broken, the pace quickens, individual movements of the dancers threaten the perfect union of the circle. The split is emphasized by the thick line of the outstretched arm and thigh of the figure straining to link the circle once again. This small detail provides a jolt out of all proportion to its size: it emits a charge which reverberates over the picture surface.

Derain pursued his transformation of the traditional bathers into dancers: we know he did other large-scale oils similar to *The Golden Age* which were destroyed in his destructive bout of 1908. Those remaining are a number of watercolours which most probably date from 1906. Their affinity to *Le Bonheur de vivre* indicates perhaps Derain's response to the musicality of line and movement in that work. What Derain's figures convey strongly is that dance can be an uninhibited, spontaneous movement that springs naturally into being. This is why his dancers perform separately, wrapt in their own movements, oblivious to those of others in the group. It is as though the medium of the dance gave Derain a metaphor for the state of mind that both he and Matisse had aspired to in the summer of 1905, 'children in the face of nature'. The burst of dance in front of nature imagined in Derain's watercolours are like the burst of painting in front of nature imagined at Collioure. They are a vivid witness to what the Collioure paintings of Derain and Matisse are about – an equivalent not so much of music as of dance. Again we are reminded that one of the purposes of ancient dance ritual was to confirm man's union with the universe. Derain's dancers spontaneously pounding the earth are as much an expression of the desire to find a universal harmony as are the relaxed and calm inhabitants of Matisse's earthly paradise.

It may be that Derain's watercolours were attempts to find a composition for another major figure painting. *Figures Dancing in a Forest* is one that is particularly close to *The Dance*, a work painted probably around the summer or autumn of 1906. The suggestion in the watercolour of an enactment of some ceremonial ritual is here crystallized into a freize of three dancers in a luxuriant forest or jungle, complete with parrot and serpent. The flat areas of colours carved out

130 André Derain *Dancers* 1906

131 André Derain *Bacchic Dance* 1906

132 André Derain *The Dance* 1906

by the curving lines are inspired as much by the Tahitian paintings of
Gauguin as is the subject. But in its blatant artificiality the subject goes
beyond the scenes painted by Gauguin: it is entirely a work of the
imagination. It is also a bold attempt to find a new pictorial language
outside the limits of Western art. Daniel de Monfreid, who had been a
close friend of Gauguin's, may well have passed on to Matisse and
Derain (when they paid a visit to his house not far from Collioure in
the summer of 1905) the advice that Gauguin had given him in 1897:
'always keep in front of you the Persians, the Cambodians and a little
of the Egyptians. The big mistake is the Greek – so beautiful is it.' If the
apparent jumble of cultural references, Indian sculpture, Cambodian
dancers, French folk art, is confusing in comparison with the outward
simplicity of Gauguin's primitivism, it is because Derain chose to
piece together his own form of primitivism. The incorporation of
creatures such as the parrot and the snake, whose inflated scale gives
them the status of symbols, is a deliberate attempt to achieve the
emblematic simplicity of folk art.

158

133 André Derain *Figures Dancing in a Forest* (*The Dance*) 1906

Figures Dancing in a Forest also looks very close in spirit to the great 133
jungle pictures of the Douanier Rousseau whose *Lion Devouring an
Antelope* had been shown inside the famous *cage aux fauves* just the year
before; both the giant parrot and the snake are inventions very much
akin to Rousseau's. Indeed, it is thought that Derain and Vlaminck
were so curious about Rousseau's painting that they paid him a visit
some time in 1905; they certainly took notice of him, as did another
Fauve, Emile-Othon Friesz, who bought a small picture from him. In
his review of the 1905 Salon d'Automne, Vauxcelles had likened
Rousseau's work to Byzantine mosaics and the tapestry-makers of
Bayeux, comparisons which probably dismayed Rousseau himself
who wanted little more than to be worthy of a place among the
established Salon painters. It was, however, precisely his flat, tapestry-
like style of painting which appealed to the Fauves as much as his
spontaneous invention of other worlds. *The Dance*, which points to
Derain's interest in Rousseau, seeks to invent figures which suggest the
timeless myths and legends of folk culture.

159

134 Fang Mask, Gabon

Vlaminck who, as Derain had pointedly told him in a letter, always wanted to be the first in everything, claimed that in the matter of recognizing the importance of African art he was well ahead of other artists. The first African objects he claimed to have seen – his accounts vary – were three figures, two of them painted, which were standing on a shelf behind the bar of a bistro in Argenteuil. He persuaded the bar owner to part with them in return for buying a round of drinks for the other customers. He showed them to a friend of his father's who

134 gave him two more figures and a Fang mask which Derain bought from him soon after for fifty francs. Recent scholarship has shown that the most likely date for this sequence of events is the second half of 1906 and not some time between 1903 and 1905, as Vlaminck claimed.

Around the same time, maybe even before, Matisse also happened on a group of African figures. 'I often used to pass through the rue de Rennes in front of a curio shop called *Le Père Sauvage*', he remembered, 'and I saw a variety of things in the display case. There was a whole corner of little wooden statues of Negro origin. I was astonished to see how they were conceived from the point of view of sculptural language; how close it was to the Egyptians. That is to say that compared to European sculpture, which always took its point of departure from musculature and started from the description of the object, these Negro statues were made in terms of their material, according to invented planes and proportions.'

135 Vili Figure, the Congo

Gertrude Stein, who confirmed that it was Matisse who introduced Picasso to African sculpture, suggested that it was the sculptor Aristide Maillol who may have called Matisse's attention to African art. She also observed that while the discovery did not particularly affect his painting it did influence his sculpture. Yet her observation is perhaps better applied to Derain, who in the autumn of 1906 began carving figures out of blocks of stone. One of these, *Standing Woman*, looks closer to Indian stone figures than it does to African wooden ones, but the way in which the figure is roughly hewn out of a block of stone has little in common with the mannered elegance of Indian stone sculpture. The deliberately unpolished look of the execution also defies the smooth surfaces associated with European bronze and marble sculpture. In painting, as in sculpture, Derain wanted the execution to look as though it depended on untutored instinct rather than on sophisticated technique; he wanted it to be free of all pretension to art. Later, he told the writer René Crevel that he had learnt about execution by watching a sailor at work painting his boat.

136 Derain's *Crouching Man* is one of the most powerfully sculpted images to come out of the Fauve period. It makes little attempt to penetrate another culture, rather it invents an equivalent of the European tradition. The way in which the hunched figure retains the volume of the square block of the limestone from which it is carved achieves the harmony between the subject and the material which is characteristic of not only tribal African art but also of other cultures, such as the Aztecs. Derain's concern with the character of the material is echoed by Brancusi in *The Kiss*, his famous stone sculpture of 1907–08. The similarity in the response by the two artists to the cult of the

137 primitive can also be seen by comparing a stone head made by Brancusi in 1907 and the heads of several figures in the large-scale

138 *Bathers* painted by Derain in 1908 (its size is near that of *The Dance*). In both works the heads are elongated, faces flattened into mask-like smoothness, each divided by long, wedge-shaped noses. In neither can the influence of African figures be said to be more than notional, but what is interesting is that quite separately from each other the two artists should have found such similar solutions to their search for a pictorial language independent of Western art.

 Matisse, with many years of making sculpture behind him, recognized immediately what African art could teach him. As we

136 André Derain *Crouching Man* 1907

have seen, he thought that whereas European sculpture 'took its point of departure from musculature', African figures 'were made in terms of the material according to inventive planes and proportions'. Thus, in *Standing Nude* (1906) Matisse pushes out the breasts, the stomach and the buttocks, exaggerating shape and size in the manner of wooden Ivory Coast figurines. Even so, as Apollinaire observed in his 1907 article, Matisse was keenly aware of his ties with European tradition and, for all the freedom of expression in the body, the fact that it is a modelled piece and not carved preserves its deeply European character. Nevertheless, a knowledge of African art was considered by Matisse to be essential. When he ran his small art class in the old Couvent des Oiseaux, it was his practice to show his own African objects to his students, pointing out to them 'the authentic and instinctive sculpturesque qualities, such as the marvellous workmanship, the unique sense of proportion, the subtle palpitating fullness of the form and equilibrium in them.'

His appreciation of these figurines for their formal qualities is a measure of his detachment from the romanticism that Gauguin, for example, invested in his view of the primitive. Gauguin's aim to make 'simple art', to 'see no one but savages, live their life, with no other thought in mind but to render, the way a child would, the concepts formed in my brain, and to do this with nothing but the primitive means of art, the only means that are good and true', was a profoundly romantic one. The Fauve painters were moved more by the formal qualities of primitive artefacts than by any knowledge of what those artefacts represented. Derain, when interviewed by the American journalist Gelett Burgess in 1908, described the conventional formula of the Egyptians 'like writing itself so direct it is', suggesting that examining non-European forms was like consciously having to learn a foreign language. The fact that Matisse as well as Derain often referred to painting and drawing as 'writing' or 'a form of script' indicates that they gave marks made on canvas or paper the status of language.

Since much of this non-European art they were looking at was in the form of sculpture, of carving, it is not surprising that several of the Fauves now turned to carving in wood. They created bedheads, decorative objects, or wood-blocks for printing. There is little doubt that it was Gauguin's experiments in carving and modelling, recently given their due in the large retrospective organized by the 1906 Salon

140
141

164

137 Constantin Brancusi *Head of a Girl*
1907

138 André Derain *Bathers* 1908

d'Automne, which triggered this engagement with a more direct means of expression. The example set by Gauguin was the freedom of the artist to be an artisan as well, to involve himself openly with all the necessary physical processes and labour that were required in the making of objects, paintings, sculptures, whatever they might be. The nakedness of the painting process revealed in the Collioure works by Matisse and Derain, and also in many of the landscapes by Vlaminck, show the extent to which they too believed in what Matisse called 'the purity of means'. Gauguin's example encouraged them to go further.

166

140 Henri Matisse *Nude in a Folding Chair* 1906

142 Henri Matisse *Cylinder with Dancing Figures* 1907

141 Paul Gauguin *Self-Portrait Jug* 1889

Derain, in order to preserve the integrity of the untutored expression in popular prints, such as the so-called *images d'Epinal*, used a pen-knife rather than a burin when he made woodcuts. The dancers on the wooden cylinder carved by Matisse are more closely related to his own sculpture than to any specific example of primitive art; the expression lies not so much in their energetically modelled forms but in the rough, uneven marks made in the wood by the tool. The work itself has the mystery of an unidentifiable object from another culture; its cylindrical form easily evokes the sense of belonging to 'a place where things could happen differently'. With Derain, the opposite is the case: he chose objects which were familiar, like carved bed-panels (thus showing an affinity with the Nabis sculptor Georges Lacombe who had carved elaborate bed-heads and bed-ends), but he decorated them with figures which suggest another culture. In the bed-head, his dancers are closer to figures carved by Gauguin in that the distancing

142

143

144

168

143 André Derain, carved bed-head, *c.* 1907

144 Paul Gauguin *Be Mysterious* 1890

from the European tradition is preserved through their formalized, ceremonial movements, and the repetition of decorative patterns increases the sense of an object made for ritual rather than for domestic use. These panels belonged to Vollard, who also owned a table carved and painted by Vlaminck. This suggests that for a short while at least Vollard may have hoped to create a viable market for such pieces of decorative furniture, but he had also seen the possibility of moving into the decorative arts when he approached the ceramist André Metthey (who worked out at Asnières) with the idea of getting him to collaborate with his artists. Thus the list of collaborators Metthey acknowledged in the catalogue of the 1907 Salon d'Automne included Derain, Matisse, Rouault and Vlaminck.

145,146

There was another way in which Gauguin offered a fresh insight into ways of returning to 'the purity of the means'. He had written of his desire to paint as a child paints, that is to say, conceptually, but although this aim may have helped him towards a greater simplification of the image and towards ridding his art of conspicuous mastery,

146 André Derain *Vase with Dancers* 1906–07

145 Maurice Vlaminck, painted ceramic plate, 1907

147 Henri Matisse *Pink Onions* 1906

the immediacy of perception peculiar to children's art remained only an idea. The Fauves were more genuinely curious about the nature of this kind of perception. As early as 1902, Derain had told Vlaminck that he wanted to study children's drawings: 'That is where the truth lies, without doubt.' Dufy said later that he found it difficult to define the quality that is special to children's paintings – the only thing he was sure about was that it was not art – but the search for an art outside Art was exactly what engaged the Fauves.

In Matisse's *Pink Onions* (1906) the jugs and the sprouting bulbs are laid as flat on the surface as though they had been cut out and pasted down, and the wide, opaque passages of paint which he had

147

previously used to bind the subject and the background together, as in
Girl Reading or *Woman in a Hat*, have been dispensed with – they were
too obviously painterly. The simplicity of the local pottery, souvenirs
from the visit he had made to north Africa earlier the same year, has
been exploited to bring out the crudity of the drawing. Matisse,
knowing that a child's attention is held by details rather than by the
whole, concentrates on the crudely painted designs on the pottery as
well as on the long shoots of the onions. With *Marguerite*, he succeeds
in entering the mind and the eye of a child with a precision that has few
precedents. He had three children of his own (Marguerite was the
eldest) and was thus well placed to observe the way young children
draw and paint (a child's love of labelling the people in their paintings
is imitated in the inscription). Picasso, to whom Matisse presented this
oil, said as much in asserting that Matisse's style had been directly
influenced by observing his children's art.

148,65

149

148 Henri Matisse
Girl Reading
1905–06

149 Henri Matisse
Marguerite 1906 or 1907

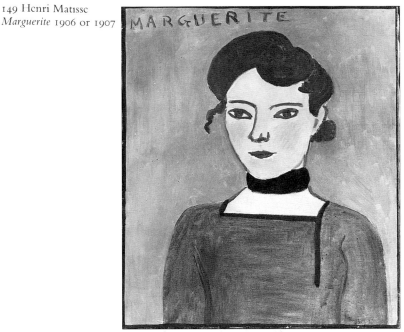

Children use a coded sign-language to create pictures, a language which is adapted from what they see and from what they know. The concentration which they bring to making images invests those images with special significance. That is why children's art, like tribal art, is iconic. There is another aspect of children's art which must have profoundly touched Matisse, and that is the enormous pleasure children take in drawing and painting and their confidence that their works in turn will give pleasure. *Pink Onions* has that confidence. The 147 quality that 'the madly anxious' Matisse surely wanted to emulate is the triumphant ease of a child's painting. Henri Rousseau possessed this quality: Vlaminck describes how, at the 1906 Salon des Indépendants, Rousseau was seen to be quite impervious to the amusement caused by his paintings, 'quite serene, wrapped in an old overcoat, he swam along in a state of bliss. He had done his best, applied himself with such fervour so that his painting would do him credit that he never thought for a moment that the laughter was directed at him.'

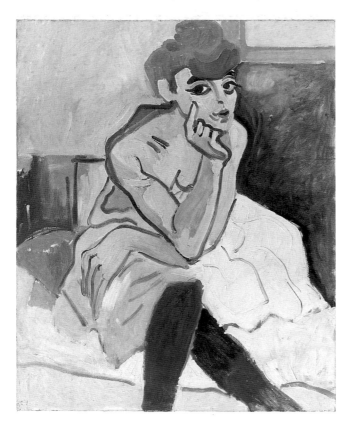

Although they were less bound up with romantic ideals of the primitive existence than Gauguin had been, the Fauves were not insensible to their emotional pull. By choosing a subject such as *The Gypsy*, Matisse alludes to a race of people outside society, and this image of the outcast is reinforced by the associations with the brothel contained in the gypsy's sprawling sexual invitation. The paint is ferociously applied, thick like plasticine, and fingered in all directions – stretched across the eyes, down the nose and dragged across the mouth. This is one of the rare paintings by Matisse where the paint gives the illusion of having been squeezed directly from the tube and spread by a mixture of brush, palette knife and fingers. There is a physical involvement with the paint which is comparable to a sculptor's involvement with his clay. In the same way, the ridge of green paint running down the centre of the face of Amélie Matisse in *Mme Matisse (The Green Stripe)* gives out such plasticity from a

154

151

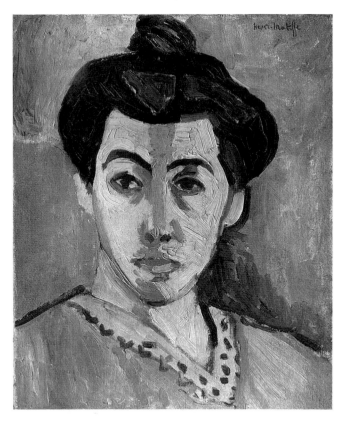

151 Henri Matisse *Mme Matisse (The Green Stripe)* 1905

distance that it looks as though it has been moulded into shape with the fingers rather than, as is the case, painted on with the brush. Less violent, but no less direct, are the paintings of dancers from a café called the Rat Mort by Derain and Vlaminck in 1906. Vlaminck sets the figure into the background in much the same way as Picasso had done some five years earlier in a work such as *The Dwarf*, by painting the dancer and the area that surrounds her in an equally energetic fashion so that she is a part of the space she occupies. Picasso engaged with his subjects to the extent of using an element of caricature to dramatize them. Vlaminck and Derain, however, remained detached from theirs, concerned only with the paint and the drawing. Emphasis is laid on the face, particularly on the eyes and on the mouth, as it very often is in primitive or folk art. In Derain's painting, the impact of the image as a whole is made all the more direct by his flatter use of colour and the more sparing evidence left by the brush-mark.

150,155

16

175

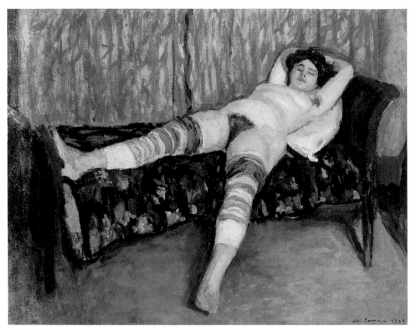

152 Charles Camoin *Girl Resting on a Bed* 1903

152 A comparison with Camoin's *Girl Resting on a Bed*, or with
153 Manguin's *The Gypsy in the Studio*, brings home the distance which
separates their kind of painting from that of full-blooded Fauvism.
Camoin's 1903 image of a St Tropez prostitute, strong as it is, has
much less force as an expression of sexuality than Matisse's gypsy,
mainly because it is a sensitive observation, rather than a painting
about sexuality. Unlike *The Gypsy*, it is a record of a scene which is
viewed, almost dispassionately, from the outside looking in and, it
might be said, from a safe distance. In the cases of Matisse or Derain or
Vlaminck there is no safety in distance, for the spectator experiences
the artist's own space; there is none of the conventional distancing
created by perspective since perspective is jettisoned in favour of
flatness.

A painter who stands somewhere between the true Fauves and the
gentle canvases of painters like Camoin or Manguin is Kees Van

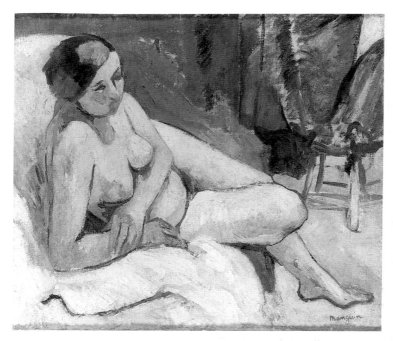

153 Henri Manguin *The Gypsy in the Studio* 1906

Dongen. Like Rouault, Van Dongen is an artist associated with
Fauvism but who touches only on its periphery; and for much the
same reasons. He is not primarily concerned with landscape or with
light. His subjects are of the demi-monde, close to those painted by
Toulouse-Lautrec or by the young Picasso around 1901 (in fact,
Picasso was his close friend and neighbour in the run-down building
in Montmartre known as the *bateau-lavoir*). By 1904, the delicate, airy
landscapes that Van Dongen had been doing over the previous four
years had been replaced by scenes of popular Paris attractions such as
the Médrano Circus, and the numerous café-concerts, as well as by
decorative nudes and portraits. These subjects brought him consider 156,157
able success: Vollard and Druet, recognizing the potential popularity
of his pictures, both gave him one-man shows early on. In contrast
with Picasso and Lautrec who invested their depiction of the life of
popular entertainers with irony, even pathos, Van Dongen appears

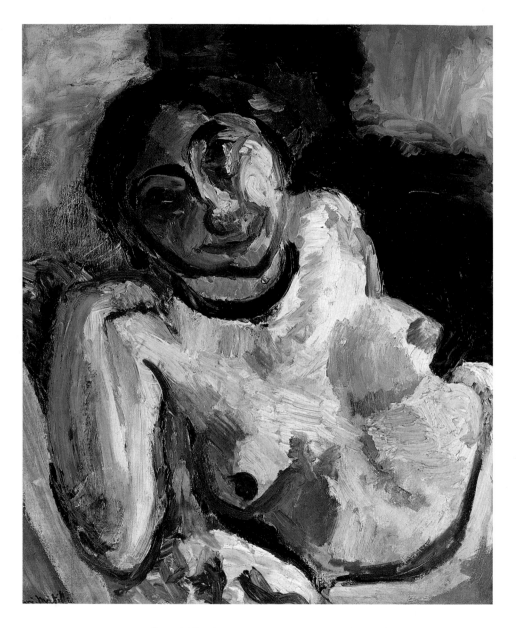

154 Henri Matisse *The Gypsy* 1906

unmoved by the precarious existence of so much of what he painted, perhaps because he was too much a part of it. While Toulouse-Lautrec and Picasso had been keen observers rather than keen participants, Matisse did not forget the sight of Van Dongen running after the dancers at the Rat Mort while at the same time trying to draw them. For a while, though, particularly in 1904 and 1905, Van Dongen's concern to strip painting down to its essentials, to find inspiration in art that depended on instinct, like childrens' art and folk art, as well as in pioneering a more aggressive sensuality, made him an ally of the Fauves. He briefly shared their involvement in making the spectator conscious of the physical act of painting by making every gesture of the brush visible to the eye, thereby reinforcing the point that the marks of colour on the canvas are the image. The factors which link him to Fauvism, as they link Rouault also, are above all the immediacy of image, the nakedness of means, and the rejection of charm – attributes of primitivism which Fauvism made its own.

179

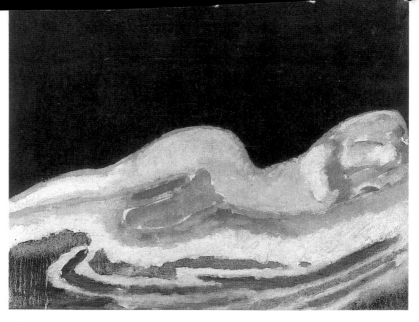

180

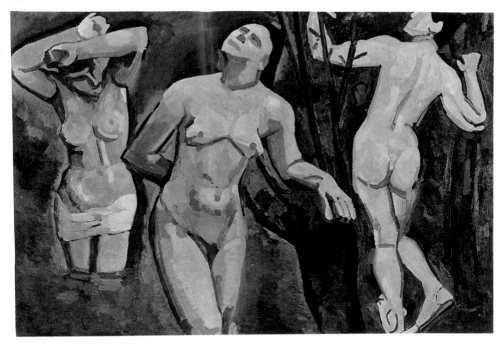

159 André Derain *Bathers* 1907

of Le Nain, of Millet and of Cézanne. But a more widespread view of
Cézanne was as a sort of primitive whose work was 'awkward',
'gauche', 'brutal', 'unfinished', words which had been chosen often to
abuse his work but which happened to describe characteristics that led
Braque to observe later: 'Cézanne is as great for his clumsiness as for his
genius.'

In bringing together Cézanne's theme of bathers with the aggression
of the Fauve technique – drawing with the brush in short, sharp
strokes, laying the paint on swiftly, even roughly and with little heed
for correction – and the theatrical gesturing of the figures (a feature of
Derain's *The Golden Age*), *Bathers* has become uneasy, disturbing and 159
unresolved. Nevertheless, though Derain could not match the scale of
Cézanne's vision, the vision itself is a synthesis of the grand manner of
a great painter of composition like Delacroix and the inventive
perception of a great realist like Cézanne and it thus pointed the way

for others, notably Picasso. Because *Bathers* is not a painting about light, it makes a significant retreat from the Fauve conjunction of strident red, blue, green, yellow and orange; the figure on the left is mostly red but the earth-coloured skin tones of the other figures, highlighted with dabs of subdued red against the Cézannesque blue of the background, strike a low-key range of colour which has little in common with the heated palette used in *The Dance*, only the year before.

160 Matisse's *Blue Nude (Memory of Biskra)* is an evocation of a brief visit Matisse had made to north Africa in the spring of 1906. Matisse was not a born traveller and it is hardly surprising that he should have confided to Manguin that there was much he had disliked about Algeria, 'despite the beauty of the light'. The main value of the journey seems to have been to refresh his jaded view of Collioure which, as he told Manguin, he had begun to find insipid before his departure for Algeria. On his return to Collioure in the summer of 1906 he found that the small fishing port still gave him 'an overwhelming desire to paint'. He went back to Collioure again early in 1907, and it was there that he painted *Blue Nude*.

 Its pronounced three-dimensional quality relates directly to a small sculpture on which Matisse had been working just before the painting. The classical pose of this reclining nude had been used by Matisse for
126 one of the figures in *Le Bonheur de vivre*, but its transformation into sculpture brings home more forcibly the allusion to a Greek prototype and thus to a model of classical beauty. Matisse admired African sculptors for the way they invented rather than copied form, and by appropriating the standard reclining nude of Western art and re-thinking its forms with the help of tribal sculpture, he went further than Derain was able to in finding a modern equivalent of Cézanne's figures in landscape. Because the ceremonial purpose of tribal art demands that figures be totemic, commanding and therefore upright, there are few, if any, reclining figures in African art. The fact that Matisse's figure adopts this relaxed posture is a reminder that Western culture looks at art for contemplation rather than for worship. In 1907 Matisse might have thought that a standing figure composed of 'inverted planes and proportions' would disturb the balance between the classical and the primitive, the balance which gives both the sculpture and *Blue Nude* their force.

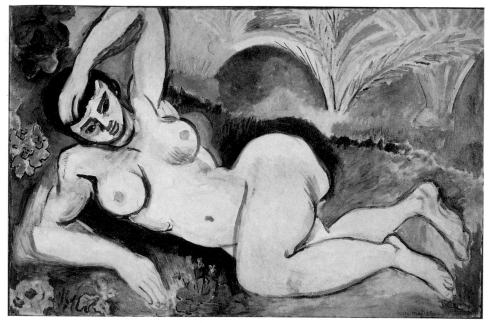

160 Henri Matisse *Blue Nude (Memory of Biskra)* 1907

Derain's figures in *Bathers* are sculptural in as much as they are 159
placed against the background in the manner of reliefs, but their
forms, though schematic, are not invented. Matisse, on the other
hand, moves towards a conceptual art by moulding the body into
shapes which he feels rather than sees: thus the *Blue Nude's* buttocks are
pulled round from the back and the limbs exaggerated. By placing the
heaviest part of the human frame, the buttocks and the thighs, at the
centre of the painting, the spectator is made very aware of the
massiveness of the figure. Matisse, like Derain, makes his nude as
anonymous as possible by treating the head as he would a hand or a
foot. It is perhaps this single fact which caused Vauxcelles and other
critics violently to take against this painting. If one considers how
often the head was made the focal point of a reclining nude (Goya's
Naked Maja and Manet's *Olympia* are two instances where the
spectator is challenged by the gaze of the woman), it is understandable
that the shorthand used here to suggest a head was disconcerting.

Vauxcelles's reaction to these two paintings as works inaugurating a new development may have been an exaggerated one, but it was symptomatic of how others were to view the Fauves in 1907 and later. The move made by the leading members of the Fauve group away from the highly charged, coloured surfaces of 1905 and 1906 towards sterner, grander compositions was the outcome of their admiration for both the expressiveness of African art and the pictorial rigour of Cézanne.

For all the uncertainty and hesitation that followed the brave beginnings of Fauvism, the sense of a group of painters bound together was as strong in 1907 and 1908 as it had been in 1905 and 1906. This continuity of a Fauve identity, after Fauvism to all appearances had finished, is seen most clearly in the evidence provided by a series of interviews with the artists conducted by Gelett Burgess, an American journalist, in the winter of 1908 to 1909. The interviews were published in one article in *The Architectural Record* in 1910 under the title 'The Wild Men of Paris'. Burgess came across Fauvism at the time of the 1908 Salon des Indépendants, when to speak about a Fauve group was to speak about a rather different alignment of painters from the one which had given the group its name in 1905. But as far as Burgess was concerned, Fauvism was the latest thing – indeed, the name itself had now become synonymous with modern art: 'Though the school was new to me, it was already an old story in Paris. It had been a nine-days' wonder. Violent discussions had raged over it; it had taken its place as a revolt and held it, despite the fulmination of critics and the contempt of the academicians. The school was increasing in numbers, in importance. By many it was taken seriously. At first, the beginners had been called "The Invertebrates". In the Salon of 1905 they were named "The Incoherents". But by 1906, when they grew more fervid, more audacious, more crazed with theories, they received their present appellation of "Les Fauves" – The Wild Beasts.' (His idea that the name Fauves was conferred in 1906 rather than 1905 reflects the time it took for the name itself to catch on: in fact, it was not in popular use much before 1907.) Burgess leaves the reader in no doubt that the artists he interviewed represented 'The Fauves': 'Matisse, being as mild a man as ever tortured the human form or debauched a palette, what of those other Fauves, who had left him out of sight in the run away from beauty? I picked out seven of the most

all, much in common with the Fauves. He shared their passionate curiosity for art outside the European cultural tradition, as well as for folk art and for children's paintings. He was also an admirer of Henri Rousseau and, what is more, was far less patronizing then Derain or Vlaminck. Like Matisse and Marquet before him, Picasso had studied Egyptian sculpture in the Louvre and as early as 1901 he had come to know the work of Gauguin through his friendship with the Spanish sculptor Paco Durrio. Again, in common with the Fauves, his full appreciation of the range of Gauguin's work as painter, sculptor, ceramist and printmaker came in the wake of the retrospective that Matisse organized for the 1906 Salon d'Automne: only then was the profound nature of Gauguin's primitivism fully revealed. A major difference between Picasso and the Fauves lies in the fact that he was never burdened with Impressionism. His nationality and, above all, his experience of the lively cultural climate of Barcelona distanced him from the movement that had shadowed the Fauves from the very beginning. On his early trips to Paris between 1900 and 1904, he found an immediate affinity with Post-Impressionists such as Toulouse-Lautrec and Van Gogh, as well as Gauguin. From the start he claimed an artistic liberty which the Fauves achieved with much greater difficulty.

Both for Picasso and for the Fauves, 1906 was the year when their curiosity about archaic and tribal art began to take a hold on their art. It was also the year when their paths began to converge. The meeting between Matisse and Picasso was effected by Gertrude Stein, who had met each of them in the autumn of 1905. By early 1906 both painters were regular visitors to the apartment Gertrude and Leo Stein shared in the rue de Fleurus which housed their growing collection of modern art. Matisse and Picasso began to see a lot of each other. Max Jacob remembered how Picasso, André Salmon, Apollinaire and himself used to dine regularly with Matisse on Thursday evenings. At the end of September 1907, Braque was introduced to Picasso by Apollinaire and shortly afterwards Picasso, Braque and Derain (who had met Picasso earlier) were to be seen regularly in each other's company. Friendship, a catalyst in the formation of Fauvism, was an equally powerful factor in its demise.

In late February or early March 1907, while Matisse was working on *Blue Nude* and Derain on *Bathers*, Picasso began planning a large

figure composition of his own, a brothel scene close in spirit to early erotic works by Cézanne. On seeing these figure paintings, which Derain and Matisse sent to the Salon des Indépendants a few weeks later, it is possible that Picasso decided to move away from his initial

idea and to construct in *Les Demoiselles d'Avignon* a more architectural, hieratic composition closer to the primitivism of these two Fauve painters. The *Demoiselles* is a powerful transmitter of the feelings of 'revelation' and 'shock' that Picasso remembered experiencing the day he walked into the Musée d'Ethnographie in Paris. His gut response to the tribal objects he saw there accounts for the completeness with which the forms of African masks have come to possess the faces of the two women on the right-hand side of the painting, part of the repainting he did immediately following the museum visit.

Picasso's immediate and instinctive response to tribal art did not prevent him from responding equally readily to the formal qualities of the pieces, the same qualities that had captured Matisse's attention some six months earlier in the autumn of 1906. Years later, when Picasso discussed with André Malraux the differences between himself and Braque, he said, 'He liked negro art, but as I told you, because they were good sculptures. He was never in the slightest way afraid of them. He had no interest in exorcism.' He could have said the same of Matisse or Derain, both of whom regarded African sculptures more as objects of aesthetic interest than vehicles for spiritual and magical powers. That Picasso had managed to convey something of the menace he thought was contained in the African objects to his own paintings is borne out by Derain's superstition (as reported by Kahnweiler) that one day Picasso would be found hanging behind his own painting.

Derain's shift from Fauve colour in *Bathers* had been a move away from painting light and it signalled his break with one of the main principles of Fauvism. Picasso had never been a painter of light (though this was to change: following Braque's lead, Picasso's analytical Cubist works are full of a glimmering light) and his freedom from what had become for Derain the tyrannous attraction of colour must have bolstered his confidence in his retreat from those 'charges of dynamite'. Derain's growing distrust of the brilliant colours of Fauvism (summed up by Signac as 'chive green and too

161 André Derain in his studio, 1908

ferocious and stalked them all over Paris.' It was probably Matisse who advised Burgess as to which artists he should interview and his purpose was surely to steer him towards the most interesting young painters around, rather than to encourage him to think in terms of a school of Fauvism. Burgess's use of the name should thus be understood as in the sense of 'avant-garde'. The group of painters presented by him to the American public as the wild men of Paris were Braque, Derain, Friesz, Picasso and a number of newcomers, Belà 161 Czobel, Auguste Herbin, Auguste Chabaud and Jean Metzinger.

The paintings Burgess reproduces by Czobel, Herbin and Chabaud show the extent to which Fauve painting of 1905 and 1906,

particularly that of Derain and Vlaminck, was attracting a number of followers. Vauxcelles had noted this when he included Czobel among other names of young adherents in his jocular roll call of the Fauve group at the time of the 1907 Salon des Indépendants: 'Les fauves! . . . M. Matisse, fauve-chef: M. Derain fauve sous-chef: MM Othon, Friesz et Dufy, fauves à la suite; M. Girieud, fauve indécis, distingué, italianisant; M. Czobel, fauve inculté, hongrois ou polonais; M. Bérémy, apprenti-fauve et M. Delaunay (quartorze ans – élève de M. Metzinger) enfantelet fauvicule.'

The result is that the style that had come to be recognized as Fauve – irregular patches of vivid colour and thick broken lines – is represented in Burgess's article by a group of followers rather than by its original members who, as Vauxcelles had realized, were now moving off in new directions. Of these original members only Matisse, Braque, Derain and Friesz feature in the article. However, Matisse had obviously made it clear to Burgess that 'he should not be classed among the Wild Beasts of this Paris menagerie'; and it is not unlikely that by 1908 Matisse should have wanted to distance himself from Fauvism as a school of painting: the process of withdrawal had already begun early in 1906 with *Le Bonheur de vivre*. One name is conspicuously absent from the article, that of Vlaminck. His absence may easily be explained by the possibility that Burgess may not have been able to fit in a visit to Reuil-Malmaison, where Vlaminck had moved the previous year. The wholesale absence of the old Moreau group – Marquet, Camoin, Manguin, together with the absence of Puy – although hardly surprising at this late date, underlines just how new this new face of Fauvism was.

The illustrations Burgess chose to represent the work that Derain, Braque and Friesz were doing in 1908 are nudes (only one landscape is reproduced, a view of Cassis by Derain). This established beyond question that the figure was now their main preoccupation. One of the works seen by Burgess on his round of the studios in the winter of 1908 has since become one of the most celebrated paintings of the twentieth century, but which at that time was virtually unknown outside the artist's immediate circle: Picasso's *Les Demoiselles d'Avignon* (1907).

Although Picasso was never associated with Fauvism, he struck the outsider Burgess as being a part of the same movement: he had, after

162

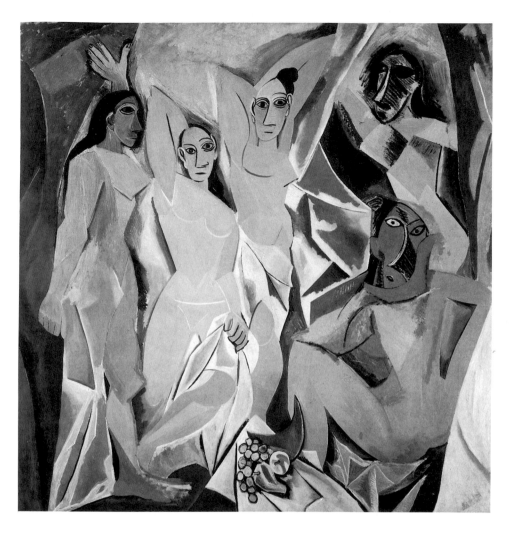

162 Pablo Picasso *Les Demoiselles d'Avignon* 1907

pure a vermilion') came out of his fear that they could all too easily distract painting into ways of decoration. *Bathers* is his first concerted attempt to find an anti-decorative style, and it was possibly this lead which Picasso in turn picked up while painting *Les Demoiselles d'Avignon*, his own, far more extreme manifesto against decoration.

126 Seeing Matisse's *Le Bonheur de vivre* 'decorating' the wall at the Stein's apartment may have had a hand in provoking Picasso's demonic retort to that work of strong Mallarmean sensibility. As he was to say many years later, 'paintings are not made to decorate apartments. They are instruments of offensive and defensive war against the enemy.'

The value of Burgess's interviews is that in spite of his tone of mock bewilderment, he approached the artists concerned with an engagingly open mind. A genuine desire on his part to know why the Fauves painted as they did was matched by an obvious willingness on the part of the painters to explain their work to the potentially vast audience of an American journal. Not one of them had the least desire to make art esoteric and difficult to understand. On the contrary, like Matisse, they wanted to reach as wide a public as possible.

From Matisse, Burgess had extracted the following definition of 'the movement'. It was, he had been told, 'a revolt against the subtleties of Impressionism. It is a revolt against "mere charm", against accidental aspects of illumination; a return to simplicity, directness, pure colours and decorative qualities.' This was a definition of the Fauvism of 1905 and 1906 – the Fauvism that Braque, for one, had left behind him. He told Burgess that he felt bound to create a new sort of beauty, 'the beauty that appears to me in terms of volume, of line, of mass, of weight, and through that beauty interpret my subjective expression'. But he also went on to say: 'Nature is a mere pretext for a decorative composition, plus sentiment. It suggests emotion, and I translate that emotion into art', a statement with which Matisse would not have found fault. Friesz, who struck Burgess as highly articulate, went further than the others in demanding a new definition of the 'School of Wild Beasts' and said: 'It is a Neo-Classical movement, tending towards the architectural style of the Egyptian art, or parallelling it, rather, in development. In its reaction against the frigidity and insipid arrangements of the Renaissance, it has gone itself to an extreme as bad, and contents itself with fugitive impressions and

premature expressions. This newer movement is an attempt to return to simplicity, but not necessarily a return to a primitive art. It is the beginning of a new art. There is a growing feeling for decorative values. It seeks to express this with a certain "style" of line and volume, with pure colour, rather than by tones subtly graded; by contrasts, rather than by modulations; by simple lines and shapes, rather than by complex forms.' *Autumn Labours*, shown at the 1908 Salon des 158 Indépendants, was Friesz's first major work in which the return to simplicity and to decorative values expressed through 'a certain "style" of line and volume' were tried out.

The fact that in the autumn of 1908 Friesz was able to talk about a 'newer movement' and 'a new art' and to deny the primitivism associated with Fauvism underlines the degree of restlessness in the Fauve camp. It was engendered largely by Derain, who increasingly took the intellectual lead among his friends in his strong reaction against the search for a sort of primal innocence which had motivated Fauvism at the beginning. In 1913 Apollinaire made the comment that 'the aesthetics of Cubism were first elaborated in the mind of André Derain'. Indeed, the changes that appeared in the work of Braque and Friesz, for example, in the months leading up to the first Cubist works in 1908 were due in no small part to Derain's initiative in rejecting Fauvism.

Braque and Friesz spent the summer of 1907 at La Ciotat, a small village not far from where Derain was staying at Cassis. From what Derain told Vlaminck in a letter written at this time, the two Havrais painters might have found Derain a little patronizing about their 'old style' Fauvism: 'Friesz and Braque are very pleased. Their idea is young and to them it seems new. They'll get over it – there are other things to be done.' At Cassis they witnessed the new landscape style Derain was evolving in the wake of *Bathers*, using a subdued palette of dark, earth colours and recapturing the receding space of classical landscape painting. For all Derain's wariness of 'decoration', the shapes constructed by his boldly defined jig-saw-like areas of colour bring just that word to mind. It was this strong sense of pattern and the adoption of a sombre palette, as well as Derain's urgency to move beyond Fauvism, that must have suggested to Braque and Friesz that they too should seek a new direction. In September 1907, on their way back to Paris from La Ciotat, they stopped at L'Estaque and two very 163,164

163 Emile-Othon Friesz *View from the Hôtel Mistral, L'Estaque* 1907

164 Georges Braque *View from the Hôtel Mistral, L'Estaque* 1907

similar paintings they did as a result of that brief visit show how accurate Friesz was when he spoke to Burgess about a new style of Fauvism. In both views of the Hotel Mistral, the mass of the stone terrace wall against the slender trunks of the umbrella pines creates an emphatic conjunction that brings out the decorative values of sharply defined areas of paint set into a shallow space. Encouraged no doubt by the counsel they had received from Derain, Braque and Friesz's palettes became considerably darker, the sombre greens and ochres lending solidity to the carefully balanced shapes of the bushes and the foliage. A major difference between these pictures and those they had done in Antwerp the previous year is that the latter were done on the spot, in front of the motif. In contrast, Braque's *View from the Hotel Mistral, L'Estaque* was mostly painted from memory in his Paris studio; the same is very likely true of Friesz's painting. A tentative

164

163

194

liberation from the demands of standing in front of the constantly shifting appearance of a landscape had begun earlier. Braque told the writer Jean Paulhan that the paintings he executed at L'Estaque in the autumn of 1906 had been conceived before he had even left Paris: 'I no longer needed the sun. I carried my light with me.' Thus from an early stage Braque was working more and more from his own conception of nature and of objects, 'translating emotion into art', as he told 165
Burgess: the immediate visual stimulus of nature had ceased to be a necessity.

On his return to Paris in September 1907, Braque's meeting with Picasso and his first unsettling sight of *Les Demoiselles d'Avignon* must 162
have confirmed this new direction. It may also have encouraged him to tackle the full-length figure, the subject currently preoccupying Matisse, Derain and Friesz, as well as Picasso. Braque had shown one figure painting at the 1907 Salon des Indépendants which, compared with Derain's *Bathers* or Matisse's *Blue Nude*, was a hesitant attempt at 159,160
modelling through colour. The skill with which he could suggest the three-dimensionality of a hill or a rocky slope entirely through colour modelling eluded him when he tried to do the same with the human figure. Now, the large canvas of a single figure, *Nude*, on which he embarked at the close of 1907, working at it over a period of six months, joins in the attempt being made by his friends to invent a new language in which to describe the complexity of the human form, by drawing on the richness of imagination contained both in Cézanne's bathers and in the forms of African and Oceanic carvings. The length of time that Braque worked on this canvas indicates how problematical he found the task to be.

Braque's return to L'Estaque and to landscape painting in the early summer of 1908 is the moment which signals the beginnings of Cubism. *Houses and Trees*, executed towards the end of that summer, 166
perfectly illustrates the style of painting which prompted Matisse, so it is said, to speak of *petits cubes*. It also appears to oppose Fauvism absolutely. More accurately, it completes what Fauvism had started – the transition of twentieth-century painting from representation to object. In a Fauve landscape such as *Landscape at Collioure*, Matisse 44
remains closely attached to a direct experience of nature. It is a painting about light which is conveyed by the colours themselves and by the neutral spaces between the colours: the experience it records is

165 Georges Braque *Still Life (Vase, Pitcher and Pipe)* c. 1907

the physical sensation of standing in a landscape. In this sense it remains close in spirit to the landscape painters of Post-Impressionism, Van Gogh in particular. In *Houses and Trees*, direct experience of nature is overruled by a conceptual re-ordering of the landscape. The break with Post-Impressionism is completed.

Dufy's emergence from the Fauvism of 1906 shows him moving first towards Matisse's distinctive arabesque line, before experimenting with the uncompromising rigour of Braque's early Cubist landscapes. His transition from the one to the other is a paradigm of the confusion experienced by the Fauves between 1907 and 1908.

166 Georges Braque *Houses and Trees* 1908

167 Raoul Dufy *The Aperitif* 1908

167 Dufy's own voice as a painter, however, was stronger than these two extremes suggest. *The Aperitif*, painted in 1908, shows the unmistakable dancing rhythm of his earlier Fauve style, even though the work itself appears fuller and richer through his use of more ambitious intervals of space between the lines of colour. Of all the Fauves, Dufy was to remain the most faithful to the style of painting he had created for himself out of Fauvism – a painting which aspired to both the artlessness of children's art and the intricate syntax of music.

While an essentially decorative painter such as Dufy (who eventually collaborated closely with textile manufacturers) could take positive pleasure in the way that Fauvism filtered through to a popular level – for example, the new approach to colour demonstrated by a

leading couturier like Paul Poiret Vlaminck was horrified, so he told the writer Francis Carco, by the extent to which the strong, bright colours of Fauvism were rapidly pirated by the street end of the fashion industry. A phenomenon such as the outbreak of gaudy colour, which he claimed swept through department-store displays immediately after the 1907 Salon d'Automne, he considered as proof of Fauvism's inherent weakness: an abject dependence on colour. But then, his reaction against Fauvism was wilfully exaggerated in later years by his strictly anti-avant-garde position. It led him to pepper his memoirs with preposterous statements such as the one found in *Paysages et personnages*, published in 1953: 'The simple play of colours did not satisfy me any more than the occasional liberty taken with a woman.'

Among his friends Vlaminck was the least interested in belonging to a group – indeed, a pride in not belonging to a group was a part of his personality. As a Fauve he had tended to stand a little apart from the others (there had always been a certain distance between Matisse and himself) and he felt uneasy in the new group that had begun to gather round Derain and Picasso, a group into which he was gathered not only through his close friendship with the more gregarious Derain, but also through his links with another friend of Picasso's, Kees Van Dongen. Vlaminck, for all his wide reading and sharp intelligence, distrusted artists who were intellectuals. Fernande Olivier, Picasso's companion of the period, was struck by how sure Vlaminck was of himself in discussions with highly articulate friends such as Derain and Picasso and yet how 'dumbfounded if he was proved wrong at the end of an argument'. The more involved Derain became in setting out his ideas of art and expounding on them in the company of Braque and Picasso, the more alienated Vlaminck appears to have become. A loner though Vlaminck was in the increasingly intellectual climate created by Derain, he was highly sensitive to the changes happening round him. By 1907 he was responding to Cézanne, as he had previously done to Van Gogh, by interpreting the work as evidence of an instinctive 'primitive' rather than of a logical mind seeking to turn sensations experienced in front of nature into painting. It was Vlaminck's own natural talent for rendering sensations into paint that coloured his interpretation of the painters he admired – he himself was much more akin to the genuine 'primitive' than either Van Gogh or

Cézanne. A still life, datable to 1907, shows the way in which he responded to the quickening interest in Cézanne shown by his Fauve companions. He employed the device of painting a subject from more than one point, a device found in many of Cézanne's still lifes: accordingly, Vlaminck paints the fruit bowl from above but the jug from head on. The delicately crafted way in which Cézanne built up his paint, hingeing one brush-stroke onto the next, is not Vlaminck's way: his impetuous, instinctive manner of applying paint could not be more different. Yet this is precisely why the painting he did in 1907 and 1908 is far from being a mere pastiche of Cézanne. On the contrary, it carries as much weight and conviction as the best of his earlier Fauve work.

While Derain, Braque, Friesz and briefly Dufy as well, began their retreat from high Fauve colour and their advance into 'volume, line, mass and weight', Vlaminck kept his independence, so that his still lifes and landscapes of this late Fauve period are painted with the same reds, blues and greens as before. His technique of brushing on the paint is more restrained in gesture than before, making for a compact, solid surface of colour rather than the jumpy, emphatically accented strokes of the previous two years. Indeed, the surface of some of these works is similar to the thick, slightly crusty surfaces of several paintings Picasso did in the autumn of 1906. In spite of the way in which Vlaminck railled against Picasso and Cubism in his several books of reminiscences, there is no doubt that during the pre-Cubist period of 1907 and 1908 he was a genuine admirer of Picasso's work, even acquiring two paintings of 1907 from Kahnweiler (probably in exchange for paintings of his own). When in late 1908 Vlaminck did turn his back on colour he did so with characteristic thoroughness. As he said later, he had become disgusted by the 'childish profligacy of colour . . . By suppressing tones and the range of possibilities that they contain in an arbitrary way, I was falling into decoration. I was no longer getting to the heart of things, I no longer fathomed them. The spirit of decoration was leading me to forget painting.'

Derain likewise came to reject his Fauve period, to resent, almost, the very nature of the movement. It was as if he and Vlaminck held Fauvism responsible for laying a series of false trails. Derain identified what he thought had been their error in the first place, 'a fear of imitating life, which made us approach things from too far off and led

168 Maurice Vlaminck *Still Life c.* 1907

us to hasty judgments'. Imitating life was the province of photography, and he claimed that their 'reaction against anything resembling photos taken from real life' had pushed them too far in the other direction: 'There was no longer a distance far enough for us to stand back and look at things with the leisure to perform our transposition.' This was why they had to return to what he called 'more cautious attitudes'. Vlaminck, who wanted painting to express 'a deeper understanding of the universe', believed that colour 'straight from the tube' was an insurmountable barrier to attaining this understanding because it reduced painting to the level of the decorative arts. For both painters Fauvism proved an impasse. Thus, first Vlaminck, then Derain, adopted a style of painting which, each in different ways, embraced a traditional fidelity to appearance. As Kahnweiler wrote

201

about Derain in 1920, 'He strives to organize his structure in such a way that the painting, though strongly unified, nevertheless shows the greatest fidelity to nature, with every object being given its "true" form and its "true" colour.'

Matisse did not turn away from the colour and light of Fauvism, but he did turn away from its violence. *Le Luxe (1)* and *Music*, two paintings he sent to the 1907 Salon d'Automne, reveal a shift towards long, sweeping lines and gently shaped forms which are painted with a soft palette consisting of umbers, ochres and sienas. The colours may not be those associated with Fauvism but the luminosity of the light – a northern light – is as convincing as that in the Collioure works. In both paintings the figures are enclosed in a deep concentration, thus adding a further dimension to the unity of the whole for which Matisse was striving. There is little sign here of the harsh primitivism which motivates Derain's *Bathers* or Braque's *Nude*. It is no accident that these figures, standing and crouching, conjure up those on Greek drinking vessels or on stone reliefs, for they signal a return to those ancient ideals of civilization. Apollinaire, in the article he published on Matisse in December 1907, was careful to point out this shift away from the primitivism of the previous months, saying, 'But, although curious to know the artistic capacities of all human races, Henri Matisse remains above all devoted to the European sense of beauty.' These paintings are also the first of a long line of 'decorations' through which Matisse was to realize his belief in the therapeutic, restoring power of art. In this sense he is dramatically opposed to Picasso, who, through the phalanx of forbidding spirits lined up in *Les Demoiselles d'Avignon*, had revealed to all who saw it the degree to which art can also be made to possess the power and the menace of magical incantations.

Colours that convey the radiance of broad daylight were central to Matisse's desire that his art should act as a balm for the human spirit. Once he had found a new scale on which to realize this he turned back to colour, using it now as a means to impregnate and to saturate the canvas rather than to whip up and agitate the surface. *Harmony in Red* shows to what extent he had moved away from the other members of the Fauve group. For while distinct differences among those members were slowly separating them from each other, a good measure of understanding still remained, not least a common

202

169 Henri Matisse *Le Luxe (1)* 1907

170 Henri Matisse *Harmony in Red* 1908

consent that for the moment colour, in the particular way they had
used it, had had its day. In spring 1908 *Harmony in Red* had been
predominantly blue and before that, green: in the autumn Matisse
painted it red. Colour remained the determining factor. The painting
has another significance. It is a version on a grander scale of his first
major exhibition piece, *The Dinner-Table*, which more than ten years
before had set him on the path to colour. In a very real sense, then, it
can be seen as a celebration of the decade it had taken Matisse to reach
the point from where he could confidently go forward.

3

204

No less acutely than Matisse, Braque saw that Fauvism by its very nature, could last only a short time: 'One cannot remain in a permanent state of crisis', he was to say later. Yet he recognized the necessity of having experienced that crisis. His move away from Fauvism was also a rejection of its fierce individuality. That was the main factor which prevented Fauvism from adopting a style unified enough to give it the status or the authority of a coherent school of painting. The year 1908 marks the beginning of his search for the anonymous personality, the effacement of individuality 'in order to find originality' which was to be so significant in the development of Cubism as well as in the larger context of twentieth-century art. As the youngest of the group he was the least 'encumbered by all the techniques of the past and the present', as Matisse put it. The same instinctive understanding of the physical nature of painting which had enabled him to dive into Fauvism without any preliminaries enabled him to abandon the high pitch of Fauve colour (which in any case he had never fully embraced) while remembering the lessons of Fauvism.

Of those lessons the one that had the most far-reaching consequences was having confidence in the autonomy of painting – that is, confidence in painting itself. Braque called it the 'a priori value' of a painting, and that recognition of the self-sufficiency of painting places Fauvism squarely at the start of the twentieth century in spirit as well as in time. For if Fauvism can boast one single achievement it is the one defined by Matisse, the achievement of making painting do 'something that only painting can do'.

Select Bibliography

The most scholarly study of Fauvism in recent years has been John Elderfield's *The Wild Beasts: Fauvism and its Affinities*, Museum of Modern Art, New York, 1976. Ellen C. Oppler's *Fauvism Reexamined*, Ph.D. dissertation, Columbia University, New York, 1969, published by Garland Publishing Inc., New York and London, 1976, has been another indispensable source for this book. In addition to the bibliographies in these two publications, the reader is advised to consult the one in Georges Duthuit's pioneering study, *The Fauvist Painters*, Wittenborn, Schultz, New York, 1950.

Publications which have appeared since 1976 include the following:

Books, periodicals and lectures

Catherine C. Bock, *Henri Matisse and Neo-Impressionism 1898–1908*, UMI Research Press, Ann Arbor, 1981; Catherine C. Bock, 'A question of quality: a note on Matisse's dark years', *Gazette des Beaux-Arts*, April 1984, pp. 169–174; John Elderfield, *Matisse in the Collection of the Museum of Modern Art*, Museum of Modern Art, New York, 1978; Jack D. Flam, *Matisse*, Cornell University Press, Ithaca, 1987; Marcel Giry, 'Le curieux achat fait à Derain et à Vlaminck au Salon des Indépendants de 1905 ou deux tableaux retrouvés', *L'Oeil*, September 1976, pp. 26–31; Marcel Giry, *Le Fauvisme, ses origines, son evolution*, Ides et Calendes, Neuchâtel, 1981; Marcel Giry, 'La periode fauve de Braque', *L'Oeil*, June 1982, pp. 32–9; John Golding, *Fauvism and the School of Chatou: Post Impressionism in Crisis*, 66, British Academy, London, 1980; Lawrence Gowing, *Matisse*, Thames and Hudson, London, 1979; Janet Hobhouse, 'The Fauve Years: A Case of Derailments', *Art News*, Summer 1976, pp. 47–50; Claude Manguin, *Henri Manguin Catalogue Raisonné*, Ides et Calendes, Neuchâtel, 1980;

Marilyn McCully (ed.), *A Picasso Anthology: Documents, Criticism, Reminiscences*, Arts Council of Great Britain in association with Thames and Hudson, London, 1981; Isabelle Monod-Fontaine, *Œuvres de Henri Matisse 1869–1954*, Centre Georges Pompidou, Musée National d'Art Moderne, Paris, 1979; N. Pouillon and Isabelle Monod-Fontaine, *Œuvres de Georges Braque 1882–1963*, Centre Georges Pompidou, Musée National d'Art Moderne, Paris, 1982; John Rewald, *Studies in Post-Impressionism*, Thames and Hudson, London, 1986; John Rewald, *Cézanne, the Steins and their Circle*, Walter Neurath Memorial Lecture 1986, Thames and Hudson, London, 1987; Pierre Schneider, *Matisse*, Thames and Hudson, London, 1984; Nicholas Watkins, *Matisse*, Phaidon Press, Oxford, 1977.

Exhibition catalogues

Henri Manguin, Chapelle de la Misericorde, Saint-Tropez, June–September 1976; *Cézanne: The Late Work*, Museum of Modern Art, New York, 1977; *D'un espace à l'autre: la fenêtre*, Musée de l'Annonciade, Saint-Tropez, June–September 1978; *Raoul Dufy*, Arts Council of Great Britain, Hayward Gallery, London, 1983; John Elderfield, *The Drawings of Henri Matisse* and Isabelle Monod-Fontaine, *The Sculpture of Henri Matisse*, both published by the Arts Council of Great Britain in association with the Museum of Modern Art, New York, and Thames and Hudson, London, 1984; *Primitivism in 20th Century Art*, Museum of Modern Art, New York, 1984; *Daniel-Henry Kahnweiler, Marchand, Editeur, Ecrivain*, Centre Georges Pompidou, Musée National d'Art Moderne, Paris, 1984; *Six Années d'acquisition du Musée de l'Annonciade*, Musée de l'Annonciade, Saint-Tropez, 1986; 'Matisse et Tahiti', *Cahiers Henri Matisse*, 1, Musée Matisse, Nice, 1986; *Le Cavalier Bleu*, Musée des Beaux-Arts, Berne, 1986.

Quotations in the text have been taken from the following:

Aragon, Louis, *Matisse: A Novel*, Collins, London, 1971.

Baudelaire, Charles, *The Painter of Modern Life and Other Essays*, translated and edited by Jonathan Mayne, Phaidon Press, London, 1964.

Burgess, Gelett, 'The Wild Men of Paris', *The Architectural Record*, May 1910, pp. 400–14.

Cézanne, Paul, *Correspondance* (ed. John Rewald), Editions Bernard Grasset, Paris, 1937.

Courthion, Pierre, *Raoul Dufy*, Pierre Cailler, Geneva, 1951.

Craig, Edward Gordon, *Isadora Duncan: Six Movement Designs*, Leipzig, 1906.

Derain, André, *Lettres à Vlaminck*, Flammarion, Paris, 1955.

Duthuit, Georges, *The Fauvist Painters*, Wittenborn, Schultz, New York, 1950.

Evenepoël, Henri, *Henri Evenepoël à Paris: Lettres Choisies 1892–1899*, (ed. F. E. Hyslop), Renaissance du Livre, Brussels, 1971.

Flam, Jack D. *Matisse on Art*, Phaidon Press, London and New York, 1973.

Herbert, Robert, *Neo-Impressionism*, The Solomon R. Guggenheim Foundation, New York, 1968.

House, John, *Monet: Nature into Art*, Yale University Press, New Haven and London, 1986.

Kandinsky, Collections du Musée National d'Art Moderne, Paris, 1984.

Malraux, André, *La Tête d'Obsidienne*, Gallimard, Paris, 1974.

'Matisse et Tahiti', *Cahiers Henri Matisse*, 1, Musée Matisse, Nice, 4 July–30 September 1986.

Olivier, Fernande, *Picasso et Ses Amis*, Librairie Stock, Paris, 1933.

Paulhan, Jean, *Braque: le Patron*, Gallimard, Paris, 1952.

Rewald, John, *The History of Post-Impressionism*, Museum of Modern Art, New York and London, 1978.

Schneider, Pierre, *Matisse*, Thames and Hudson, London, 1984.

Stein, Gertrude, *The Autobiography of Alice B. Toklas*, Harcourt Brace, New York, 1933.

Stein, Leo, *Appreciation: Painting, Poetry and Prose*, Crown, New York, 1947.

Vlaminck, Maurice, *Paysages et Personnages*, Flammarion, Paris, 1953.

Vlaminck, Maurice, *Dangerous Corner*, Elek Books, London, 1961.

Translations of passages taken from Georges Duthuit, 'Le Fauvisme', *Cahiers d'Art*, nos 5, 6, 10 in 1929, no. 3 in 1930 and no. 2 in 1931; Derain, *Lettres à Vlaminck* and Vlaminck, *Paysages et Personnages* have been provided by Stephen Cox.

List of Illustrations

27 Kees Van Dongen *Le Moulin de la Galette* 1904. Oil on canvas 55.2 × 46.1 (21¾ × 18⅛) Private Collection
28 Paul Signac *In the Age of Harmony* 1895. Oil on canvas 300 × 400 (118 × 157½). Mairie de Montreuil. Photo Suzanne Bosman
29 Henri-Edmond Cross *The Evening Air* 1893–4. Oil on canvas 116 × 164 (45⅝ × 64½). Musée d'Orsay, Paris. Photo Réunion des musées nationaux
30 Henri Matisse *The Terrace* 1904. Oil on canvas 71.7 × 57.7 (28¼ × 22¾). Isabelle Stewart Gardner Museum, Boston
31 Henri Matisse *Luxe, calme et volupté* 1904. Oil on canvas 98.3 × 118.5 (38¾ × 46⅝). Musée d'Orsay, Paris. Photo Réunion des musées nationaux
32 Henri Matisse *The Gulf of St Tropez* 1904. Oil on canvas 50 × 65 (19⅝ × 25⅝). Kunstsammlung, Nordrhein-Westfalen, Düsseldorf
33 Henri Matisse *Marquet Painting from the Model* 1904–05. Oil on paper 31.1 × 24.1 (12¼ × 9½). Musée National d'Art Moderne, Centre Georges Pompidou, Paris
34 Henri Matisse or Henri Manguin *Artist Painting from the Model* 1904–05. Oil on canvas 91.1 × 72.1 (35⅞ × 28⅜). Musée National d'Art Moderne, Centre Georges Pompidou, Paris
35 Albert Marquet *Matisse Painting from the Model* 1904–05. Oil on canvas 100 × 73 (39⅜ × 28¾). Musée National d'Art Moderne, Centre Georges Pompidou, Paris
36 Jean Puy *Woman in a Hammock* 1904–05. Oil on canvas 73 × 92 (28¾ × 36¼). Private Collection, Boston. Photo courtesy Rolly Michaux Galleries, Boston
37 Henri Matisse *The Port of Abaill, Collioure* 1905–06. Oil on canvas 60 × 148 (23⅜ × 58¼). Private Collection
38 André Derain *Trees* 1905. Oil on canvas 65 × 85 (25⅝ × 33½). Private Collection
39 Leo and Gertrude Stein's apartment in the rue de Fleurus showing Henri Manguin's *The Studio*, 1906, top left. The Baltimore Museum of Art, The Cone Archives
40 André Derain *Banks of the Seine*, 1904. Oil on canvas 85 × 95.5 (33½ × 37⅝). Musée National d'Art Moderne, Centre Georges Pompidou, Paris
41 André Derain *The Bridge at Le Pecq* 1904–05. Oil on canvas 98.1 × 116.2 (38⅝ × 45¾). Private Collection
42 Maurice Vlaminck *My Father's House* 1905.

Oil on canvas 54 × 65 (21¼ × 25⅝). Private Collection. Photo through the courtesy of Sotheby's, London
43 Henri Matisse *Landscape at Collioure* 1905. Oil on canvas 39 × 46.2 (15⅜ × 18⅛). Private Collection
44 Henri Matisse *Landscape at Collioure* 1905. Oil on canvas 46 × 54.9 (18⅛ × 21⅝). Statens Museum for Kunst, Copenhagen
45 Henri Matisse *Beach at Collioure* 1905. Pen and ink 22.8 × 17.5 (9 × 6⅞). Private Collection
46 Henri Matisse *Landscape, St Tropez* 1904. Pencil 31 × 20 (12¼ × 7⅞). Musée Matisse, Nice
47 Henri Matisse *View of the Port, Collioure* 1905. Oil on canvas 59.3 × 73 (23⅜ × 28¾). Hermitage Museum, Leningrad
48 André Derain *Matisse Painting his Wife* 1905. Pen and ink. Private Collection
49 Henri Matisse *Mme Matisse in the Olive Grove* 1905. India ink 20.3 × 26.7 (8 × 10½). Private Collection. Photo Courtesy Sotheby's Inc
50 Henri Matisse *La Japonaise : Woman beside the Water* 1905. Oil on canvas 35 × 29 (13¾ × 11⅜). Collection The Museum of Modern Art, New York
51 André Derain *Landscape at Collioure* 1905. Oil on board 35.7 × 46 (14 × 18⅛). Private Collection. Photo through the courtesy of Sotheby's, London
52 Henri Manguin *The Fourteenth of July at St Tropez* 1905. Oil on canvas 61.9 × 50.2 (24⅜ × 19¾). Private Collection
53 André Derain *The Port, Collioure* 1905. Oil on canvas 62.2 × 78.1 (24½ × 30¾). Musée d'Art Moderne de Troyes
54 Henri Manguin *The Vale, St Tropez* 1905. Oil on canvas 50.2 × 61 (19¾ × 24). Private Collection. Photo Galerie Schmit, Paris
55 André Derain *Boats at Collioure* 1905. Oil on canvas 60 × 73 (23⅜ × 28¾). Kunstsammlung, Nordrhein-Westfalen, Düsseldorf
56 André Derain *Collioure* 1905. Oil on canvas 81 × 100 (31⅞ × 39¾). Private Collection
57 Henri Matisse *The Open Window* 1905. Oil on canvas 55 × 46 (21⅝ × 18⅛). From the Collection of Mrs John Hay Whitney
58 Albert Marquet *Port of St Tropez* 1905. Oil on canvas 65 × 81 (25⅝ × 31⅞). Musée de l'Annonciade, St Tropez. Photo Réunion des musées nationaux
59 Charles Camoin *La Place aux Herbes, St Tropez* 1905. Oil on canvas 81 × 65 (31⅞ × 25⅝).

Musée de l'Annonciade, St Tropez
60 Henri Matisse *Seascape* 1905. Oil on cardboard mounted on panel 24.5×32.4 ($9\frac{5}{8} \times 12\frac{3}{4}$). San Francisco Museum of Art, Bequest of Mildred B. Bliss
61 Maurice Vlaminck *Portrait of André Derain* 1905. Oil on canvas 27.3×22.2 ($10\frac{3}{4} \times 8\frac{3}{4}$). Private Collection
62 Henri Matisse *Beach at Collioure* 1905. Watercolour 20.5×27 ($8\frac{1}{8} \times 10\frac{5}{8}$). Private Collection
63 André Derain *Fishing Boats, Collioure* 1905. Watercolour 17.8×18.3 ($7 \times 7\frac{1}{4}$). Private Collection
64 André Derain *The Mountains, Collioure* 1905. Oil on canvas 81.3×100.3 ($32 \times 39\frac{1}{2}$). National Gallery of Art, Washington, John Hay Whitney Collection
65 Henri Matisse *Woman in a Hat* 1905. Oil on canvas 81×65 ($31\frac{7}{8} \times 25\frac{5}{8}$). Private Collection, San Francisco, Ca.
66 Page from *L'Illustration*, 4 November 1905. Photo Sygma
67 Henri Matisse *Portrait of André Derain* 1905. Oil on canvas 39.4×28.9 ($15\frac{1}{2} \times 11\frac{3}{8}$). Tate Gallery, London
68 André Derain *Portrait of Maurice Vlaminck* 1905. Oil on canvas 41.3×33 ($16\frac{1}{4} \times 13$). Private Collection
69 Henri Manguin *Siesta* 1905. Oil on canvas 50×61 ($19\frac{5}{8} \times 24$). Courtesy Fridart Foundation
70 Georges Rouault *The Old Quarter* 1906. Watercolour and gouache 28.6×24.4 ($11\frac{1}{4} \times 9\frac{5}{8}$). Private Collection
71 Henri Matisse in the apartment of Michael and Sarah Stein, 58 rue Madame, *c.* 1908. The Baltimore Museum of Art, The Cone Archives
72 Leo, Gertrude and Michael Stein, early 1906. The Baltimore Museum of Art, The Cone Archives
73 Pablo Picasso *Portrait of Leo Stein c.* 1906. Pen and brown ink 32×23.5 ($12\frac{5}{8} \times 9\frac{1}{4}$). Private Collection. Photo through the courtesy of Sotheby's, London
74 Georges Rouault *At the Galerie Druet* 1906. Oil on paper laid on canvas 62.2×50.8 ($24\frac{1}{2} \times 20$). Private Collection
75 Kees Van Dongen *Portrait of Kahnweiler* 1907, original state before cut down. Photo courtesy Galerie Louise Leiris
76 Claude Monet *The Houses of Parliament* 1903. Oil on canvas 81×92 ($31\frac{7}{8} \times 36\frac{1}{4}$). Musée

d'Orsay, Paris. Photo Réunion des musées nationaux
77 André Derain *The Pool of London* 1906. Oil on canvas 65.7×99.1 ($25\frac{7}{8} \times 39$). Tate Gallery, London
78 André Derain *The Houses of Parliament* 1905–06. Oil on canvas 79.1×86 ($31\frac{1}{8} \times 33\frac{7}{8}$). Musée d'Art Moderne de Troyes
79 André Derain *Charing Cross Bridge* 1905–06. Oil on canvas 81×100 ($31\frac{7}{8} \times 39\frac{3}{8}$). National Gallery of Art, Washington, John Hay Whitney Collection
80 André Derain *Effect of Sunlight on Water* 1905–06. Oil on canvas 78.1×100 ($30\frac{3}{4} \times 39\frac{3}{8}$). Musée de l'Annonciade, St Tropez. Photo Réunion des musées nationaux
81 André Derain *Seine Barges* 1906. Oil on canvas 79.4×97.2 ($31\frac{1}{4} \times 38\frac{1}{4}$). Musée National d'Art Moderne, Centre Georges Pompidou, Paris
82 André Derain *The Bend in the Road, L'Estaque* 1906. Oil on canvas 128.2×194.6 ($50\frac{1}{2} \times 76\frac{5}{8}$). The Museum of Fine Arts, Houston. John A. and Audrey Jones Beck Collection
83 André Derain *Landscape at L'Estaque* 1906. Oil on canvas 82.2×101.6 ($32\frac{3}{8} \times 40$). Private Collection
84 André Derain *Trees, L'Estaque* 1906. Oil on canvas 100.3×79.9 ($39\frac{1}{2} \times 31\frac{1}{2}$). Israel Museum, Jerusalem, Gift of Sam and Ayala Zacks
85 Vincent Van Gogh *Iris* 1889. Oil on paper 62.2×48.3 ($24\frac{1}{2} \times 19$). The National Gallery of Canada, Ottawa
86 André Derain *The Old Tree* 1904–05. Oil on canvas 41.3×33 ($16\frac{1}{4} \times 13$). Musée National d'Art Moderne, Centre Georges Pompidou, Paris
87 André Derain *Banks of the Seine* 1905. Oil on canvas 60×81 ($23\frac{5}{8} \times 31\frac{7}{8}$). Private Collection. Photo through the courtesy of Sotheby's, London
88 Maurice Vlaminck *The Seine at Chatou* 1906. Oil on canvas 50.2×65.1 ($19\frac{3}{4} \times 25\frac{5}{8}$). From the Collection of Mrs John Hay Whitney
89 Maurice Vlaminck *The Seine at Chatou* 1906. Oil on canvas 81×101 ($31\frac{7}{8} \times 39\frac{3}{4}$). Private Collection, North America
90 Maurice Vlaminck *Boats on the Seine* 1906. Oil on canvas 38.1×47 ($15 \times 18\frac{1}{2}$). The Metropolitan Museum of Art, New York, Robert Lehman Collection
91 Claude Monet *Banks of the Seine* 1877. Oil on canvas 54×65 ($21\frac{1}{4} \times 25\frac{5}{8}$). Present where-

abouts unknown. Photo Durand-Ruel
92 Maurice Vlaminck *Landscape, Chatou* 1906.
Oil on canvas 54.5 × 65 (21½ × 25⅝). Private
Collection
93 Maurice Vlaminck *The Red Trees* 1906. Oil
on canvas 65.1 × 81 (25⅝ × 31⅞). Musée
National d'Art Moderne, Centre Georges
Pompidou, Paris
94 Maurice Vlaminck *Banks of the Seine at
Chatou* 1905–06. Oil on canvas 59 × 80
(23¼ × 31½). Musée d'Art Moderne de la Ville de
Paris
95 André Derain *Three Figures Sitting on the
Grass* 1906. Oil on canvas 38.1 × 54.9 (15 × 21⅝).
Musée d'Art Moderne de la Ville de Paris
96 Maurice Vlaminck *The White House* 1905–
06. Oil on canvas 45 × 55 (17¾ × 21⅝). Private
Collection. Photo Galerie Schmit, Paris
97 Maurice Vlaminck *Landscape at Chatou*
1906. Oil on canvas 65.1 × 73.7 (25⅝ × 29).
Stedelijk Museum, Amsterdam
98 Maurice Vlaminck *The Olive Trees* 1906.
Oil on canvas 53.5 × 65 (21 × 25⅝). Thyssen-
Bornemisza Foundation, Lugano, Switzerland
99 Raoul Dufy *Street Decked with Flags
(Fourteenth of July at le Havre)* 1906. Oil on
canvas 46.5 × 38 (18¼ × 15). Courtesy Fridart
Foundation
100 Raoul Dufy *Sainte-Adresse* 1906. Oil on
canvas 64.8 × 80 (25½ × 31½). Milwaukee Art
Museum Collection, Gift of Mrs Harry Lynde
Bradley
101 Albert Marquet *The Pier at Sainte-Adresse*
1906. Oil on board 49 × 60 (19¼ × 23⅝). Private
Collection. Photo Galerie Schmit, Paris
102 Maurice Vlaminck *Poppies* 1906. Oil on
canvas 60.5 × 37.5 (23⅞ × 14¾). Private Collec-
tion. Photo through the courtesy of Sotheby's,
London
103 Maurice Vlaminck *Landscape, the Bois Mort*
1905–06. Oil on canvas 65 × 81 (25⅝ × 31⅞).
Courtesy Fridart Foundation
104 Claude Monet *Beach at Sainte-Adresse* 1867.
Oil on canvas 75 × 101 (29½ × 39¾). Courtesy of
The Art Institute of Chicago, Mr and Mrs Lewis
L. Coburn Collection
105 Albert Marquet *The Beach at Fécamp* 1906.
Oil on canvas 50 × 60.8 (19⅝ × 24). Musée
National d'Art Moderne, Centre Georges
Pompidou, Paris
106 Raoul Dufy *The Regatta* 1906. Oil on
canvas 60.7 × 73 (23⅞ × 28¾). Galerie Beyeler,
Basle

107 Raoul Dufy *The Beach and Pier at Trouville*
1905. Oil on canvas 65 × 81.2 (25⅝ × 32). Private
Collection
108 Raoul Dufy *Trouville* 1906. Oil on canvas
65 × 88 (25⅝ × 34⅝). Musée National d'Art
Moderne, Centre Georges Pompidou, Paris
109 Emile-Othon Friesz *Stevedores in the Port*
1906. Oil on canvas 70.5 × 80.5 (27¾ × 31¾).
Private Collection
110 Emile-Othon Friesz *The Port, Antwerp*
1906. Oil on canvas 69.5 × 80 (27⅜ × 31½).
Musée de l'Annonciade, St Tropez. Photo
Réunion des musées nationaux
111 Georges Braque *Antwerp Docks* 1906. Oil
on canvas 38 × 46 (15 × 18⅛). Von der Heydt
Museum, Wuppertal
112 Georges Braque *The Small Bay, La Ciotat*
1907. Oil on canvas 36.2 × 47.9 (14¼ × 18⅞).
Musée National d'Art Moderne, Centre
Georges Pompidou, Paris
113 Emile-Othon Friesz *The Small Bay, La
Ciotat* 1907. Watercolour 44 × 55 (17⅜ × 21⅝).
Private Collection. Photo through the courtesy
of Sotheby's, London
114 Emile-Othon Friesz *La Ciotat* 1907. Oil on
canvas 65 × 81 (25⅝ × 31⅞). Musée d'Art
Moderne de Troyes
115 Henri-Edmond Cross *Le Cap Nègre* 1906.
Oil on canvas 89 × 116 (35 × 45⅝). Private
Collection
116 Georges Braque *La Ciotat* 1907. Oil on
canvas 71 × 60 (28 × 23⅝). Collection The
Museum of Modern Art, New York. Acquired
through the Katherine S. Dreier and Adele R.
Levy Bequests
117 Georges Braque *Countryside at La Ciotat*
1907. Oil on canvas 38 × 46 (15 × 18⅛).
Kunstsammlung Nordrhein-Westfalen, Düs-
seldorf
118 Georges Braque *L'Estaque* 1906. Oil on
canvas 60 × 73 (23⅝ × 28¾). Musée de
l'Annonciade, St Tropez. Photo Réunion des
musées nationaux
119 Georges Braque *L'Estaque* 1906. Oil on
canvas 46 × 38 (18⅛ × 15). Private Collection,
Basle
120 Georges Braque *L'Estaque* 1906. Oil on
canvas 50 × 61 (19⅝ × 24). Courtesy Fridart
Foundation
121 Georges Braque *L'Estaque* 1906. Oil on
canvas 50 × 60 (19⅝ × 23⅝). Musée National
d'Art Moderne, Centre Georges Pompidou,
Paris

122 Emile-Othon Friesz *La Ciotat* 1907. Oil on canvas 64.8 × 80 ($25\frac{1}{2}$ × $31\frac{1}{2}$). Courtesy Fridart Foundation
123 Henri Matisse, sketch for *Le Bonheur de vivre* 1905–06. Oil on canvas 41.2 × 55 ($16\frac{1}{4}$ × $21\frac{5}{8}$). Private Collection, San Francisco, Ca.
124 André Derain *The Golden Age* 1905. Oil on canvas 176.5 × 189.2 ($69\frac{1}{2}$ × $74\frac{1}{2}$). The Museum of Modern Art, Tehran
125 André Derain, page from a sketchbook, c. 1904. Conté crayon 29.8 × 20 ($11\frac{3}{4}$ × $7\frac{7}{8}$). Musée National d'Art Moderne, Centre Georges Pompidou, Paris
126 Henri Matisse *Le Bonheur de vivre* 1905–06. Oil on canvas 174 × 238 ($68\frac{1}{2}$ × $93\frac{3}{4}$). Barnes Foundation, Merion, Pa.
127 Jean-Auguste-Dominique Ingres *L'Age d'or* 1862. Oil on paper affixed to a panel 47.8 × 62 ($18\frac{7}{8}$ × $24\frac{3}{8}$). Courtesy of the Harvard University Art Museums (Fogg Art Museum), Bequest – Grenville L. Winthrop
128 Pierre Puvis de Chavannes *Le Doux Pays* 1882. Oil on canvas 25.7 × 47.3 ($10\frac{1}{4}$ × $18\frac{5}{8}$). Yale University Art Gallery, Abbey Fund
129 René Ménard *Nymphs* c. 1900. Oil on canvas 172 × 137.5 ($67\frac{3}{4}$ × $54\frac{1}{8}$). Private Collection
130 André Derain *Dancers* 1906. Watercolour and pencil 49.7 × 64.7 ($19\frac{5}{8}$ × $25\frac{1}{2}$). Private Collection. Photo Courtesy Sotheby's Inc
131 André Derain *Bacchic Dance* 1906. Watercolour and pencil 49.5 × 64.8 ($19\frac{1}{2}$ × $25\frac{1}{2}$). Collection The Museum of Modern Art, New York. Gift of Abbey Aldrich Rockefeller
132 André Derain *The Dance* 1906. Watercolour and pencil 45 × 61 ($17\frac{3}{4}$ × 24). Private Collection. Photo through the courtesy of Sotheby's, London
133 André Derain *Figures Dancing in a Forest (The Dance)* 1906. Oil on canvas 228 × 183 ($89\frac{3}{4}$ × 72). Courtesy Fridart Foundation
134 Fang Mask, Gabon. Musée National d'Art Moderne, Centre Georges Pompidou, Paris
135 Vili Figure, the Congo. Formerly Matisse Collection
136 André Derain *Crouching Man* 1907. Stone h. 33 (13). Museum Moderner Kunst, Vienna
137 Constantin Brancusi *Head of a Girl* 1907. Stone. Present whereabouts unknown
138 André Derain *Bathers* 1908. Oil on canvas 179.4 × 231.8 ($70\frac{5}{8}$ × $91\frac{1}{4}$). The National Gallery, Prague
139 Maurice Vlaminck *Young Girl Brushing her*

Hair c. 1906. Monotype 44 × 32 ($17\frac{3}{8}$ × $12\frac{5}{8}$). Private Collection
140 Henri Matisse *Nude in a Folding Chair* 1906. Woodcut 47.5 × 38.1 ($18\frac{3}{4}$ × 15). Kornfeld Galerie, Berne
141 Paul Gauguin *Self-Portrait Jug* 1889. Stoneware h. 19.5 ($7\frac{5}{8}$). Museum of Decorative Arts, Copenhagen
142 Henri Matisse *Cylinder with Dancing Figures* 1907. Fruit wood h. 44.1 ($17\frac{3}{8}$). Musée Matisse, Nice
143 André Derain, carved bed-head, c. 1907. Present whereabouts unknown
144 Paul Gauguin *Be Mysterious* 1890. Painted linden wood 73 × 95 ($28\frac{3}{4}$ × $37\frac{3}{8}$). Musée d'Orsay, Paris. Photo Réunion des musées nationaux
145 Maurice Vlaminck, painted ceramic plate, 1907. Musée des Arts Décoratifs, Paris
146 André Derain *Vase with Dancers* 1906–07. Ceramic h. 55 ($21\frac{5}{8}$). Private Collection
147 Henri Matisse *Pink Onions* 1906. Oil on canvas 46 × 54.9 ($18\frac{1}{8}$ × $21\frac{5}{8}$). Statens Museum for Kunst, Copenhagen
148 Henri Matisse *Girl Reading* 1905–06. Oil on canvas 72.4 × 59.4 ($28\frac{1}{2}$ × $23\frac{3}{8}$). Private Collection
149 Henri Matisse *Marguerite* 1906 or 1907. Oil on canvas 65 × 54 ($25\frac{5}{8}$ × $21\frac{1}{4}$). Musée Picasso, Paris. Photo Réunion des musées nationaux
150 André Derain *Dancer at the 'Rat Mort'* 1906. Oil on canvas 100.3 × 82.6 ($39\frac{1}{2}$ × $32\frac{1}{2}$). Statens Museum for Kunst, Copenhagen
151 Henri Matisse *Mme Matisse (The Green Stripe)* 1905. Oil on canvas 40.5 × 32.5 (16 × $12\frac{3}{4}$). Statens Museum for Kunst, Copenhagen
152 Charles Camoin *Girl Resting on a Bed* 1903. Oil on canvas 65 × 81 ($25\frac{5}{8}$ × $31\frac{7}{8}$). Musée d'Art Moderne de la Ville de Paris
153 Henri Manguin *The Gypsy in the Studio* 1906. Oil on canvas 46.5 × 55 ($18\frac{3}{8}$ × $21\frac{5}{8}$). Musée de l'Annonciade, St Tropez. Photo Réunion des musées nationaux
154 Henri Matisse *The Gypsy* 1906. Oil on canvas 54.9 × 46 ($21\frac{5}{8}$ × $18\frac{1}{4}$). Musée de l'Annonciade, St Tropez. Photo Réunion des musées nationaux
155 Maurice Vlaminck *Reclining Nude* 1906. Oil on canvas 27 × 41 ($10\frac{5}{8}$ × $16\frac{1}{8}$). Courtesy Fridart Foundation
156 Kees Van Dongen *Western Dancer* c. 1906. Oil on canvas 65 × 54.5 ($25\frac{5}{8}$ × $21\frac{1}{2}$). Private Collection

157 Kees Van Dongen *Reclining Nude c.* 1905. Oil on canvas 46 × 55 (18⅛ × 21⅝). Private Collection
158 Emile-Othon Friesz *Autumn Labours* 1907–08. Oil on canvas 200.5 × 250 (78⅞ × 98¾). Nasjonalgalleriet, Oslo
159 André Derain *Bathers* 1907. Oil on canvas 130.2 × 192.7 (51¼ × 75⅞). Private Collection
160 Henri Matisse *Blue Nude (Memory of Biskra)* 1907. Oil on canvas 92 × 140 (36¼ × 55⅛). The Baltimore Museum of Art, The Cone Collection
161 André Derain in his studio, 1908. From Gelett Burgess, 'The Wild Men of Paris', *The Architectural Record* 1910
162 Pablo Picasso *Les Demoiselles d'Avignon* 1907. Oil on canvas 243.8 × 233.7 (96 × 92). Collection The Museum of Modern Art, New York. Acquired through the Lillie P. Bliss Bequest
163 Emile-Othon Friesz *View from the Hôtel Mistral, L'Estaque* 1907. Present whereabouts unknown

164 Georges Braque *View from the Hôtel Mistral, L'Estaque* 1907. Oil on canvas 81.3 × 61 (32 × 24). Private Collection
165 Georges Braque *Still Life (Vase, Pitcher and Pipe) c.* 1907. Oil on canvas 52.5 × 63.5 (20⅝ × 25). Josefowitz Collection
166 Georges Braque *Houses and Trees* 1908. Oil on canvas 73 × 59.5 (28¾ × 23⅜). Kunstmuseum, Bern, Hermann and Margit Rupf-Stiftung
167 Raoul Dufy *The Aperitif* 1908. Oil on canvas 59 × 72.1 (23¼ × 28⅜). Musée ·d'Art Moderne de la Ville de Paris
168 Maurice Vlaminck *Still Life c.* 1907. Oil on canvas 53 × 72 (20⅞ × 28¾). Courtesy Fridart Foundation
169 Henri Matisse *Le Luxe (1)* 1907. Oil on canvas 210.2 × 139.1 (82¾ × 54¾). Musée National d'Art Moderne, Centre Georges Pompidou, Paris
170 Henri Matisse *Harmony in Red* 1908. Oil on canvas 177.2 × 218.1 (69¾ × 85⅞). Hermitage Museum, Leningrad

Index

Numbers in *italic* refer to the illustrations